Sean Scully

Sean Scully

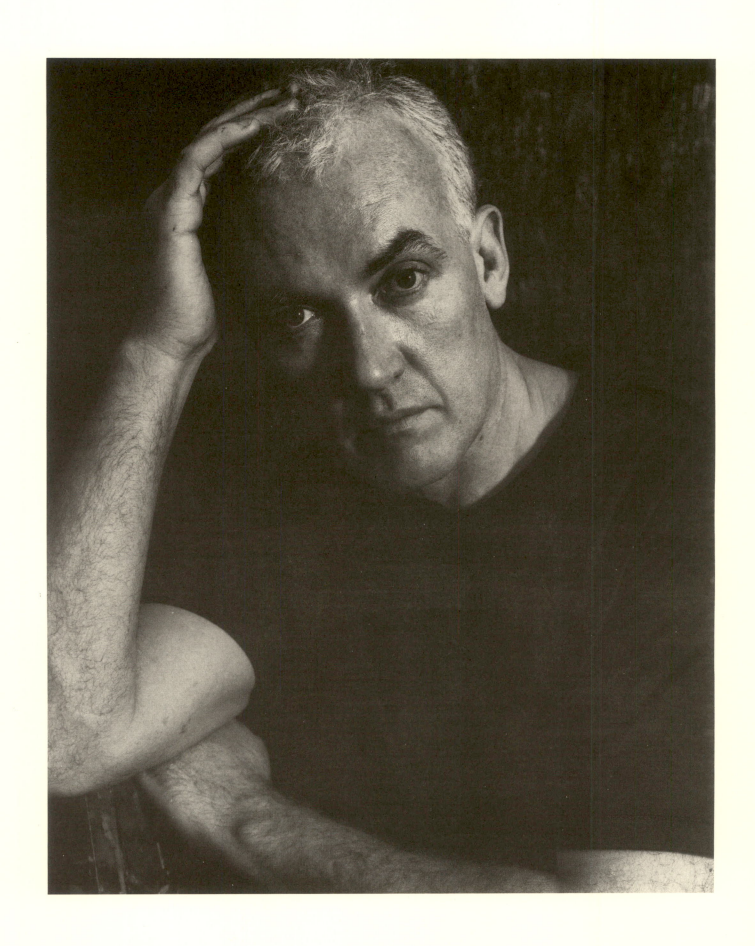

Sean Scully

MAURICE POIRIER

Hudson Hills Press
New York

à mes parents

FIRST EDITION

Text © 1990 by Maurice Poirier
Illustrations © 1990 by Sean Scully

Published in the United States by Hudson Hills Press, Inc.,
Suite 1308, 230 Fifth Avenue, New York, NY 10001-7704.

Distributed in the United States, its territories and posses-
sions, Canada, Mexico, and Central and South America by
Rizzoli International Publications, Inc.
Distributed in the United Kingdom and Eire by Thomas Heneage
& Co. Ltd.
Distributed in Japan by Yohan (Western Publications
Distribution Agency).

Poirier, Maurice.
 Sean Scully / Maurice Poirier.—1st ed.
 p. cm.
 Includes bibliographical references and index.
 ISBN 1-55595-040-X (alk. paper)
 1. Scully, Sean, 1945– —Criticism and interpretation.
I. Title.
ND497.S414P65 1990
759.13—dc20 90-80946
 CIP

Editor and Publisher: Paul Anbinder

Copy Editors: Virginia Wageman and Judy Spear

Designer: Binns & Lubin/Betty Binns

Composition: U. S. Lithograph, typographers

Manufactured in Japan by Toppan Printing Company

Library of Congress Cataloguing-in-Publication Data

Contents

Colorplates

Acknowledgments

I should like to thank the many people who have helped in one way or another in the materialization of this book, among them Irving Sandler, Paul Anbinder of Hudson Hills Press, Renee and David McKee, Per Jensen, Mark Zucker, Harriet Berry and Alex Gregory-Hood of the Rowan Gallery in London, and, not least, the artist himself for his unstinting cooperation. To Chieh-Ju Tsai of the David McKee Gallery I am especially indebted for her role in coordinating the bibliography. Virginia Wageman and Judy Spear have provided valuable editorial comments and I am thankful to them. Most of all I wish to express my gratitude to Jane Necol for her research assistance, her encouragement, and her help in shaping the text.

Introduction

In February 1989 an exhibition of recent paintings by Sean Scully was held at the David McKee Gallery in New York. All included one or more insets of square or rectangular shape, and, in composition, all were based on the interaction between the horizontal and the vertical. Mysteriously, within this restrictive structural system, a living, intense current of pictorial eloquence flowed, transforming the works into vehicles of poetic expression of a unique type. Two of the perceivable reasons for this phenomenon were the sensuously vibrant spread of paint and the mesmerizing—at times quasi-magical—color relationships that reached deep into the core of one's sensibility. But permeating the coloring as well as the design was an element of control and discipline that set the works in a very specific class.

Scully's art addresses itself to the side of the human spirit where order, discipline, and restraint are prime criteria. In this pursuit as well as in its cultivation of the principle of rectangularity, it recalls the art of a great pioneer of modern geometric abstraction, Piet Mondrian. Indeed, in the past ten years or so, it is as if Scully had been attempting—on one level—to reconcile the path mapped out by the Dutch artist with Post-Modern needs for expressive content. Mondrian's fundamental contribution had been to establish verticals and horizontals as a compositional framework on which great painting could be based. While he had attempted, in the late years, to instill specific feelings into his work (e.g., in *Broadway Boogie-Woogie*), the restriction of his palette placed substantial limitations on what could be achieved; in addition to black, white, and gray, only the primary colors were admitted. It is in this area of color invention that Scully has proven to be particularly persuasive and far-reaching, devising color combinations of such power, and in such compelling harmony with the design, that he has been able to generate a range of feelings and emotions unmatched by any other artist working within similar structural parameters. Inseparable from Scully's colors has been the remarkable quality of his brushwork, allowing him to imbue compositions with a living presence of a rare kind. Insofar as inheri-

tance of an artistic tradition demands adaptation to contemporary needs in order to justify itself to the fullest, Scully qualifies as the most legitimate Post-Modern heir to Mondrian.

Scully's achievements may be viewed in yet another light. As a European immigrant to the United States (he moved to New York in 1975), he brought with him a mentality distinct from that of those born in this country. The openness and vastness of the land, the rich diversity of cultures, and the sense of optimism and energy in the air—the perception that the opportunities are there for virtually anyone willing to work hard enough—could not but make a vivid impression on him, as they do on most sensitive newcomers. Living in New York brought Scully into daily contact with urban realities of a unique kind, as well as exposing him to an art scene of a vitality unparalleled anywhere. Consciously or not, Scully had to reconcile this experience, and the best evidence that he has done so successfully is the work of the past ten years. Like a crescendo whose momentum cannot be repressed, Scully's paintings have evolved from low-keyed compositions to increasingly assertive ones, to the point where today they breathe with the confidence and authority of the best art being shown in Europe and America.

In shaping his work to this level of accomplishment, Scully absorbed what he needed from several of the most talented artists this country has produced. Among the more notable sources of inspiration are the allover, forceful image deployment of Jackson Pollock, the indefinable colors of Brice Marden, the uncanny brushwork of Jasper Johns, and the severity and profundity of intention of Mark Rothko. That Scully's paintings often look as if they are painted on barn boards is perhaps another indication of the keenness with which he has assimilated the American landscape context. More significant is the fact that Scully has been able not only to synthesize all those sources but also to move beyond and infuse his geometric compositions with a powerful humanizing feeling that is uniquely his.

Of vital importance to Scully's development has been his use of the stripe. More than any other

artist in history, Scully has succeeded in animating this ornamental and otherwise mute motif into an instrument of expressiveness for conveying feelings and emotions. From a thin band whose eloquence depended on ceaseless repetition in the paintings of 1980, the stripe has grown in Scully's hands to enormous dimensions, causing the unaware viewer to interpret it on occasion no longer as a stripe but as a broad band or even a block. But a stripe it has remained, even when oversized and juxtaposed to drastically smaller versions of itself, and to persist in viewing it as such is to retain control of a major entrance route to Scully's work. For then the compositions become significantly easier to read. Formal relationships within the same painting emerge as less esoteric, thus facilitating access to the content. More broadly, to view Scully's work as an unending romance with the stripe is to penetrate to the very core of his development as an artist.

1 Europe

Perhaps the best entrance to the art and personality of Sean Scully is to acknowledge the reality of his Irish heritage. On the one hand, he is Scully the lyric poet, once moved to the core at the sight of a portrayal of an empty chair by Vincent van Gogh, and who has found in painting an outlet for his creative needs. On the other hand, he is Scully the fighter, today still refusing to be pushed around, and haunted by a violent past. That these two traits can find accommodation within the same individual —and lead him to produce a body of work as arresting as Scully has—testifies to the enigmatic complexity of human nature.

Outwardly, the artist projects a model image of a successful professional. His life seems as regulated as one would expect. For over fourteen years now he has shared it with a sculptor, Catherine Lee. As to his bellicose instincts, he has harnessed them into the practice of karate, at which he is highly adept (he has a black belt). The extent to which Scully's art mirrors the discipline of his life is indeed striking.

Yet a temperamental disposition and past have taken their toll, leaving Scully a tormented individual for whom art appears to be the only way to salvation. In this predicament, he joins a group of artists whose lineage can be traced back at least as far as Michelangelo. As much as anyone who could make such a claim, Scully is an artist for whom the act of painting provides mental relief and allows him to come to terms with daily existence. The notion of painting because it is a pleasurable activity is foreign to him. Scully paints because he needs to. "When I have finished a painting, that's when I feel normal," he says.[1] But the respite is usually short-lived. Inescapably, anguish will build up again and a new painting will have to be made in order to reestablish equilibrium.

Sean Scully was born in Dublin on June 30, 1945. Before he had reached his fourth birthday, his family moved to London, living for a while in the poorest, most broken-down street of the city, the infamous Old Kent Road. The next domicile, a few months later, was a rambling Victorian house rented by Sean's grandmother on Highbury Hill, an area that then amounted to an Irish ghetto. "Vir-

tually all the people living there were Irish," Scully says, adding that most of them had come from Ireland to work for low wages and would eventually return home. Street life was teeming and raucous, an Ireland outside Ireland. In that Victorian house, which at some point was shared also by an aunt, an uncle, two cousins, and itinerant Irish workers, Sean grew up, attending the local convent school. Life was rough. Sean's father, a barber, had great difficulty making ends meet and, on Sundays, went to people's houses to cut their hair in order to earn extra money. It was in this atmosphere that Sean's earliest artistic efforts took place.

At age six he bought some rubber molds of a rabbit and the Virgin Mary, which he filled with plaster of Paris. "I cast a lot of them and painted them with different colors," he recalls. Curiously, he gave away the casts to adults rather than to children, leading him to think, in retrospect, that he must have been looking for some kind of approval. But this activity came to a premature end. Because of his father's habit of working on Sundays and behavioral problems of his own, Sean somehow got into trouble with the Catholic Church. He was told by the priest and nuns that the devil would take up residence under his bed, and irrational fears forced him to see a psychiatrist. "That was the end of the Catholic Church for me," he says. Anxiety that the devil might be living under his bed imprinted itself so strongly on his child's mind that, to this day, Scully finds it unbearable to be in darkness.

Scully was fully initiated into the realm of violence a few years later, when his family relocated to South London. "It was an awful, cold, oppressive, and snobbish environment," he recalls. Going to school, one had to fight physically in order to command respect. At age nine Sean won a fight over an older boy, an event that brought him admiration from his schoolmates but also led him into further brawls. "I had to defend that reputation," he says. "I was like the fastest gun in town." Oddly enough, Scully's interest in art had crystallized at that time to such an extent that he aspired seriously to be an artist. His eagerness and tal-

Fig. 1
Vincent van Gogh
The Chair and the Pipe, 1888
Oil on canvas
36¼ × 28¾ inches
National Gallery, London

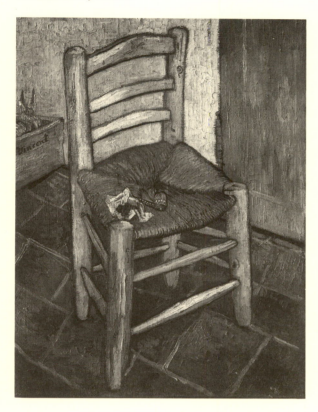

ing shop. "He thought I'd be happy and indulge my visual senses," Scully recalls. Two years later he joined a graphic design studio and began to go to evening classes at the Central School of Art in London to study life drawing. He also visited the Tate Gallery regularly, sorting out those artists who could penetrate his sensibility. The ones he found most accessible were the Impressionists and the Post-Impressionists. Scully recalls that he read miniature monographs on Paul Gauguin, Vincent van Gogh, and Henri de Toulouse-Lautrec, among others. He was especially fascinated by what the artist stood for, the idea of the artist as a free individual, challenging the established order to pursue his dreams. The issue of freedom was indeed a crucial one for Scully in those years. He remembers how, at sixteen, he was part of a street gang involved with motorbikes and violence: "The environment caused so much frustration. . . . Riding around on bikes was a way of creating freedom for ourselves."[2]

An event that took place in those formative years still holds special significance for Scully. On a visit to the Tate Gallery in 1964, he came upon van Gogh's Chair (fig. 1).[3] "It was as if the world had just stopped," he recalls, adding that the painting seemed to contain everything that he expected of art. "What was especially poignant about it is that there was nobody sitting in the chair. It had a kind of nobility, an honesty about it. . . . It was so direct —the subject matter, the application of paint, the color." The emotional impact of van Gogh's painting will find echoes in many of Scully's works.

From 1965 to 1968 Scully attended Croydon College in London. While he took various subjects required for graduation, the focus of his interest remained painting. He recalls the great influence that his art-history teacher, Ron Howard, exerted on him in his approach to paintings of the past: "He used to discuss the making of a painting in terms of surface rather than picture space: how the paint was put down and how different surfaces were built up at different points in history. He talked about the way a Fragonard or a Pissarro was made as if he was talking about the way someone would make a brick wall." Also of major importance to

ents were so pronounced that he had become the school artist. That involved making puppets for the puppet shows and creating scenery for the school plays. Scully recalls one major source of artistic inspiration from those days: a reproduction of Child Holding a Dove from Pablo Picasso's Blue Period, which hung in his school. He remembers staring at it often when he passed by it. "That's what I had to deal with," he says, adding that the paintings he did at the time tended to be flat with black outlines, much as in the Picasso.

By the time Scully was fifteen, he had convinced his father that he wanted to become an artist—a feat not easily accomplished, given the fact that such a proposition was virtually unheard of in the Irish working class. Foremost on his father's mind was that Sean should have financial security, and he helped him get a job as an apprentice in a print-

Scully's development at Croydon was his painting teacher, Barry Hirst: "He used to talk about color in a way that made it very real." Fauvism was discussed extensively, leading Scully to do big figurative paintings in that brightly colored mode. Scully recalls the enthusiasm he felt especially toward the works of André Derain, and particularly his paintings of the River Thames: "I was just crazy about Derain. . . . His color is a lot more complex than that of the other Fauvist painters. He used secondary and tertiary colors in conjunction with very bright ones. He was much more expressionistic, while the others were more theoretical."

In 1967 Scully obtained the catalogue of an exhibition of paintings by Mark Rothko that had been held at the Museum of Modern Art in New York six years earlier.[4] Although he had been exposed to abstract painting before, he had never been very moved by it, certainly not to an extent comparable to what took place then. "I had the same sort of revelation that I had had with van Gogh's *Chair*," he recalls. "Even though they were only reproductions, these paintings seemed primitively truthful in their simplicity and unpretentiousness—in the same way that van Gogh's *Chair* was. They seemed to have something that was more deep and truthful than other kinds of abstract painting. They seemed to break through to something essential." It was under the impact of this experience that Scully began composing abstract paintings. "I did a group of them that were like homages to Rothko," he says. This proved to be a major turning point, for Scully henceforth was never to return to figuration. He had found his vocation.

Scully then became interested in other abstract artists, among them Bridget Riley, Victor Vasarely, and Mark Tobey, who was regarded, in many respects, as a kind of counterpart to Jackson Pollock. "Tobey was hugely popular at that time," Scully recalls, "and he was there, on the scene. He painted in London for long stretches, like six months at a time. His work was constantly being shown on the London art scene." In the wake of this enthusiasm Scully made a number of calligraphic paintings with repetitive strokes. None of these paintings has been preserved, but they were

important for helping to orient his mind toward the syncopation and rhythmic repetitions that were to characterize the next stage of his output.

In 1968 Scully enrolled at the University of Newcastle, where he would spend the next four years (the last one, after graduating, as a teaching assistant). A city close to the Scottish border, Newcastle was then an industrial center with an economy sustained primarily by shipbuilding and coal mining. Its character and location gave it cultural isolation, a fact that Scully views positively in that it allowed him to find himself. At the university's art department a kind of Conceptual-Pop atmosphere prevailed. "It was a very unsympathetic environment for painting," Scully recalls, "especially abstract painting. Marcel Duchamp and Richard Hamilton were talked about a lot. Anything that was kind of a joke was okay; anything that was a kick in the pants for abstraction and high art was okay." Two of the artists who were considered okay were David Hockney and Jim Dine, the latter mainly because he put tools in his paintings. "People thought that this was funny and therefore acceptable," Scully remembers. In order to gain respect from his new peer group, Scully found that he had to revise his approach to painting and give it more conceptual elegance. While the emphasis had been on freedom and experimentation at Croydon College, here at Newcastle these impulses would have to be curbed and subjected to intellectual discipline. "I tightened my work up and made it much more rigorous, conceptually, than it had been," Scully says. One of the main aspects of his paintings to be affected by this new attitude was the handling of the edges of forms within the compositions, which until then had been made by hand. They would now be traced using masking tape.

Red Blue Yellow Green of 1969 (no. 1) illustrates the transitional stage at which Scully found himself in that year. Subjecting to a rigorous systematization the calligraphic language that he had toyed with while at Croydon, Scully applied the paint in short strokes, creating a fluctuating yet homogeneous surface reminiscent in some ways of the work of the Neo-Impressionist Georges Seurat. But

quite different from Seurat is the sense of mystery generated by the design. Framed by blocks of color that lend structure to the overall composition, the central portion of the painting seems to dissolve, leading the eye backward and forward in an ever-changing pattern. "It was the first time that I got one of these calligraphic paintings to be so intense, as an emotional thing," says Scully.

More assertively structured is *Square* (no. 2). Here diagonal brushstrokes, supported by the clockwise layout of the four bands framing the inner square, impart a rightward directional impulse to the composition. Counteracting this impulse is the stability of the square configurations within. It should be noted also how the white strokes in the inner square give the impression of a "clearing" behind that image, thus engendering additional tension.

A significant influence on the formal character of the paintings just discussed—and on the grid paintings that were to follow—was Scully's deep interest in music. For a while, at age eighteen, he had run a discotheque in London with the help of his brother Tony, who worked the turntable. "We played rhythm and blues, a lot of great imports that were hard to get, by people like Chuck Berry, Sonny Boy Williamson, and B. B. King," he remembers. "It was a rough place. One night we got into a fight with bouncers from another club, and we pursued them in cars on the sidewalk." This stormy episode in his life came to an end when the police closed down the discotheque. But Scully remained in touch with avant-garde musical developments. In the late 1960s he was particularly intrigued by the experiments of Phil Spector, a Motown record producer. "He overlaid sounds until he created what he called a wall of sound," Scully recalls. "His music would put you on a very high plane, a kind of delicious emotional plane. It was so seductive. It would hold you there for the length of the record through saturation and repetition of sounds." While he insists that he was not trying to make a visual counterpart to that music, Scully, who normally paints while listening to music, acknowledges its important role in shaping his artistic sensibility in those years. To a large extent,

both *Square* and *Red Blue Yellow Green* may indeed be said to achieve intensity through saturation. Their weavelike character imparts a pulsating feeling to the compositions that one may justifiably associate with musical rhythms.

In the summer of 1969 Scully took a trip to Morocco, an event that was to be of prime importance to his development. There his imagination was captured by countless colored strips of material he saw hanging on wooden bars. Moroccans stretched the dyed wool used for the making of rugs in individual segments, "maybe six inches wide by eight feet long," Scully recalls. "They lay these strips—of all different colors—to dry side by side, in a very ordered way. In the bright sun they were just awesome. . . . It was intoxicating." Equally impressive to him were the huge tents set up by Moroccans on the beach. Made of bands of canvas of different colors set at various angles to one another, these tents amounted collectively to abstract compositions that Scully remembers vividly: "Against the yellow sand, they created exotic and arbitrary color relationships so unique. . . . I thought it was the most beautiful thing I had ever seen in my life."

Returning from Morocco in August of that year, Scully stopped in Paris, where he saw an exhibition of works by the Venezuelan artist Jesus Raphael Soto at the Museum of Modern Art of the City of Paris.[5] The experience reinforced what he had seen in Morocco. Scully recalls that Soto had installed a remarkable piece outside the museum. "It was made of strips of semitransparent nylon hanging down. It covered a huge area and you could walk through it. I remember walking through it." Inside the museum were many striped paintings by Soto that Scully can still visualize. "That whole show made a tremendous impact on me," he says.

Back at the University of Newcastle, Scully made a large painting (six feet high by twelve feet wide) consisting of some thirty horizontal stripes of different colors spread one above the other (no. 3). The impression created by the strips of dyed cloth hanging on bars in Morocco, as well as the impact of the Soto exhibition, prompted Scully to cut the

canvas open in the center and allow most of the stripes there to hang down, each one cut individually. Appropriately, he titled the painting *Morocco*. His love affair with the stripe, which continues to the present day, had been given here its first visual manifestation.

While his Moroccan trip proved to be the triggering factor behind the work just described, Scully admits that the idea of striped paintings was in the air at Newcastle around that time. In particular, he knew about the American artist Gene Davis, whose vertically striped compositions had attracted the attention of the art world since the early 1960s. More immediate as an influence, however, was Bridget Riley, an Englishwoman who, by 1969, had created a variety of parallel-striped paintings (see fig. 2). Scully was also acquainted with the work of François Morellet, a French artist he still admires a great deal. In the 1950s Morellet had made striped paintings that proved influential for a number of artists interested in the theme (see fig. 3).[6]

His work continued to be of inspiration to Scully for some time.

However appealing and potentially rich was the idea of parallel stripes (and he was to return to it several years later), Scully needed a more dynamic compositional scheme to channel his artistic energy at that stage of his development. Although the way he arrived at such a scheme may seem deceptively simple today, it required a good deal of adjustment on the conceptual level. Using masking tape, Scully began by painting vertical yellow stripes on an eighty-nine-inch-square raw canvas. Returning to the canvas two days later (after much pondering), he rotated it so that the stripes were now horizontal. Again using tape, he then painted another set of vertical stripes, this time green. Rotating the painting a second time, Scully sprayed a third set of verticals, dark red, thus ending up with a grid. This work, titled *Soft Ending* (no. 4), is his first grid painting. It triggered a group of works in which the artist confronted the problem of how

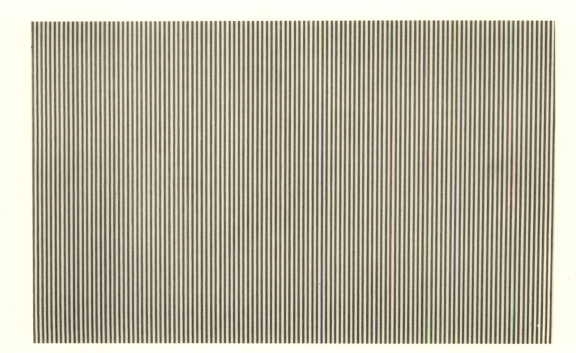

Fig. 2
Bridget Riley
Late Morning, 1967
Acrylic on canvas
88⅞ × 141⅝ inches
Tate Gallery, London

Fig. 3
François Morellet
Lignes parallèles, 1957
Oil on plywood
31½ × 31½ inches

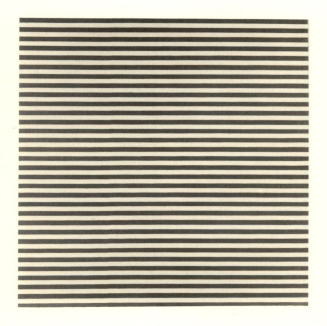

to enliven the interaction of horizontal and vertical stripes in a way that would satisfy his creative needs.

First among these works was *Newcastle Boogie-Woogie*, a painting no longer extant, in which Scully unleashed his energy while acknowledging his indebtedness to Piet Mondrian. As if attempting to intensify the tempo of Mondrian's *Broadway Boogie-Woogie* to its potential limit, Scully multiplied and overlapped the verticals and horizontals to the point where they created a maze through which penetration seemed virtually impossible. Then came *Backcloth* (no. 5), completed in January 1970, in which Scully developed the idea of illusionistic space within a tightly woven network of perpendicular bands. Here small windowlike rectangles unfold rhythmically across the canvas, building up momentum as the eye reads them laterally and vertically. The result is an intensely assertive and optically mobile latticelike configuration. Contributing to this effect is the open-endedness of the composition on all four sides, suggesting that what we see is only part of a larger whole. As Scully interprets it, "These things hurtle around

at a hundred miles an hour; they just fly off the canvas." In *Bridge* (no. 6), which followed *Backcloth*, the interest in windowlike openings was refined, as Scully enlivened the innermost rectangular shapes with modulated color. Much of the optical movement here is generated by the configuration of the windows, which keeps changing from one to the next, both laterally and vertically. *Red Light* of 1971 (no. 7), executed in a similar mode, is even more densely packed, fully justifying Scully's claim that his work was about presenting "an extreme state of one kind or another."[7]

The grid had emerged in popularity in the 1960s.[8] By the time Scully turned to it to channel his creative needs, it had been used widely by prominent painters and sculptors alike, namely Sol LeWitt, Carl Andre, Agnes Martin, Robert Ryman, and François Morellet, among others. What distinguished Scully's grid paintings at that early stage was, in part, their exceptional weblike density that turned them into active agents of mobility and light, earning them the appellation "supergrids." Scully acknowledges the influence of artists such as Riley, Morellet, and Soto on that aspect of his work: "What interested me about these artists' work was that it was environmental. Everything was shooting off the edge of the picture plane and it was creating light effects into the room. There was a restlessness about it that I really found exciting, as if there were new possibilities for a kind of aggressive abstraction." Scully's interest in popular musical rhythms may also bear mention here. Another aspect to be taken into consideration is the industrial landscape and urban climate of Newcastle. While the city could not compare to London, there was certainly an energy and vitality about it to which people of Scully's age and background would have reacted easily. Intersecting railroad tracks at the main station (fig. 4) and local bridges, with their rhythmic linear configurations and busy traffic patterns (fig. 5), would have made an impact on an artist of his visual sensibility. Scully endorses this idea, pointing out that he in fact titled one of his paintings *Bridge* with reference to the main thoroughfare leading into Newcastle. On a broader level, his work of that period evokes the frenzied,

allover character of Pollock's work. Retrospectively, Scully declares that he was indeed attempting to reconcile the freedom and openness of Pollock's compositions with the disciplined approach of Mondrian.

Scully's interest in allover compositions was strengthened in 1969 by the viewing of the exhibition "The Art of the Real" at the Tate Gallery[9] and a performance of Samuel Beckett's *Waiting for Godot* at the Newcastle university playhouse. The exhibition grappled with some of the major changes in American art over the last two decades, in particular the interaction of painting and sculpture. Beckett's play is about two tramps waiting for an elusive character named Godot. The connections Scully drew between the two events still stand vividly in his memory: "The exciting thing about the play was that it didn't try to establish a context for the action, as is the case in a Shakespearean drama. There was no real beginning and no real end. It was so frontal, like in real life. . . . I got the same feeling with the exhibition. The works in it were so frank, so unpretentious. Carl Andre had a piece of sculpture on the floor operating like

a painting that normally would have been on the wall. It was like a painting that was so real you didn't have to put it on a wall any more. Tony Smith had a big black sculpture outside that just confronted you head on. As to the paintings in the show, it was as if all issues of romantic space had been beaten out of them. That's why I was so interested in allover painting. Because it doesn't try to establish a context for the drama within the painting. The painting *is* the drama, and the drama goes out all the way to the edge. It's as frontal as life is."

Important as the grid was to Scully at that stage, it was not the only compositional scheme he would employ. Nor did he feel bound to verticals and horizontals. Experimentation, more than anything else, was paramount. In *Gray Zig Zag* of 1970 (no. 8) diagonal stripes are opposed to horizontal ones. A major element linking this work to the preceding ones, and an issue that remained of great importance to Scully for a few more years, is optical movement. It is generated here by the overlapping of stripes, the rhythmic repetition of strongly contrasting colors, and the sketchy application of

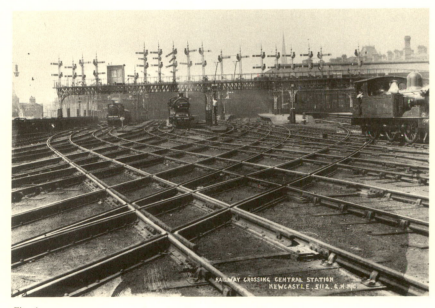
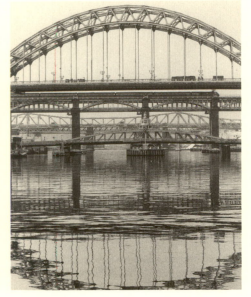

Fig. 4
Railway crossing, Central Station, Newcastle-upon-Tyne

Fig. 5
Bridges and River Reflections, Newcastle-upon-Tyne

paint in selected passages. In *Shadow* (no. 9) Scully returned to the principle of rectangularity but varied the intervals between the horizontals. Discernible behind and through these forms, which tend to function collectively as a fence, are multicolored, undulating stripes bathed in a soft, flickering light. One gets the impression that the stripes are engaged in some kind of ritualistic dance, of which we are allowed to catch only glimpses. *Blaze* of 1971 (no. 10) consists of small grids laid out diagonally and functioning again like window openings. Through these openings can be seen vertical stripes of various colors, many of them offset by diagonal beams of colored light. Pinks and yellows predominate, imparting to the painting a mood of restless and joyful exuberance. In a painting of the following year (*18.3.72;* no. 11) Scully crisscrossed the canvas with sharp and bold diagonals that reach from top to bottom. Perceivable in this composition is the influence of Kenneth Noland, who would continue to be of interest to Scully.

In the summer of 1972 a slowing of the tempo is noticeable in Scully's work. *Red* (no. 12), painted at that time, is a much more open grid of fewer units than his previous ones, the red background asserting itself as a field virtually unobstructed. An untitled watercolor (no. 13) is even calmer and more simplified, integrating only six fully defined rectangular areas. While there may be several explanations for this change of attitude, one no doubt played an important role. Scully had won a Frank Knox Fellowship to attend the graduate school of Harvard University during the year 1972–73. It is as if the knowledge of this forthcoming experience had had a sobering effect on him on the eve of his departure—a conjecture Scully subscribes to. Perhaps he was aware that his hyperkinetic work might not find easy acceptance in the United States; if so, a transition to a more quiet language would have been in order. But the respite proved to be relatively short-lived.

Upon arrival at Harvard in September 1972, Scully found the academic atmosphere substantially less dynamic than at Newcastle, soon leading him to seek encouragement and stimulation elsewhere. After a period of adjustment, he began

making paintings related in character to his earlier work, although less agitated optically. All were based on the grid and all involved the stripe. His first painting (destroyed) included as part of the background six prominent vertical green stripes of equal size and equidistant from one another. While at Newcastle, Scully had constructed a number of works consisting of strips of colored canvas wrapped around freestanding wooden frames—the idea derived from what he had seen in Morocco. At Harvard he returned to this theme, doing several more versions. No. 14 shows one example; although fragmented, the vertical units stand as a whole for enlarged stripes. These wrapped pieces indeed constitute an important testimony to the continuing influence of Scully's Moroccan experience on his use of the stripe.

As it had been for Scully at Newcastle, experimentation at Harvard continued to be the order of the day, but at a more feverish level still. "Someone said that I painted like a wild man," the artist recalls. "My rate of production was tremendous. I didn't like locking into anything. I kept my options wide open." Such restlessness helps explain Scully's use of acrylic at that time. He had used oil in his earlier student days but, because of its faster drying properties, had switched to the synthetic medium when he began working with the grid. *Grid* of 1973 (no. 15) shows Scully's attempt to create movement by shifting directions and images around. In *Pink-Blue Grid* (no. 16), on the other hand, crisscrossing diagonals are locked indivisibly on the surface in a unified trellislike pattern. While optical mobility may still be detected, the end result here speaks essentially of resolution and passivity. *Inset 2* (no. 17) embodies an interesting theme, which remained an isolated example at the time. On the right side of the painting, Scully painted two squares made of vertical stripes of alternating colors that look like insets. He would return to this pictorial idea and develop it in the 1980s, as *Catherine* of 1987 (no. 115) shows.

A major subject of interest to Scully at Harvard was the shaped canvas. Building on the example of artists such as Frank Stella and Kenneth Noland, he made a group of paintings shaped loosely like

chevrons—an image Noland had dealt with extensively. Scully's *East Coast Light 2* (no. 18) is a representative example. Here again we see him attempting to generate movement through the use of grids laid out diagonally. Scully admits that the diagonal was of great interest to him at that point. But differently from *Blaze* (no. 10), where the grids were all leaning in the same direction, Scully here split the main directional impulse to right and left. Furthermore, by shaping the bottom of the canvas like a chevron, he asserted two additional directions through which the energy latent in the painting could be released. The painting thus becomes more involved and active spatially than it would otherwise be. Notable also is the way in which the overlapping of the stripes in their individual "compartments" induces the eye to penetrate and explore their labyrinthine structure. An additional feature of interest in this painting is Scully's use of a spray gun to create shadowy effects, the end result of which is the generation of a shimmering silvery light within the composition.

Scully's experience at Harvard taught him an important aspect of American culture: "I realized how seriously Americans take art, how much credibility it has in the culture, whereas in the north of England, forget it. . . . I became aware that there was a kind of support system for what I did—and people liked what I did because it was daring and aggressive." Scully adds that awareness of this phenomenon encouraged him to experiment as boldly as he did.

Back in London in the summer of 1973, Scully continued to pursue the exploration of illusionistic space within a compositional scheme based on the grid. *Cream Red Cream* (no. 19) essentially reinterprets the idea of *East Coast Light 2*, although the pattern is less elaborate. The painting itself is also wider with respect to height, so that the lateral and downward movements emerge as less abrupt. In *Arrival* (no. 20), the pattern has become still more simplified. To Scully this painting is particularly satisfying because of its sense of resolution: "At Harvard I had experimented with rolling the paint on, trying to get it beefed up to an acceptable level, and in this painting I feel that I finally did it." In the same general spirit is a group of paintings titled *Overlay*, done in late 1973 (nos. 21 and 22). Scully explains that a major interest of his in all these works is the layering of information, the idea that the painting is a record of what one does. The more he could include, the more he would put in; hence the exceptional tightness of the compositions. But beyond these formal preoccupations can be sensed an equally compelling obsession that indeed runs through all the grid paintings: that of giving tangible expression to the youthful, unbounded energy of their maker.

Scully's return to England proved to be cause for rejoicing, for his work now began receiving recognition on the international level. In 1973 four paintings were included in "La Peinture anglaise aujourd'hui," an exhibition organized by the critic Edward Lucie-Smith and held at the Museum of Modern Art of the City of Paris.[10] The same year, he was given his first solo exhibition by Alex Gregory-Hood at the Rowan Gallery in London. Reviewing the show for the London *Sunday Times*, John Russell expressed a favorable opinion, commenting that Scully's paintings addressed spatial issues raised first by Mondrian and more recently by Kenneth Noland. "The systems in operation are complex, but they never get out of hand; all is lucid, crisp, exact," he wrote.[11] Concurrent with the exhibition, the first serious study of Scully's work, written by William Feaver, appeared in *Art International*.[12] The exhibition was a financial success in that all the paintings were sold. While Scully certainly felt happy about that, he also admits that from another angle it bothered him. "It bothered me because I didn't want to get locked up into a product," he says. That feeling proved to be prophetic, for within six months Scully was to disengage from the path he had been following and reorient his approach to painting.

Since he began the grid paintings in 1969, Scully had been aware that the issue of illusionistic space in painting had been set aside by most mainstream abstract painters. In line with Clement Greenberg's theorizing that Modernist painting had come irreversibly to confront the canvas according to its intrinsic character (a two-dimensional surface), a

tacit agreement had been reached whereby flatness—or the assertion of the picture plane—was considered a primary requirement of serious abstract painting.[13] Scully had disregarded this requirement, primarily because he found it limiting and unsuited to the expression of his creative urges. Another reason had to do with artistic beliefs. His method of overlaying taped-up bands of color repeatedly was to him a positive achievement. ''I thought it was a very strong idea because it brought back a kind of Cubistic space into abstraction,'' he recalls, ''but at the same time I was aware that I was flying in the face of American Formalism.'' What happened is that Scully decided eventually to join the main discourse. ''At that point I began to dialogue more with the mainstream of American and European art—'serious, high-minded abstraction.' I joined in the discourse after considering it and rejecting it, considering it and rejecting it. That really is the crux of the matter. These grid paintings had a kind of eccentric stance. I now wanted to be in center stage rather than being a sideshow, and make a contribution that was major.''

Scully's transformation was to be tortuous, but it can be documented. *Subtraction Painting* (no. 23), done in early 1974, still deals with space-defining grids laid out diagonally. In *Crossover Painting 1* (no. 24) the design is simplified drastically. Gone are the diagonals (these were not to reappear in Scully's work for over a decade) and gone are the multiple overlapping bands of color. Against a background of vertical stripes of alternating blue and orange, Scully laid flat red horizontal stripes equidistant from one another. Whatever illusionistic space remains is limited strictly to that suggested by this single overlapping. In *Crossover Painting 2* (no. 25) Scully seemed to be making a last-ditch effort to salvage his earlier approach by devising a compromise. Optical mobility is virtually absent and the stripes are wider and far fewer, but Scully insisted on overlapping them in a way that still leads the eye compellingly inward. Some of the horizontal stripes shimmer and glow alluringly, imparting to the painting a new kind of expressiveness. It is apparent that

Scully might have been onto something promising here, had he chosen to pursue the implications of this painting.

But his decision had been made. In the next group of works, beginning with *Overlay 1* (no. 26), all vestiges of illusionism are eliminated. Even the stripe has been taken out in this painting, leaving the rectangles making up the composition articulated simply by lines. Only a hazy painterliness relates the work to *Crossover Painting 2.* A similar approach governs *Overlay 3* (no. 27), In *Overlay 5* (no. 28) painterliness itself is now eliminated. As if to compensate for it, Scully painted the lines separating the rectangles with different colors. Then the tempo accelerates and composition gets tighter in subsequent paintings. Instead of large rectangles, *Overlay 9* (no. 29) consists of very small rectangles separated by lines of rhythmically repeated colors. The painting remains totally flat but the eye is led across it with much greater urgency.

At this point we see Scully reintegrate the stripe, although for a brief period only. *Second Order 1/2* (no. 30) basically repeats the composition of *Overlay 9,* except that the stripes now pass over and under each other, resulting in a tension between two-dimensionality and three-dimensionality that is asserted more tightly than in any of Scully's previous works. Mondrian's late works were no doubt of particular interest here, as were Noland's paintings of the early seventies. Then another avenue is explored: in *Black Composite* (no. 31) we see Scully turning to very small squares as a means of activating the composition optically. Literally thousands of such squares separated by lines of various colors generate a subtle pulsation. Although very tightly substructured, the composition itself is divided into nine large squares that impose a sense of order on the activity generated. Of great importance for Scully's future work also is the introduction of real divisions in this painting: the large squares are painted on nine canvases, suggesting that Scully was already thinking in terms of individual units within a single work. He would develop this idea in the 1980s.

The idea of such physically discrete units is taken up again in *Red Composite* (no. 32). Here the

possibility for the occurrence of insets is striking, since the composition can be read as made up of a doorway in the middle, a vertical bar on the left, and an inverted L on the right. Asked why he did not at that point pursue the implications of individual canvases within a single painting, Scully explains that he was wrestling with too many ideas: ''I felt too restless. I was bursting at the seams with ideas. Every day I'd get three different ideas. I couldn't make the stretchers, put the canvas on, and paint the damned things as fast as I could think of them. My brain was on fire. I remember I used to think I was going crazy because I had so many ideas.''

Scully's feverish search for a way out helps explain the uneven character of his work in that year. After the busy opticality of *Black Composite* (which itself contrasted with the far more sedate ''Overlay'' group that preceded it), a transition to a quieter pace can be noticed in *Red Composite* —attributable mainly to less assertive color contrasts. This direction is pursued further in *Hidden Drawing 2* of 1975 (no. 33). Of special interest here is Scully's attempt to make a painting that would retain an allover character while negating it compositionally. By breaking up the square composition into nine equal squares different from one another coloristically, Scully was able to create various focal points of attention and still compel the eye to relate them to one another. As the artist may have learned from Ad Reinhardt's dark-hued paintings and their cruciform image, the Greek cross has a unique ability to draw the eye toward the center no matter how disparate the components may be. Why title the painting *Hidden Drawing?* ''Because it has a lot of secrets buried in it,'' replies Scully. These secrets have to do with his use of tape in the making of the painting. Sometimes he'd pull out part of the tape and paint over the remaining part; at other times he'd leave the whole of it in and camouflage it with paint. ''It's really a collage painting,'' he says.

Having proceeded to break up the grid into individual components, Scully was now ready to move on to still more simplified compositions. An untitled work of 1975 (no. 34) consists of two square canvases, one above the other. Gone—as they would be for the next several years—are the multiple viewpoints. Only two basic fields of color (one blue, the other brown) are allowed to interact. A new calm prevails. Although Scully did not quite realize it at the time, he had virtually entered the territory he had been seeking unconsciously.

As might be expected, Scully's *volte-face* met with resistance among those who had cheered his vibrant checkerboard paintings. ''A lot of people thought I was going to produce a certain kind of painting—and I didn't and they got kind of pissed off,'' he recalls. The most tangible evidence of this resistance was that Scully's market went plunging down. In 1975 he had his second one-man show at the Rowan Gallery in London; none of the paintings was sold. But Scully was determined to go on with his search despite this setback. He had won a Harkness Fellowship to live in the United States for two years, and he knew he would be sufficiently secure for that period of time. As he recalls, ''I just thought: Fuck it. I'm going to do what I need to do. I'm going to get in there and make some real serious paintings, and if it costs me it'll cost me.''

While waiting for departure day, Scully, who had given up his studio, took over the front room in his parents' house and, over a period of a month, completed a group of fifty works in acrylic on paper. Titled *Change*, the works, which range from two- to four-part compositions, are among the most moving of all his creations. The explanation seems clear. On the eve of his departure, Scully had reason enough to feel apprehensive. He had just separated from his second wife, his work was not selling, and he had set his mind on pursuing an artistic path that offered no guarantee of success whatsoever. While he had visited New York on a few occasions when working at Harvard, he would now be thrown into the commotion of the city head on. These apprehensions are vented in the ''Change'' drawings. Most are dark colored and evoke prisons (nos. 35 and 36; 7 and 24). The grid on which they are based here becomes the visual equivalent of a grille, in part because of its

tight structure and in part because Scully left the masking tape on the surface, creating with it tangible horizontal stripes that alternate with ''empty'' ones. Covered with layers of paint at times opaque and at other times almost translucent, the tape glows mysteriously, suggesting sunlight filtering through the bars of subterranean prison cells. In none of his previous works had Scully conjured up human feelings with nearly as much vividness and intensity. But if the artist felt trapped, he also knew that the opportunities were out there. Hope there was and, with time, Scully would indeed turn the unsettling conditions—internal and external—of 1975 into a victory.

NOTES

1 Unless otherwise noted, Scully's quotes are from a series of conversations held with the author since 1987.

2 Scully says that the movie *Quadrophenia* (1979), directed by Franc Roddam and featuring a musical soundtrack by the Who, accurately captures the way things were for him at that age.

3 The painting is now in the National Gallery, London.

4 The exhibition traveled to the Whitechapel Art Gallery in London later in 1961, but Scully did not see it.

5 The exhibition was on view from June 10 to August 21. For a discussion of this artist, see *Soto: A Retrospective Exhibition*, exh. cat. (New York: Solomon R. Guggenheim Museum, 1974).

6 See Serge Lemoine, *François Morellet* (Zürich: Waser, 1986). Morellet is best known as one of the founding members of the ''Groupe de Recherche d'Art Visuel,'' which subscribed to optokinetic principles.

7 The remark was made to critic William Feaver. See ''Sean Scully,'' *Art International* (November 1973), p. 26.

8 An exhibition titled ''Grids Grids Grids . . . ,'' held in 1972 at the Institute of Contemporary Art in Philadelphia, documented that phenomenon. See also Gregory Battcock, ed., *Minimal Art: A Critical Anthology* (New York: E. P. Dutton, 1968).

9 The exhibition had originated at the Museum of Modern Art in New York in 1968. A catalogue with text by E. C. Goossen, director of the exhibition, accompanied it.

10 In 1973 Scully's work was also included in the exhibition ''Critics' Choice'' at the Gulbenkian Gallery, Newcastle.

11 John Russell, ''Building on the Flat,'' *Times* (London), November 11, 1973.

12 William Feaver, ''Sean Scully,'' *Art International* (November 1973), pp. 26–27.

13 See Clement Greenberg, *Art and Culture* (Boston: Beacon Press, 1961); idem, *Post Painterly Abstraction*, exh. cat. (Los Angeles County Museum of Art, 1964); and idem, ''Modernist Painting,'' in *The New Art: A Critical Anthology*, ed. Gregory Battcock (New York: E. P. Dutton, 1966), pp. 66–77 (reprinted from *Art and Literature*, no. 4, Spring 1965); further, Donald B. Kuspit, *Clement Greenberg: Art Critic* (Madison: University of Wisconsin Press, 1979); Irving Sandler, *Al Held* (New York: Hudson Hills Press, 1984).

1 Red Blue Yellow Green, 1969. Acrylic on canvas, 72 × 84 inches.

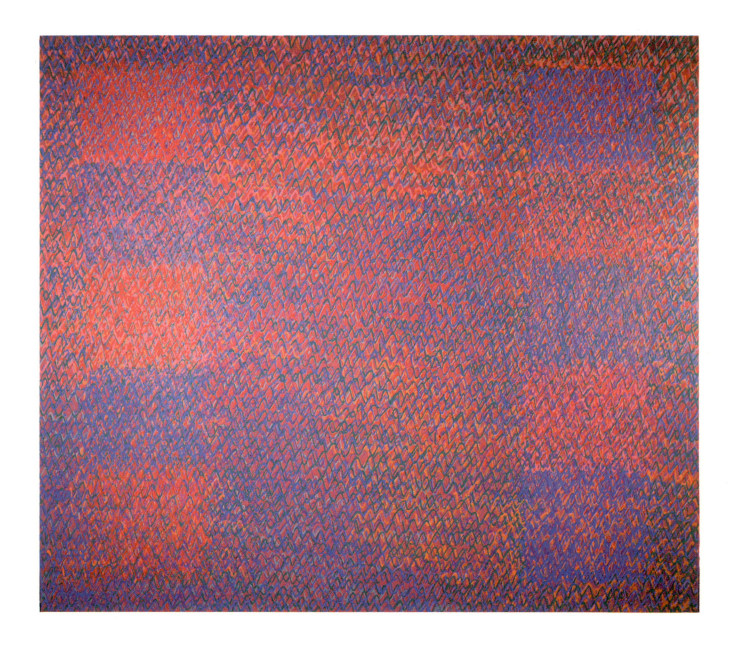

2 Square, 1969. Acrylic on canvas, 81 × 81 inches.

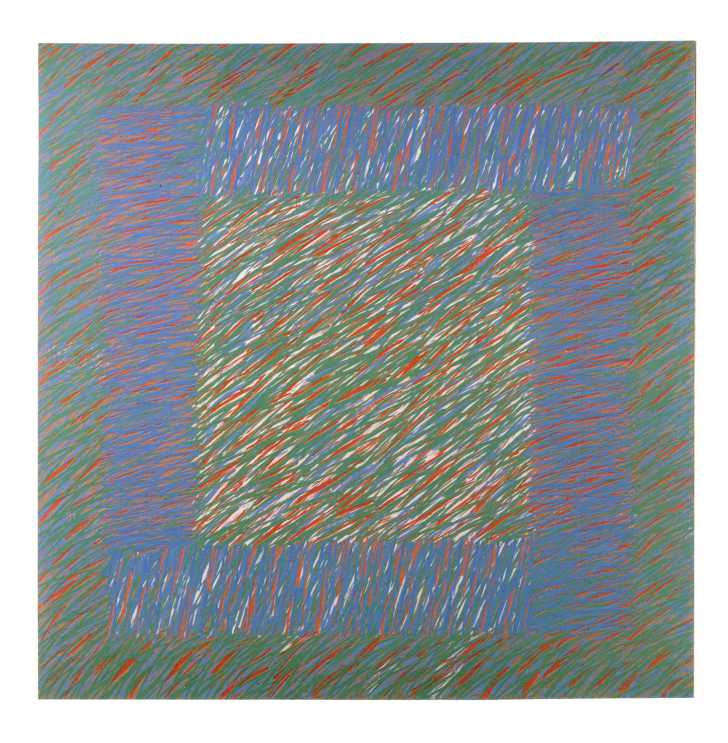

3 Morocco, 1969. Acrylic on canvas, 72 × 144 inches (destroyed).

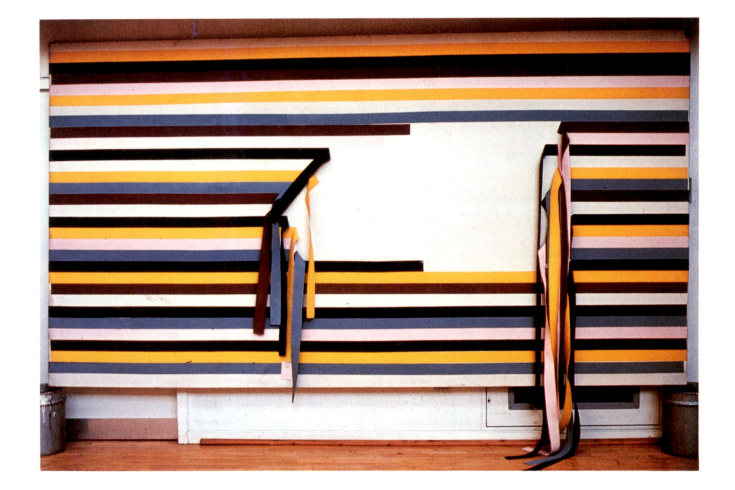

4 Soft Ending, 1969. Acrylic on canvas, 89 × 89 inches.

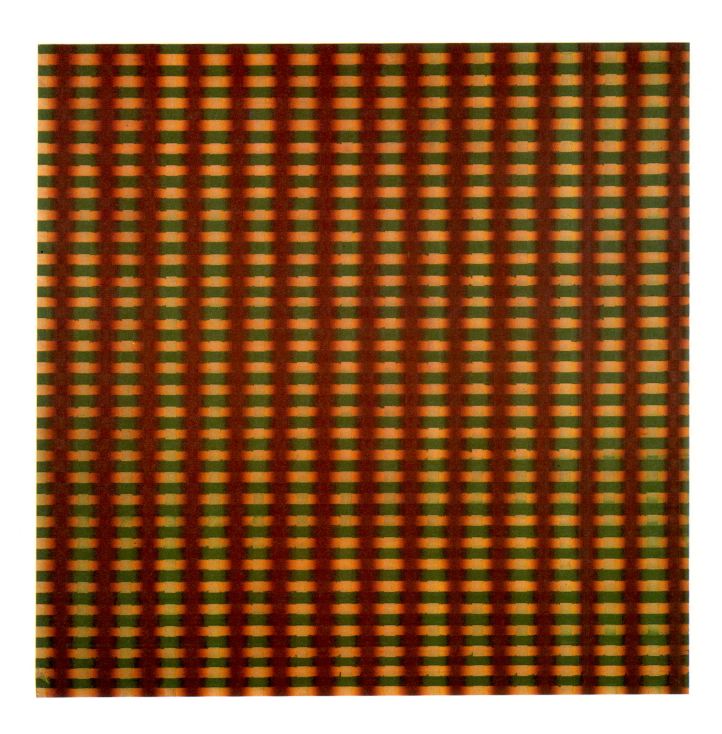

5 Backcloth, 1970. Acrylic on canvas, 78 × 120 inches.

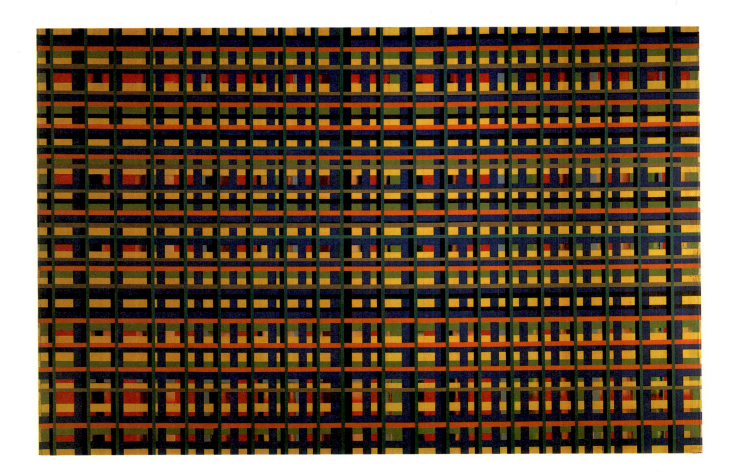

6 Bridge, 1970. Acrylic on canvas, 108 × 72 inches.

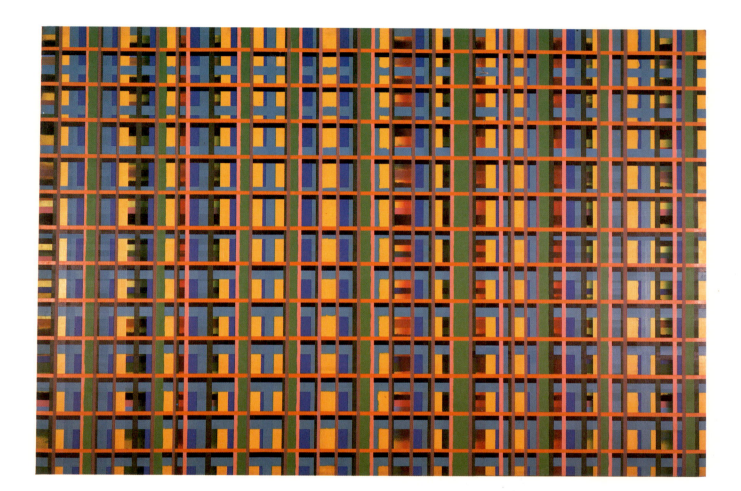

7 Red Light, 1971. Acrylic on canvas, 108 × 72 inches.

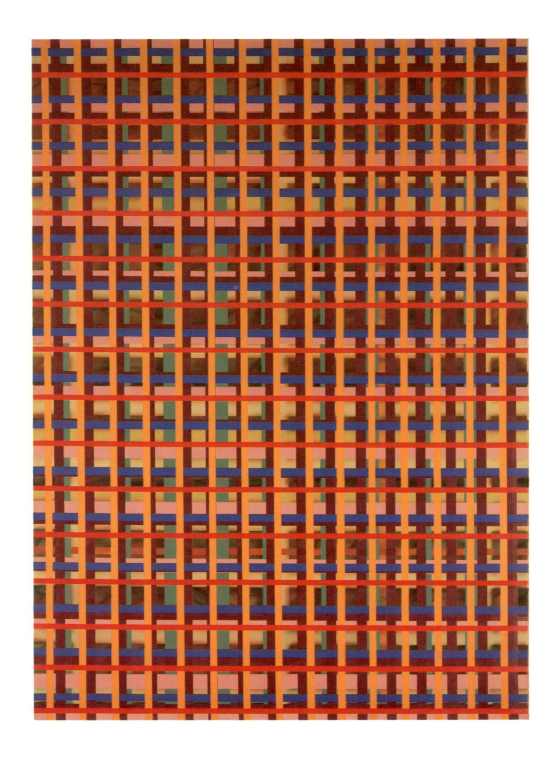

8 Gray Zig Zag, 1970. Acrylic on canvas, 96 × 108 inches.

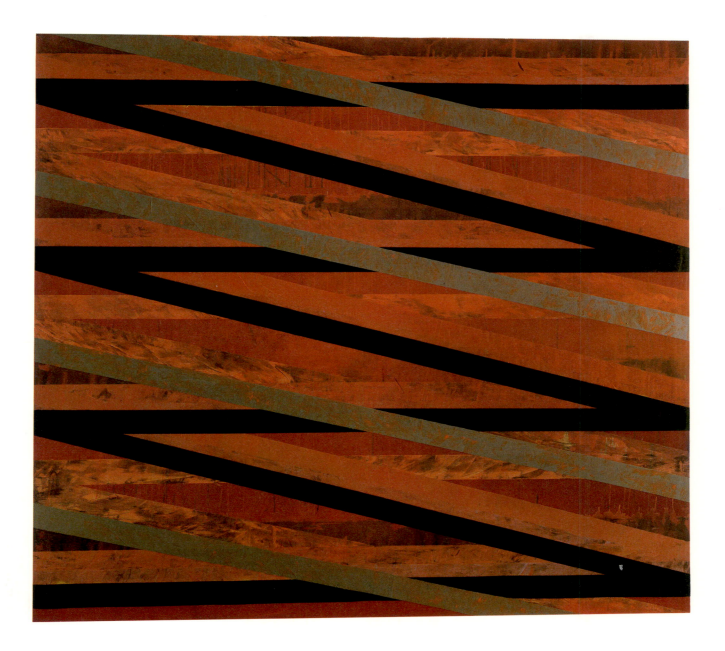

9 Shadow, 1970. Acrylic on canvas, 96 × 144 inches.

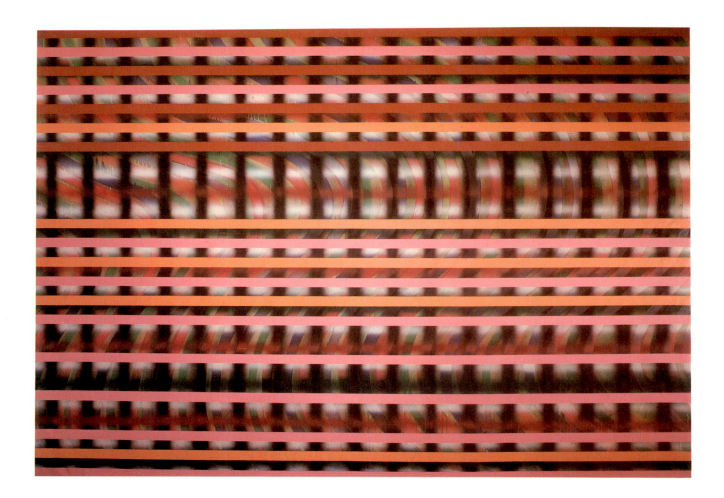

10 Blaze, 1971. Acrylic on canvas, 85 × 152¾ inches.

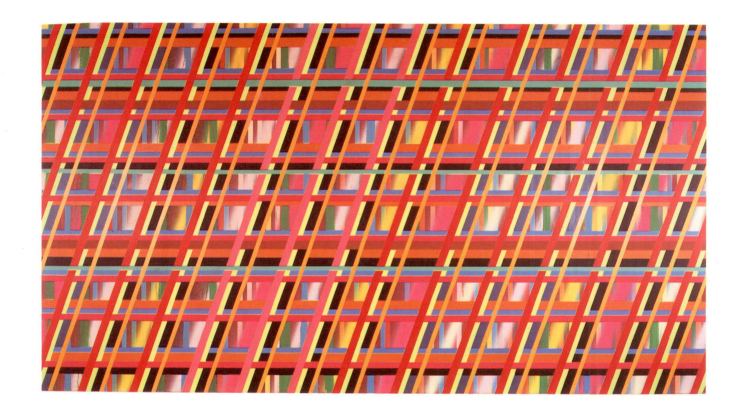

11 18.3.72, 1972. Acrylic on canvas (destroyed).

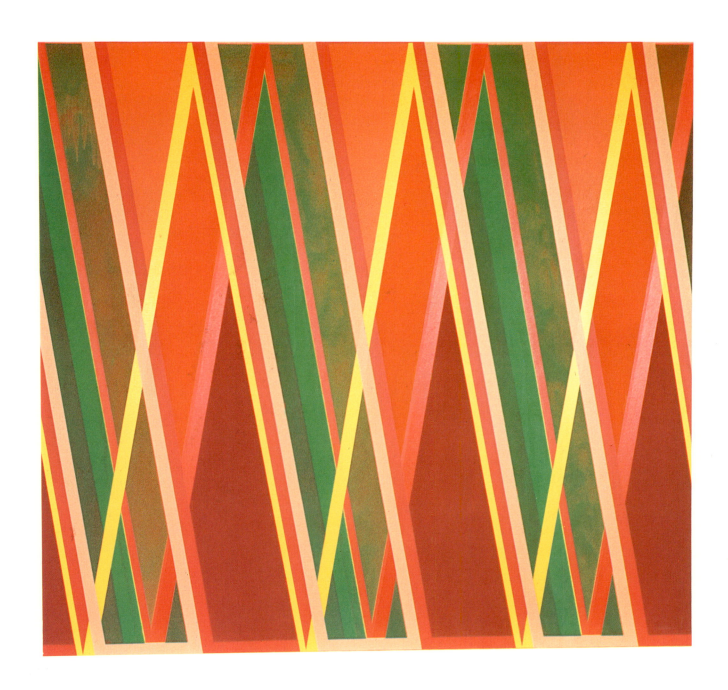

12 Red, 1972. Acrylic on canvas, 96 × 108 inches.

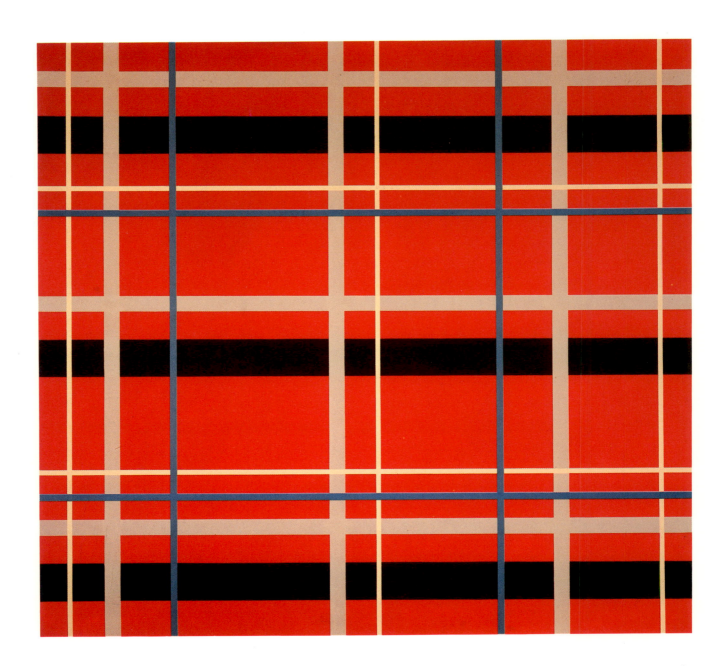

13 Untitled, 1972. Gouache and watercolor on paper, 20 × 28½ inches (destroyed).

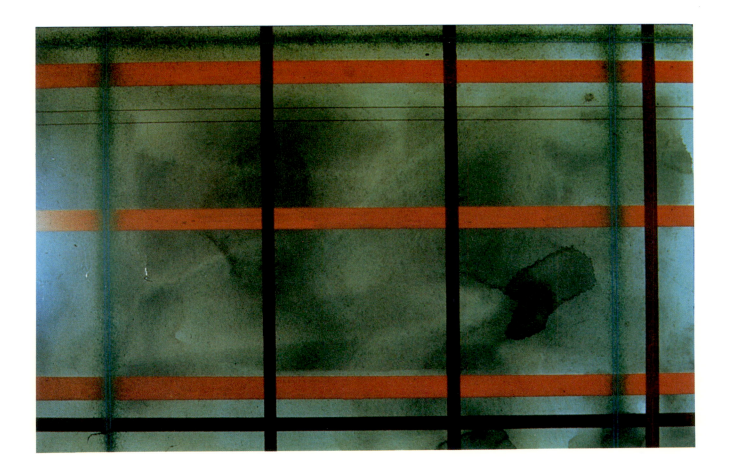

14 Wrapped Piece (Harvard), 1973. Acrylic, fabric, and wood, 82 × 82 inches, Carpenter Center, Harvard University, Cambridge.

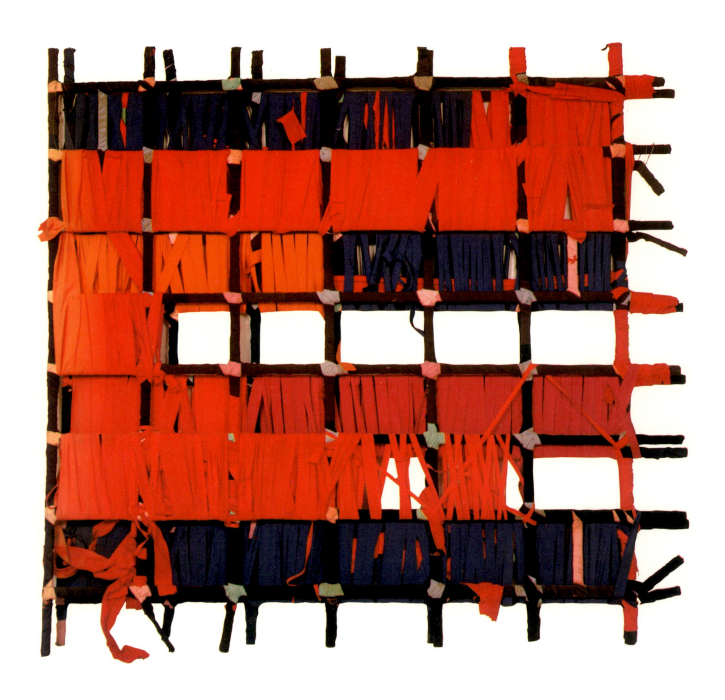

15 Grid, 1973. Acrylic on canvas, 96 × 96 inches.

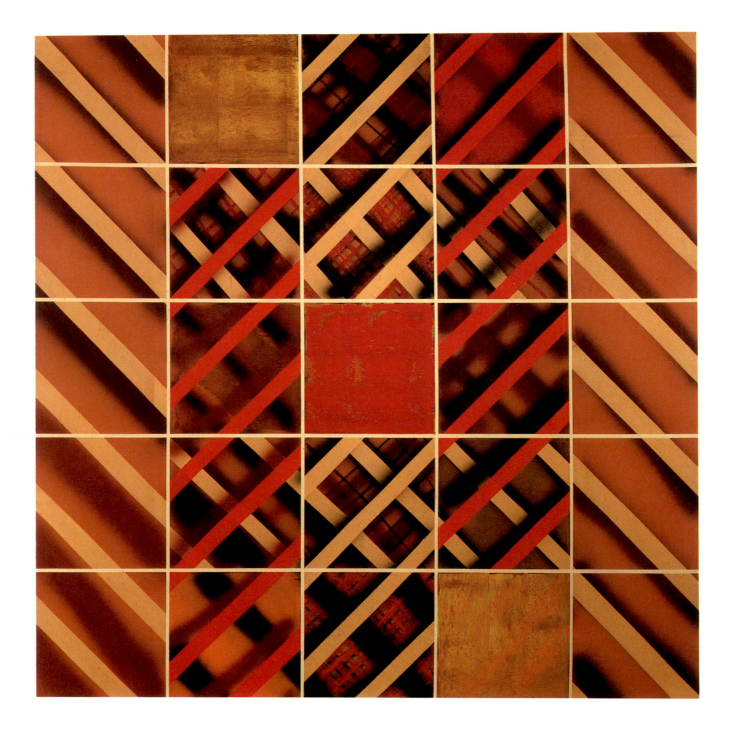

16 Pink-Blue Grid, 1973. Acrylic on canvas, 96 × 96 inches.

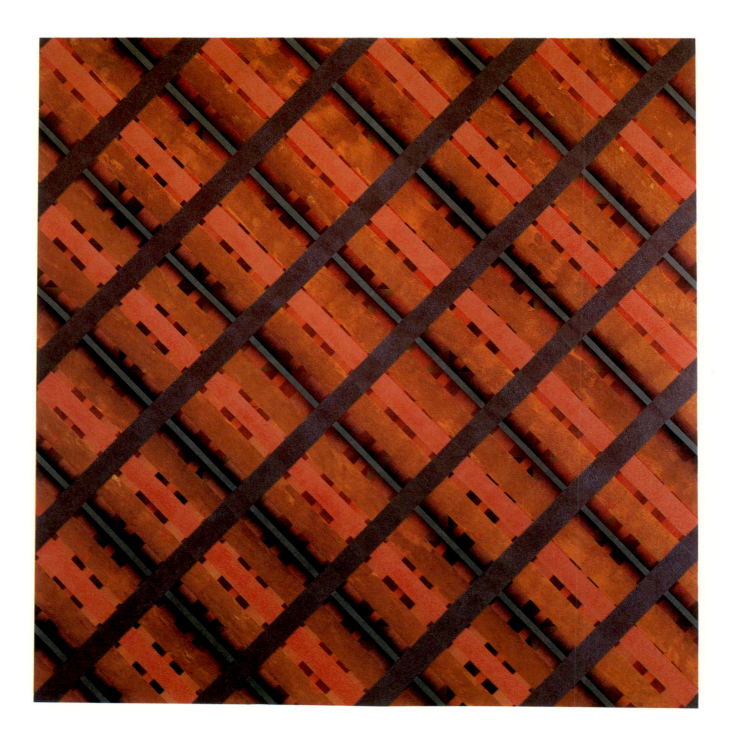

17 Inset 2, 1973. Acrylic on canvas, 96 × 96 inches.

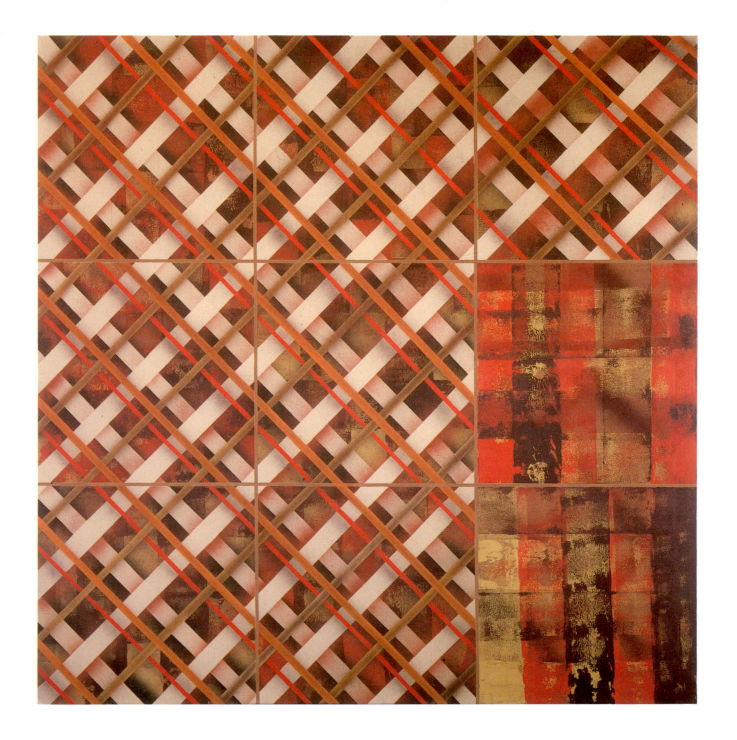

18 East Coast Light 2, 1973. Acrylic on canvas, 84 × 96 inches.

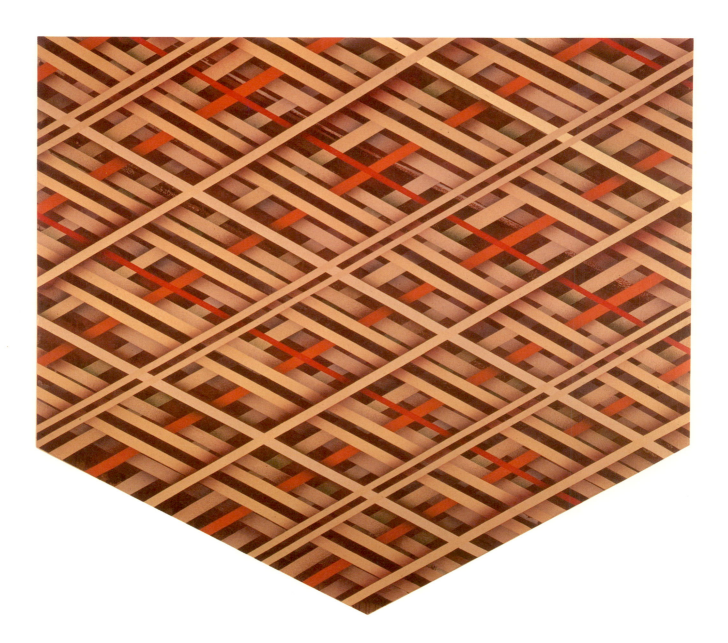

19 Cream Red Cream, 1973. Acrylic on cotton duck, 84 × 144 inches.

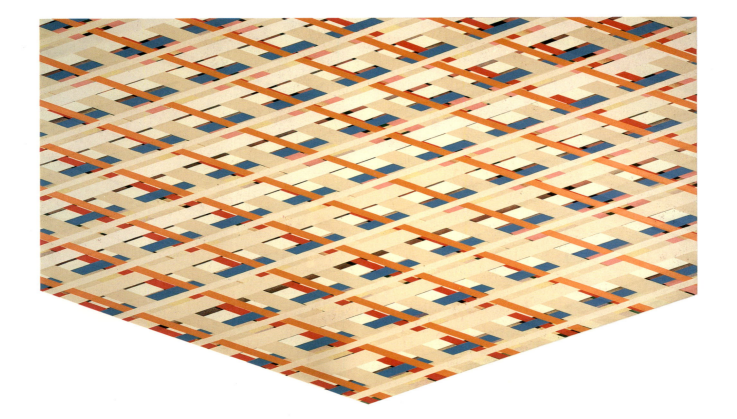

20 Arrival, 1973. Acrylic on cotton duck, 86 × 100 inches, National Gallery of Victoria, Felton Bequest, Melbourne, Australia.

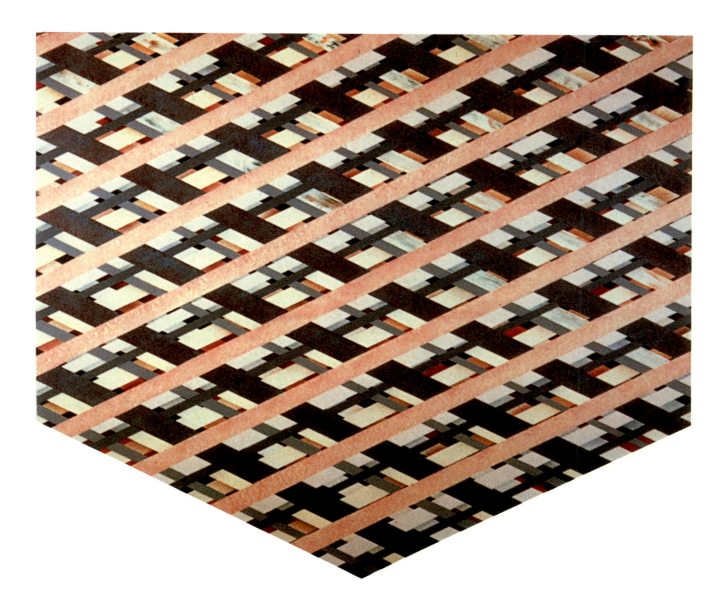

21 Overlay 1, 1973. Acrylic on canvas, 84 × 100 inches.

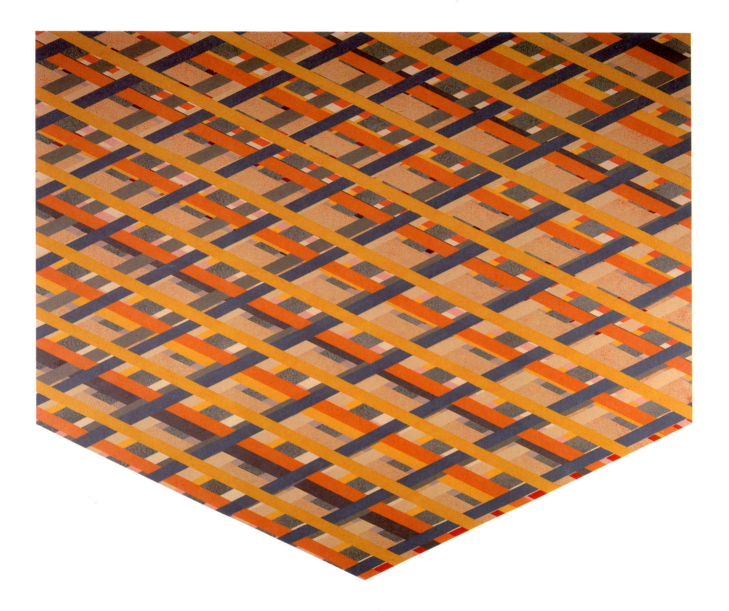

22 Overlay 2, 1973. Acrylic on canvas, 84 × 100 inches.

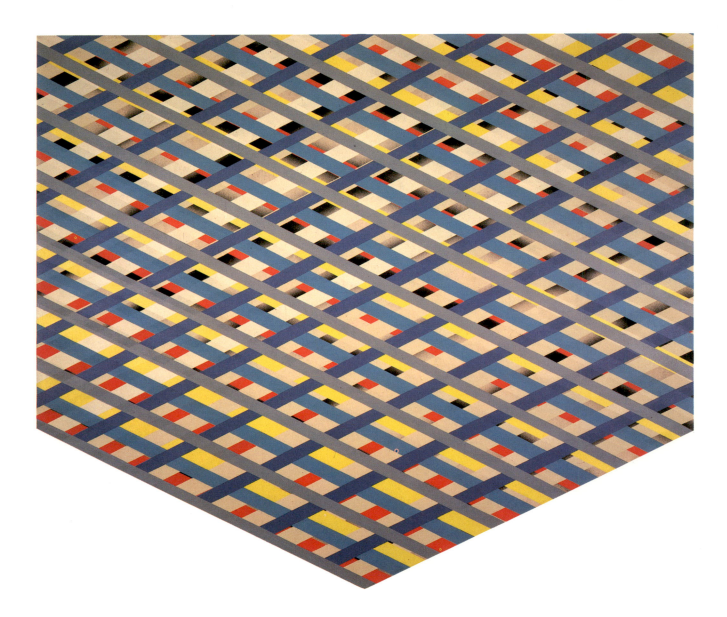

23 Subtraction Painting, 1974. Acrylic on canvas, 102 × 68 inches.

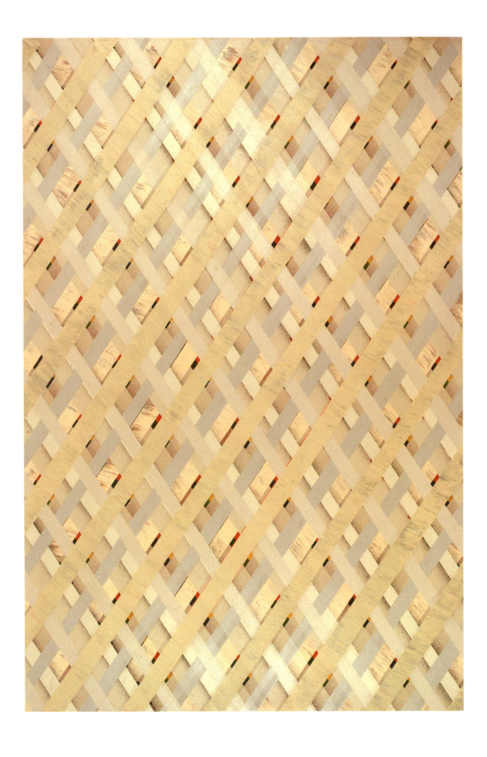

24 Crossover Painting 1, 1974. Acrylic on canvas, 102 × 108 inches.

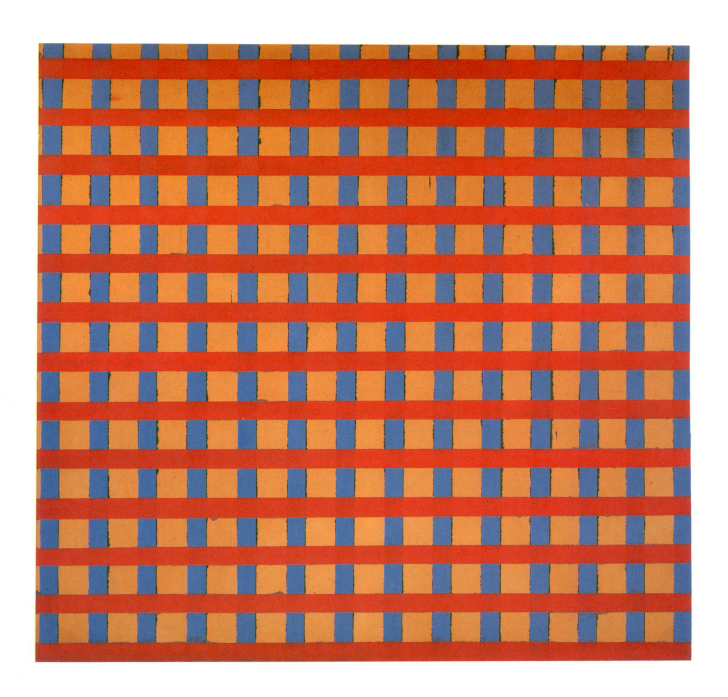

25 Crossover Painting 2, 1974. Acrylic on canvas, 102 × 96 inches.

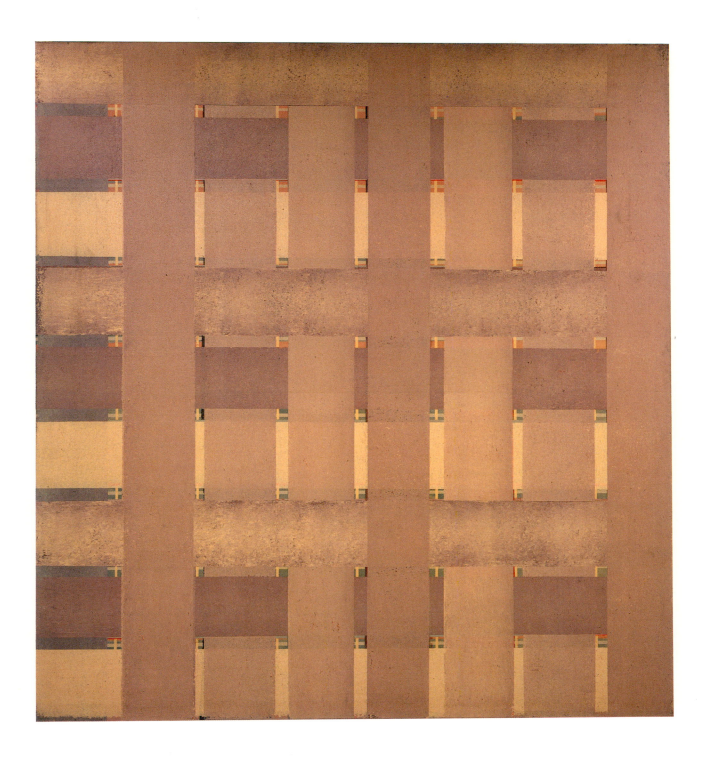

26 Overlay 1, 1974. Acrylic on canvas, 96 × 96 inches, private collection.

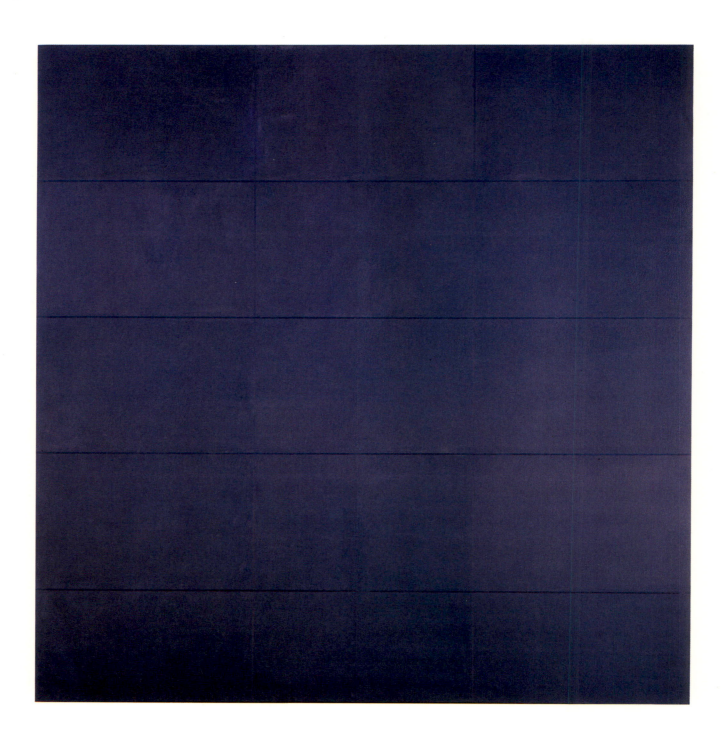

27 Overlay 3, 1974. Acrylic on canvas, 96 × 96 inches.

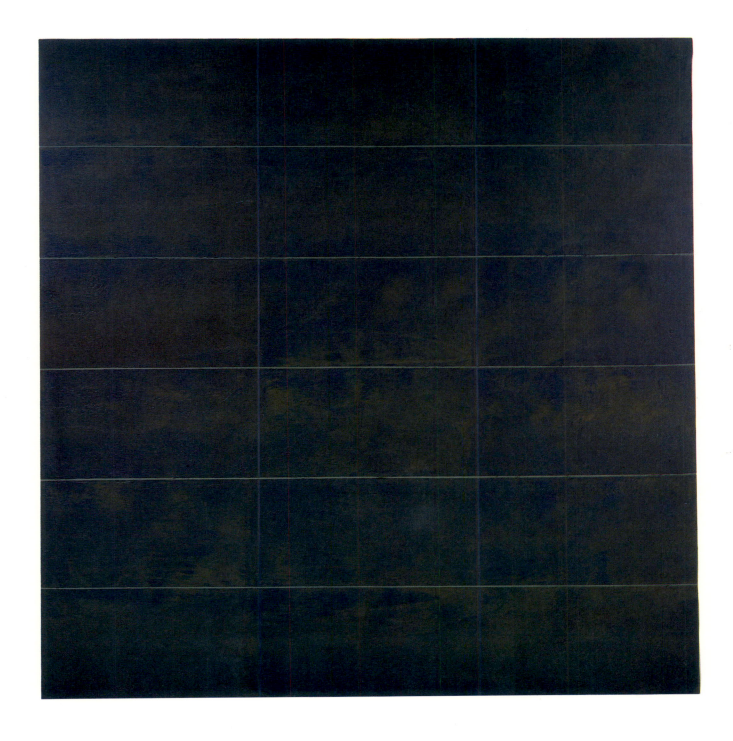

28 Overlay 5, 1974. Acrylic on canvas, 96 × 96 inches.

29 Overlay 9, 1974. Acrylic on canvas, 96 × 96 inches.

30 Second Order 1/2, 1974. Acrylic on canvas, 60 × 60 inches.

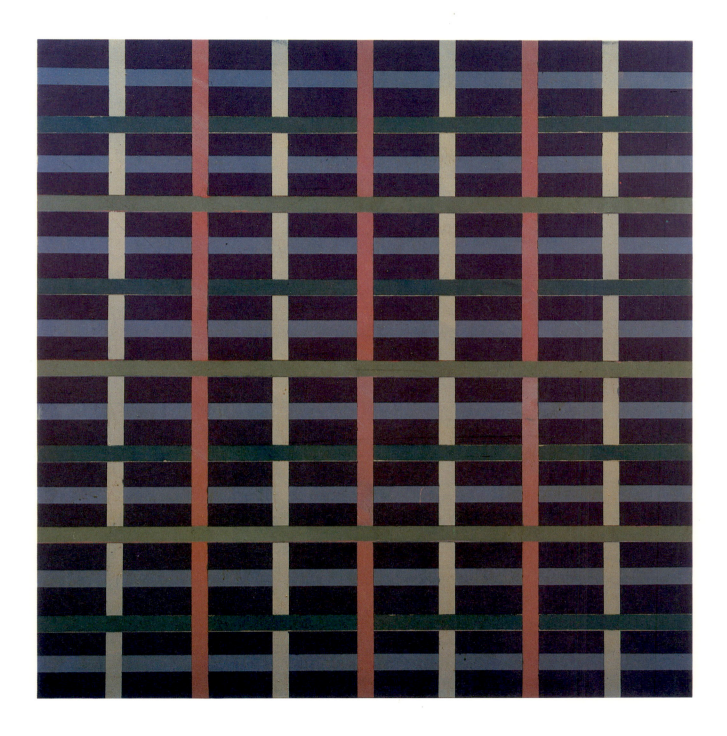

31 Black Composite, 1974. Acrylic on canvas, 90 × 90 inches.

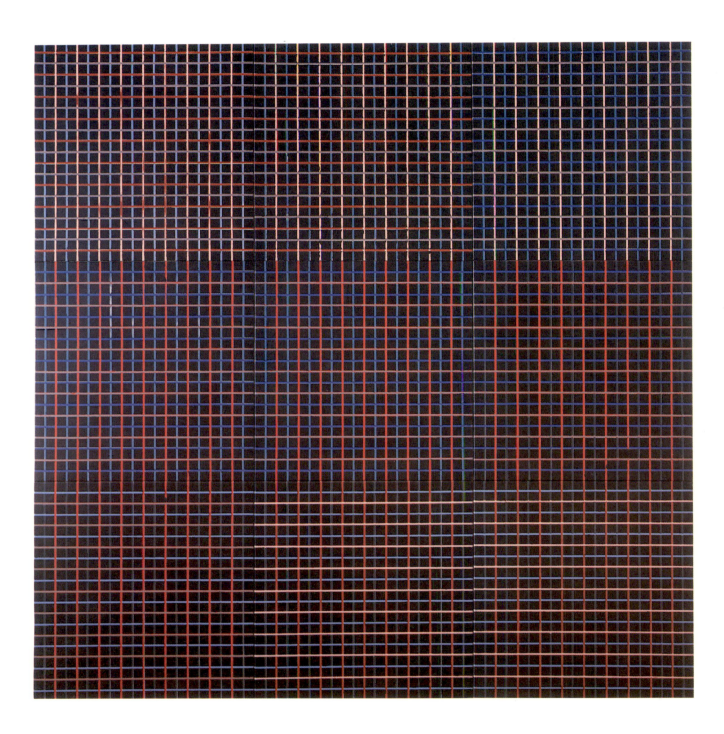

32 Red Composite, 1974. Acrylic on canvas, 90 × 90 inches.

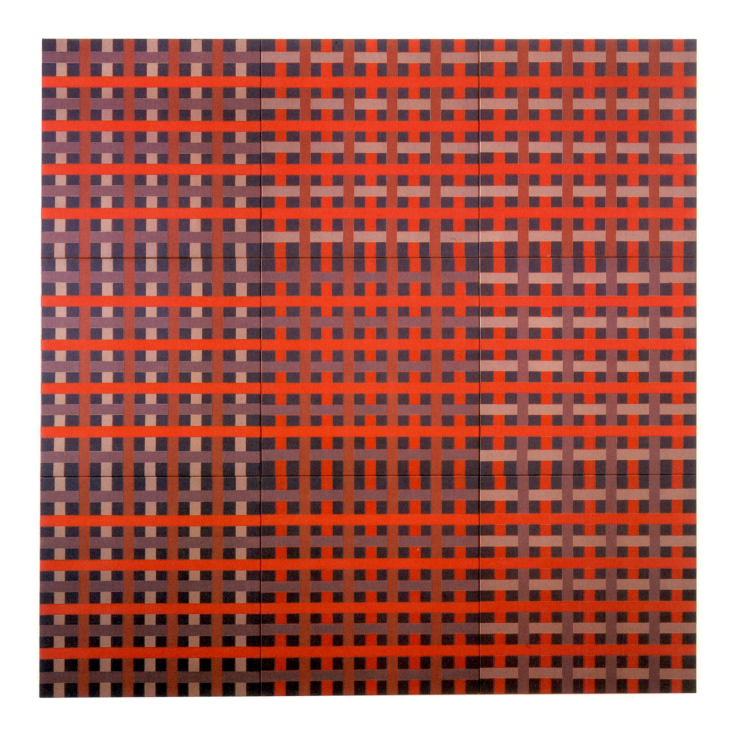

33 Hidden Drawing 2, 1975. Acrylic on canvas, 84 × 84 inches.

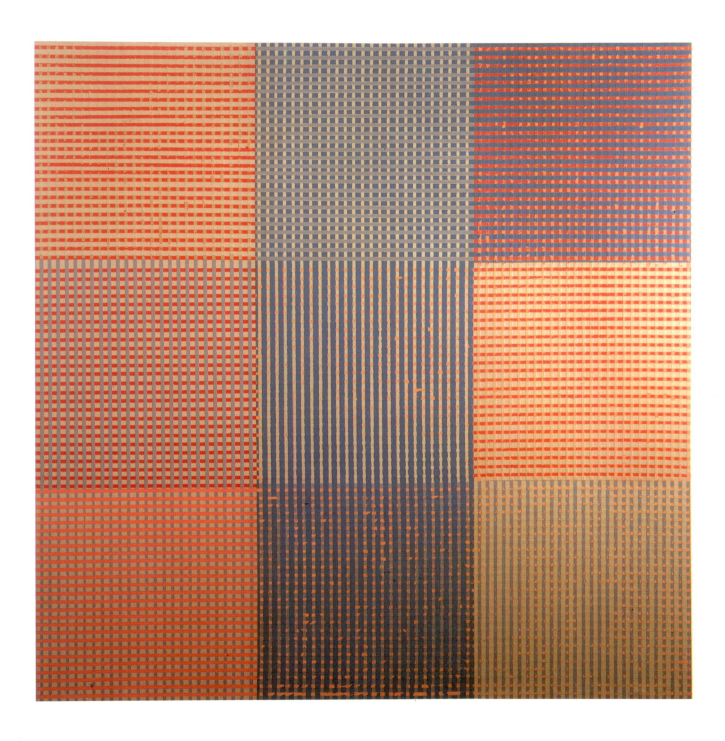

34 Untitled 1, 1975. Acrylic on canvas, 60 × 30 inches.

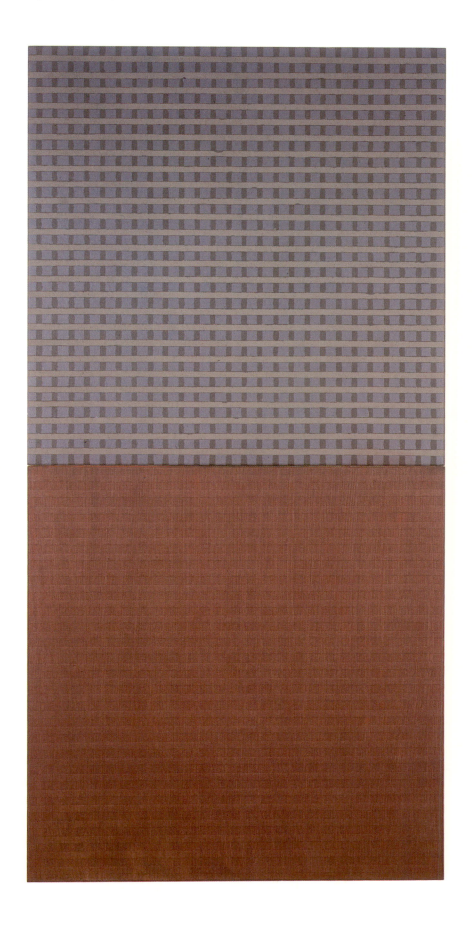

35 Change Drawing 7, 1975. Acrylic on paper, 22 × 30 inches.

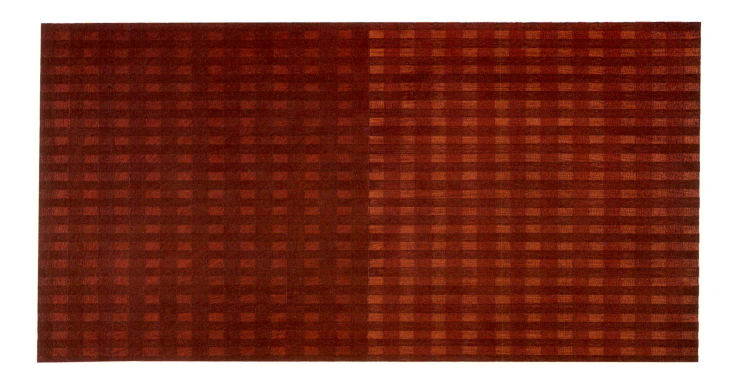

36 Change Drawing 24, 1975. Acrylic on paper, 22 × 30 inches.

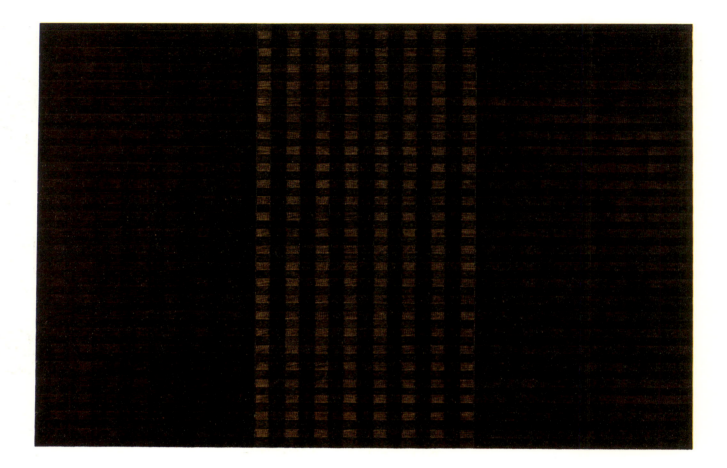

Little did Scully know upon arriving in New York, in July 1975, that the next five years would take him down a path of abnegation and solitary retreat such as few artists have traveled. His quest for an art that would compete on equal terms with the most advanced formalist abstraction was to lead him virtually underground, as if into a tunnel whose exit he could reach only by purging his work of nearly all but the most fundamental elements. As earnestly as the earlier paintings had dealt with optical movement, vivid color contrasts, and the high-spirited vitality of urban life, the new works would deal with meditative qualities and the stringencies of a Zenlike ethos. It was to be a period of intense self-purification, as well as an all-out attempt to come to grips with the very essence of artistic creation.

For this odyssey to be possible, Scully needed sufficient financial stability. The first two years were covered by his Harkness Fellowship, supplemented by money earned doing construction work. From 1977 to 1983 a part-time teaching position at Princeton University helped him to meet his expenses. While very few of his works were bought by the general public, Scully was fortunate enough to enjoy the patronage of two individuals: William Beadleston, then a private art dealer, who would come to his studio now and again and buy a painting,[1] and Charles Choset, a collector as well as a writer and composer. He met Choset in 1977. In exchange for a drawing or painting, which he would come and select occasionally at Scully's studio, Choset, over a period of about three years, gave him a monthly stipend upon which Scully depended. "If it hadn't been for him," he recalls, "I would have had to leave New York."[2]

An additional source of income for Scully was pool playing, at which he was highly adept. He recalls that whenever money was short, he would go out around 11 P.M. and shoot pool, normally until he had made around $100 or more, sometimes up to $200. Coming home around 3 or 4 A.M. was not uncommon, leading him to view the dark-hued paintings he did in those days as being about nocturnal light.

Pool playing had another reward for Scully: it brought him into regular contact with Robert Ryman. "I used to go play pool in his house," he says with obvious delight. More than any other living artist, Ryman became a role model for Scully, who to this day has retained great respect for the older artist. For many years Ryman had been exploring the properties of paint, the various types of brushstrokes, and the effects of layering through white paint only. "I think I found his work the most interesting because it was the most extreme in its reduction and in what it gave up," Scully says. "It seemed that he was not trying to make paintings in the same way that most of the other artists were. He was prepared to give up more, and I found that very interesting in one sense, because it forced me to see his work quite experientially—almost out of the umbrella of art history." Especially meaningful to Scully were Ryman's professional bearing and the moral character of his work. "For me the strongest part of his work was its profound ethical stance. I was very interested in that. He represented an ideal to me. I think I learned things from knowing him that are hard to articulate...but it was really like a way to carry yourself."

Scully's odyssey was not to be without its moments of anxiety, and on many occasions required exceptional inner strength and commitment to the mission he had set for himself in order to go on. At first, disorientation prevailed. The grid, which had been his structural anchor for years, soon proved to be an impediment and he abandoned it. He also discarded the vertical for the remaining duration of the seventies. Scully's quest would now focus exclusively on the horizontal, the most evocative, absolute, and timeless of all directions.

Collectively, the paintings that followed display an economy of means, a sense of austerity, and a restraint of such unexpected character that they bring to mind the experience of entering a monastic establishment in which the most rigorous rules prevail. A period of acclimation is essential for full appreciation of their qualities. Also important is the lighting, which ideally should prevent surface glare from interfering with viewing. Most compositions consist of thin horizontal stripes uniformly spaced and colored, set against a slightly lighter ground. With few exceptions, all are of a dark tone

or tend toward neutrality. Particularly significant are the hues themselves, often made up of two or more colors layered one over the other and often eluding precise definition. For example, undertones of red and yellow may seep through a black. As his search progressed, Scully was impelled to strip as much color as he could from his palette. From 1977 on, he made paintings that were totally black or of such a somber tonality that the name "black paintings" has been given to them as a group. When he began reintroducing recognizable colors around 1979, these remained within the dark end of the spectrum.

The majority of the paintings executed by Scully during that period consist of a single unit, the others being mostly two-part and three-part works. In a representative two-part work, such as *Red Diptych 1* of 1976 (no. 37), the artist might paint one half in a darker shade than the other. So inviting and serene is the composition here that the eye is led across the boundary line as if urged on by a breeze of the gentlest kind. Elsewhere, as in *Horizontals Brown-Blue,* also of 1976 (no. 38), Scully set up a more active dialogue between the two sides by painting them in different colors. In other works, such as *Fort 3* of 1979 (no. 39), a single canvas is divided into four squares, each one assigned its own color. But however different the colors may be, as they are in this work, they normally remain within the same tonal range, so that the eye passes from one to the other with minimal effort. From the interaction between the stripes and their background, subtle variations emerge, imparting to the compositions a living presence evocative of muted musical strains. In *Upright Horizontals Red-Black* of 1979 (no. 40), the lingering effect is of the murmur of an organ chord.

Technically, the paintings under discussion adhere to a rigorous system that included precise duplication of the stripes' dimensions. Scully's procedure was first to paint the entire canvas the color of the ground. After laying masking tape from edge to edge, he would build up the stripes by applying two or more coats either of the same color as the ground or different ones. "There were certain things I wouldn't do," explains Scully. "For instance, it was very important that the color at the top edge was not at the bottom edge, because then the distribution wouldn't have been 50-50." Acrylic continued to be used, but increasingly in competition with oil. *Blue* of 1977 (no. 41), for instance, alternates oil and acrylic stripes, as Scully was exploring the textural and light-refracting contrasts between the two.

In some works, especially the earlier ones, Scully might leave a portion of the tape on the canvas, while in others the differences in surface quality result entirely from the thickness of the paint. *Diptych* of 1976 (no. 42) is an informative example. On the cream-colored one-piece canvas, Scully placed black tape horizontally all the way across so as to create very thin spaces that read as lines. He then painted these lines gray a number of times to build them up. At that point, he cut the tape with a razor blade down the middle of the canvas and pulled it off the right side, thus leaving gray lines and bare canvas on that half, while the left half remained gray and black, collagelike. "I was playing around with the idea of the physicality of the paint," Scully explains. In *Upright Horizontals Red-Black* (no. 40), the same idea is stated in different terms. Here the black stripes are built up of three coats of paint and the red ones of a single coat. The visual effect promotes the impression that the black stripes are actually made of black tape. Scully had begun experimenting with such illusionistic contrasts in 1977. As he explains it, his interest had been to establish a type of "figure-ground" relationship, so that the painting would be about relief as well as about color.

The materiality of the paint proved indeed to be of great interest to Scully throughout that period. For this reason, he welcomed occasional drips of paint and allowed them to remain while refusing to let them become overtly rhetorical. Scully explained that he was striving to impart a new kind of expressiveness that would substitute for the one he had lost when he had stopped making the illusionistic grid paintings. "The grid paintings had a compelling expressiveness of their own," he says. "When I gave up the illusionism of the picture

space, I felt that a void had been created and had to be filled. That's when the physicality of the paint became a dominant issue.'' By the end of 1979, Scully had been so captivated by the expressive possibilities of oil paint that he renounced acrylic permanently.

Illuminating as they may be, Scully's comments still explain only part of the haunting appeal of the paintings under consideration. While surface differentiation and nuances of textures and paint application no doubt capture the eye and contribute to the expressiveness of the works, the compositions themselves and the selection of colors certainly impart this quality to them as well. More important, they are the aspects that determine the exceptional severity of these paintings. Some, such as *Upright Horizontals Red-Black* (no. 40), are so austere that, despite their inclusion of color, they suggest funerary banners. The impression is that Scully was intent on penetrating as deeply as he could to the core of artistic creation.

To speak of the experience as akin to a religious one may not be exaggerated, for the comparison certainly helps the viewer to understand the mysterious impact that the paintings make collectively. There seems to be in them a genuine element of Zenlike asceticism, which can only be attributed to the utter sincerity and moral integrity that went into their making. It is as if Scully had stripped himself bare, unwilling to make any kind of compromise, unconcerned whether the paintings were of interest to anyone except to his vision. In doing so, he was aware that he was courting failure, but he was willing to pay that price. ''I lay naked,'' he says. ''Making these paintings took me to the edge of the world . . . to the edge of my existence.''[3]

While Scully's paintings of that period were not commercially viable, they commanded respect from a substantial number of people in the art world. In 1977 the artist met the critic Joseph Mascheck, who began to make frequent studio visits. The following year Scully was introduced to Sam Hunter, who wrote a penetrating article about his work in a 1979 issue of *Artforum*.[4] One of Scully's works (no. 95) was reproduced on the cover of this issue. Showing his paintings remained problematical for Scully throughout the late seventies, although there were moments of encouragement and critics were generally favorable to him in their reviews. In 1977 he was given his first solo exhibition in New York at the Duffy-Gibbs Gallery. Two years later, he created a ten-by-twenty-foot L-shaped wall painting in Peter Nadin's space at 84 West Broadway (*Painting for One Place;* no. 43).[5] Early in 1979, Scully participated in a two-person show at the Susan Caldwell Gallery.[6] Late in that year, twenty of his paintings went on view at the Clocktower (an alternative space in lower Manhattan) in an exhibition curated by Per Jensen. Although none of these twenty paintings found buyers, Scully had reasons by then to feel good about his position. It is worth noting that the paintings of this period subsequently found a receptive audience in Japan, where self-sacrifice, discipline, meditation, and a Zen-inspired philosophy of life have a long tradition.

Aside from Robert Ryman, who continued to be of inspiration throughout the late 1970s, several artists had a share in determining the path followed by Scully, among them Agnes Martin, with her quiet linear compositions, and Brice Marden, as evidenced in the reductivism of his approach in the 1960s. Frank Stella's black stripe paintings of the late 1950s were also well known to Scully, as were Ad Reinhardt's black paintings of the same period. Looming behind these artists as a kind of *éminence grise*, athough the syntax of his work differed in important ways from Scully's, remained Mark Rothko.

On the theoretical level, Scully derived sustenance especially from the writings of Barnett Newman and Ad Reinhardt. ''What interested me most about Newman was the philosophical aspect of him,'' he says, ''. . . how he could discourse very esoterically, but very articulately, for ages, about extremely simple paintings, compositionally. It made it clear that painting was philosophical.''[7] Reinhardt's appeal to Scully had more to do with the restrictive tone of his precepts. ''I read a list of things you shouldn't do by Reinhardt and I was

interested in that," he says. "I liked that kind of moralizing." Reinhardt had stressed that control and rationality were part of any morality, and he had pushed the idea of reductive painting to its theoretical limit when in 1955 he described the ideal black-square painting as "formless, no top, no bottom, directionless . . . dark, no-contrasting (colorless) colors, brushwork brushed out to remove brushwork . . . matte, flat."[8] Scully also found moral encouragement in the example of Paul Cézanne. "I remember something that Cézanne said," he explains, "that the artist has to sublimate himself into his work, so that the work becomes more important than the artist. That was another idea that attracted me a great deal."

Ultimately, especially with regard to the experience itself, Scully's journey to "the edge of the world" may have more in common with the odyssey of the Russian Suprematist Kasimir Malevich than any other artist. Malevich described how, in his "desperate" attempt to free pure feeling in art, he had been led to renounce all connections to the objective world, arriving in 1913 at a picture consisting solely of a black square on a white ground. He spoke symbolically of the stage he had reached as a desert, a plateau of elevated silence where nothing but pure feeling could be perceived. To him the experience amounted to the rediscovery of "pure art," and he commented on the "painfulness" and "arduousness" of the journey that led to it: "Even I was gripped by a kind of timidity bordering on fear when it came time to leave the world of will and idea, in which I had lived and worked and in the reality of which I had believed."[9]

NOTES

1 Beadleston gave Scully a solo exhibition in his gallery in New York in 1982.

2 Scully's retrospective exhibition at the Whitechapel Art Gallery in London (May–June 1989) was dedicated to Charles Choset, who died of AIDS in 1986.

3 It is worth noting that Scully began taking karate lessons at this time.

4 Sam Hunter, "Sean Scully's Absolute Paintings," Artforum (November 1979), pp. 30–34.

5 Nadin created the space and invited six artists, among them Scully, to respond to it by creating a work of their choice. Although no financial remuneration was involved, Scully considered it an honor to have been selected.

6 Caldwell gave Scully a solo exhibition in 1980.

7 Scully saw the film Painters Painting (1972) by Emile de Antonio, which features, among others, Barnett Newman, Jasper Johns, Robert Motherwell, and Jackson Pollock.

8 Ad Reinhardt, in Art-as-Art: The Selected Writings of Ad Reinhardt, ed. Barbara Rose (New York: Prentice-Hall, 1975), p. 82.

9 Kasimir Malevich, "The Non-Objective World" (1927), in Herschel B. Chipp, Theories of Modern Art (Los Angeles: University of California Press, 1968), p. 342.

37 Red Diptych 1, 1976. Acrylic on canvas, 68 × 144 inches.

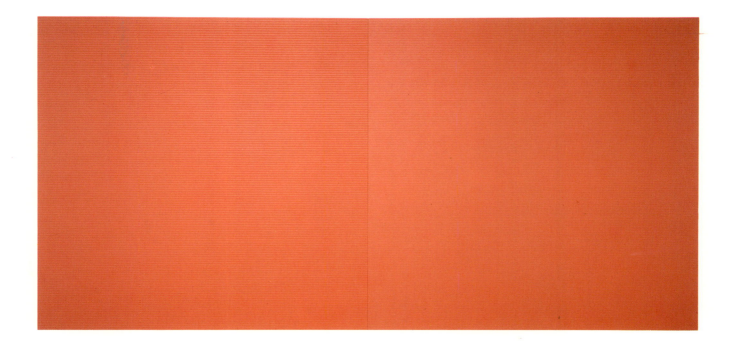

38 Horizontals Brown-Blue, 1976. Acrylic on canvas, 48 × 96 inches.

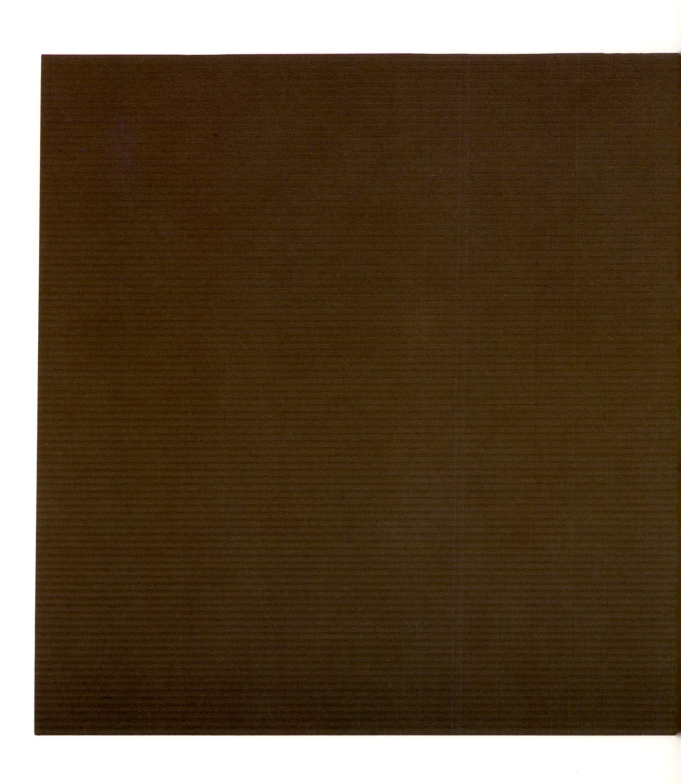

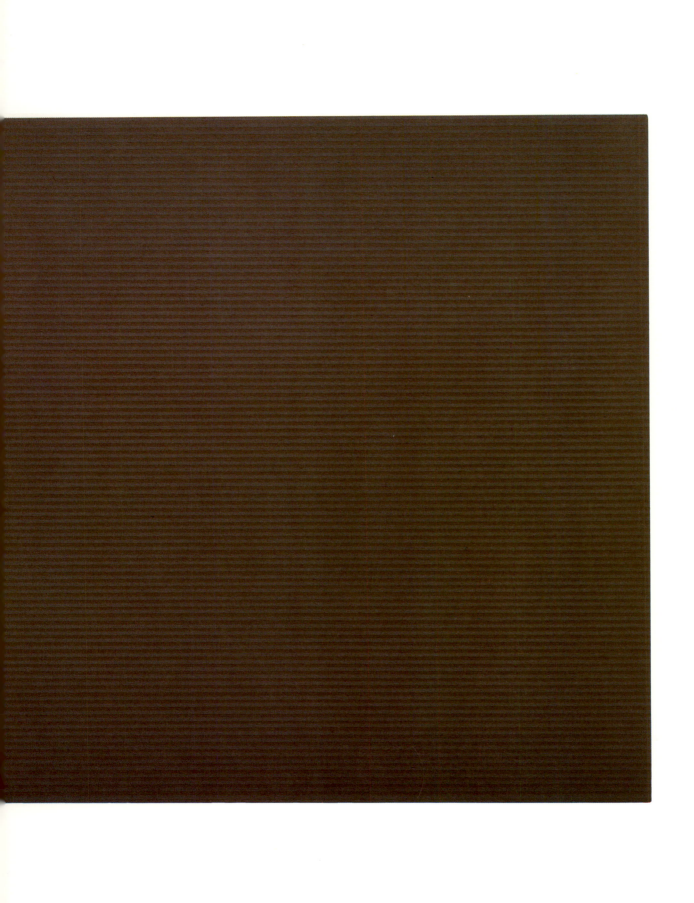

39 Fort 3, 1979. Oil on canvas, 48 × 48 inches.

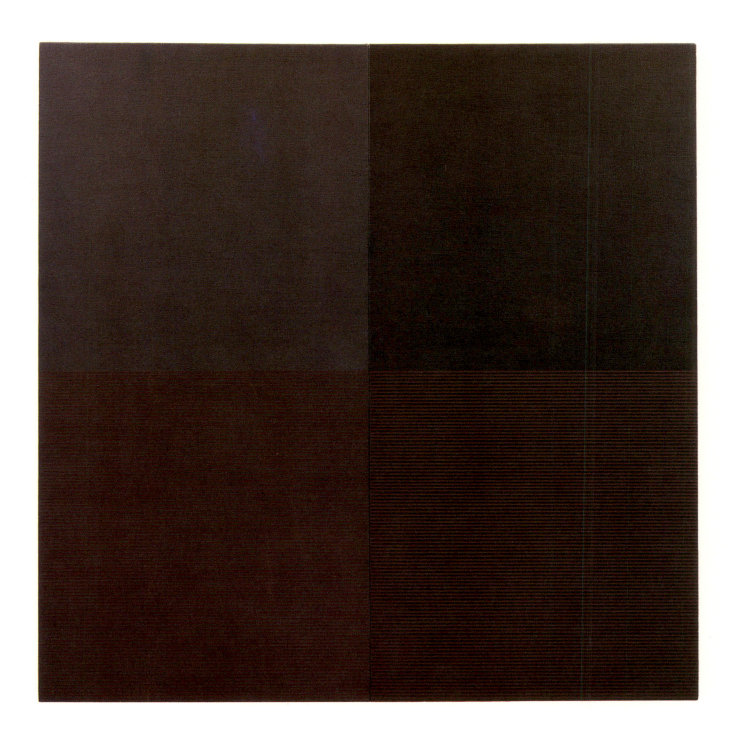

40 Upright Horizontals Red-Black, 1979. Oil on canvas, 108 × 36 inches.

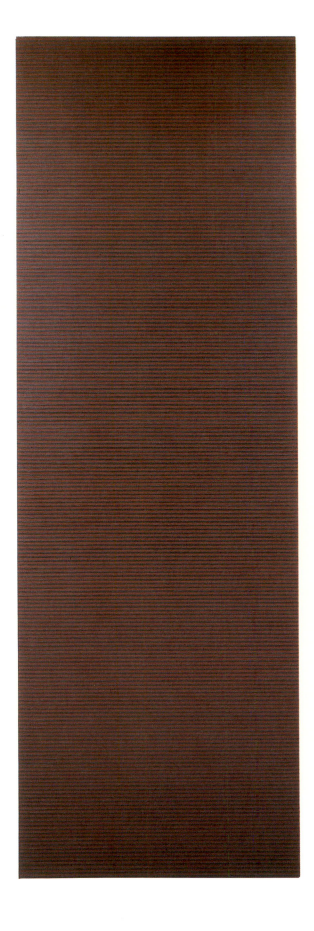

41 Blue, 1977. Oil and acrylic on canvas, 48 × 36 inches.

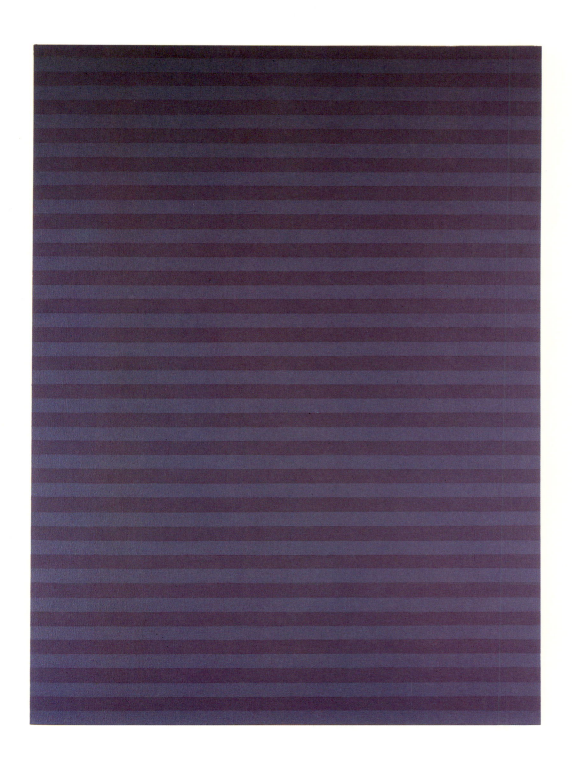

42 Diptych, 1976. Acrylic on canvas, 68 × 72 inches.

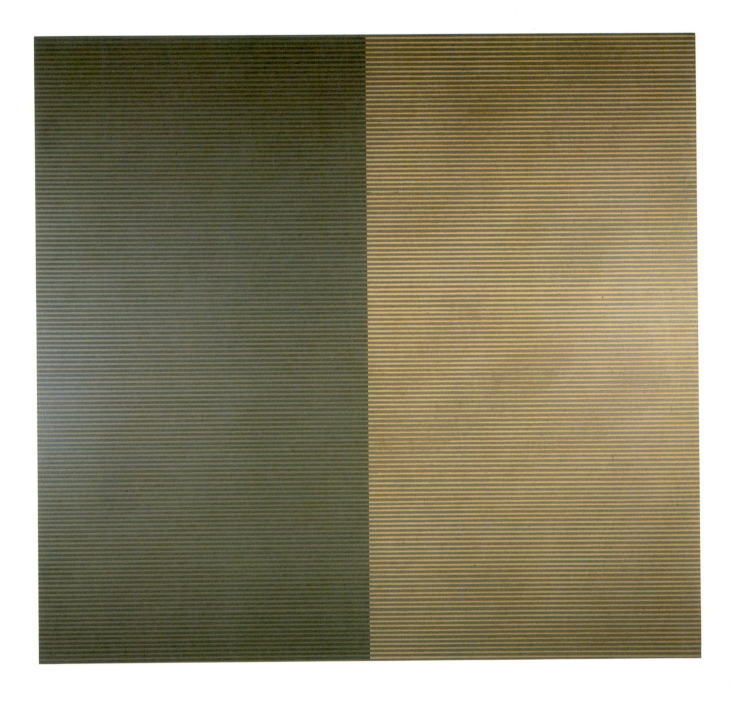

43 Painting for One Place, 1979. Acrylic on the wall, 120 × 240 inches (destroyed).

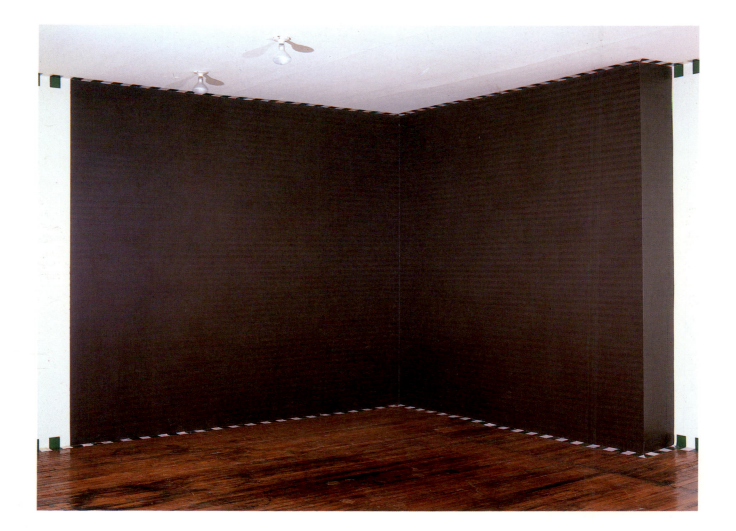

Scully's reemergence into the world of visual action in 1980 and his rise to the position he has achieved today is a phenomenon that reads like a picaresque novel. While individuals with a specific sense of mission are likely to go through a period of retreat or self-purification prior to embarking on their self-imposed assignment, there was, in Scully's case, no such planning. In fact, his odyssey of the late 1970s was an undertaking unto itself, with no definable ulterior motivation. What took place was the equivalent of a sense of mission emerging *after* he had traveled far enough and long enough and when he had secured sufficient strength to reconsider his options. It was at this point that the idea of interacting full-face with the world was reactivated within him. ''I felt it was time for me to make a different move, to go out into the culture and affect it in a more direct way,'' he says.

In practical terms, this decision turned out to mean that most of the elements Scully had taken out of his painting—including color, drawing, proportion, and visual excitement—would be put back into it. One by one, these elements would be reintegrated. Not in the same way as before, to be sure. For the position of strength the artist had achieved was bound to leave its mark. Scully's new paintings would indeed radiate a spirit of renewed confidence. There would be no more retreat, no more hesitation, only a relentless progression forward. Even titles would now be assigned frequently for their connotations, attesting to the artist's concern for relating his work to the external world. Asked to summarize how it felt to reenter the main art scene after remaining in the wings for so many years, Scully put it succinctly: ''It was like coming out of a cave.''

A thematic format that proved crucial to Scully's emancipation was the two-part construction. The artist had done such works on and off for several years, either juxtaposing the canvases or placing one above the other. *Upright Horizontals 1* (no. 44) of 1980 follows in this tradition, the lower canvas being of a slightly darker tonality than the one above, but so inconspicuously that the eye reads the two panels easily in continuity with one another.[1] One of the main attractions of the painting, in fact, is the unified upward pull of the composition. In *Rose Rose* (no. 45) a new territory is entered. Here, two tall and narrow canvases are set next to each other. Both still consist of horizontal stripes, but the right-hand one is substantially darker than the other, interrupting visual continuity. A tension between the two images has been established, opening a path of expression that Scully was quick to pursue. This painting indeed led to a group of similarly shaped works in which Scully explored the possibilities of dynamic interaction between two panels in a variety of ways.

Another notable distinction of *Rose Rose* is that, according to the artist, it was the first truly successful oil painting he had so far completed. Since he had switched from acrylic to oil in 1979, Scully had experienced difficulties with the medium. ''I had tremendous technical problems. . . . I had to learn all over again,'' he recalls. Most of these problems, as he explains, had to do with the unpredictable nature of oil paint: ''It combines differently with different pigments. In other words, you cannot standardize in the way that you can with acrylic paint, which is standardized. With black, for example, the surface dries matte. Black absorbs oil like crazy. Other colors like green or blue come out much more shiny, because they don't absorb so much oil. So the surface is going to be animated, whether you want it or not.'' Surface animation was indeed of great interest to Scully, and now that he had mastered the process behind it, he was to turn the capricious behavior of oil paint as well as its other positive properties (e.g., luminosity and intensity of color) into powerful instruments of pictorial eloquence.

But the time was not yet ripe for truly overt expressiveness. Refinements in the use of oil would have to take place first in quieter compositions, as we see in *Quintana Roo* (no. 46) and *Ada* (no. 47), two works in which the artist adapted the concep-

* ''Oh what Joy!'' is the text of the opening passage of the Prisoners' Chorus in Beethoven's opera *Fidelio*, as the inmates emerge from their subterranean cells into the open sunlight.

tion of *Rose Rose* to increasingly larger canvases. Particularly enticing is *Ada*, with its shimmering, muted colors and solemn mood, which hark back to Scully's work of the late 1970s while taking it to a more rhetorical level of expression.

In retrospect, it is clear that the most urgent problem facing Scully at that stage had to do not so much with paint as with composition. And so we see him finally taking the step on which his subsequent development would depend: the reintroduction of vertical stripes in conjunction with the horizontal. It is somewhat ironic that the title of the work in which this took place should be *Tyger Tyger* of 1980 (no. 48) for, despite its striped imagery, the painting does not really evoke much about the aggressive animal.[2] But to its maker, reintroducing verticals after such a long time was a gesture of great audacity, and no doubt the title, at least in part, was meant to convey the significance and complexity of this gesture.

In terms of design, the painting, which is exceptionally resolved, is of the same bipartite composition as the works just discussed, with the difference that one of the panels is vertically striped and the other horizontally. The result is an entirely new kind of tension. Scully explains that he evolved this compositional idea by thinking about the grid: "I wanted to bring back the dynamic of the grid without giving up the flatness of the painting.... I had gotten rid of the grid because the way I painted it—by overlapping—created a certain obvious space. So what I did was to make this painting where the horizontals and the verticals were on separate panels, which insisted, of course, on the painting's flatness and frontality but at the same time brought the grid back into the work. The painting really is a separated grid, a grid that has been pulled apart."

Central to Scully's thinking in terms of the grid was that the panels constituting the painting should be of identical size, and for the rest of 1980 he was to adhere to this idea. Both *Catherine* (no. 49)[3] and *Firebird* (no. 50), executed in that year, basically repeat the composition of *Tyger Tyger*, but in mirror-image. In the same mode as *Tyger Tyger* is *Boris and Gleb* (no. 51), a painting named

after a fourteenth-century Russian icon representing these two saints, of which Scully had seen a reproduction. Since the late 1970s, the artist had had a tendency to interpret some of the tall rectangular paintings he made in terms of standing figures, and the bipartite composition of the icon struck him as unusually close in proportions to his current work. In *In the Old Style* (no. 52) we see Scully break away from the tall narrow format and stack two square canvases: the top one horizontally striped, the other vertically striped. This order is reversed in *Blue Blue Red* (no. 53), a composition also consisting of two square panels, one above the other. The impression generated from all these works is of the artist slowly disengaging himself from the confines of a straitjacket.

In *Fort 5* (no. 54), also of 1980, Scully became more adventurous still, juxtaposing four square canvases to form a square, a compositional idea he had used in *Red Composite* of 1974 (no. 32). More meaningful is that the images are no longer divided equally between horizontally striped ones and vertically striped ones, making it clear that Scully was now moving away from the limitations of the grid as such; only one of the four canvases includes verticals. Another feature of significance here is that the stripes in the upper right-hand panel are hand painted and not taped, as they are in the rest of the composition, thus creating variations in the paint surface. Adding to the burgeoning character of the work is the color, which is much stronger in contrasts than in any painting made by Scully since 1975. A comparison of this painting with the severe *Upright Horizontals Red-Black* of 1979 (no. 40) makes apparent the great distance traveled by the artist in the span of a single year.

In some respects, the stage at which Scully found himself at the beginning of 1981 is reminiscent of the mental struggle he had gone through in 1974. At that time, he had been intent on breaking away from the spatial illusionism of his grid paintings, and we saw that the process proved to be anything but a smooth operation. A similar restlessness was now taking over, leading the artist to try out various solutions with increasing boldness and

to move back and forth among them. *How It Is* (no. 55) is still remarkably disciplined in composition, consisting of four vertical canvases alternating twice from a vertically striped one to a horizontally striped one. But the title, adapted from one of Samuel Beckett's novels, alerts us to the fact that Scully was on the verge of an important move. As he explains it, ''That's the way it was going to be from now on. I wasn't going to worry anymore about having things make sense.''

And so, in *Backs and Fronts* of 1981 (no. 56), we see Scully literally break loose and put together ten panels varying a great deal in height as well as in width. Some are horizontally striped, the rest vertically, and the thickness of the stripes as well as their coloring changes from one panel to the next. Variations in surfaces can also be observed from panel to panel, since some were painted freehand, others were taped, and still others received multiple coats of paint. No true logical pattern can be perceived behind the juxtapositions, except that collectively they amount to a striking statement in loudness and defiance. Scully recalls that each panel was painted separately and then he assembled them. ''I didn't think of how they were going to go together,'' he says. ''I wanted to do something I didn't understand. I wasn't trying to make a unity. In fact, I wanted something that didn't have a unity but had a kind of urban spread.''

The painting, which remains unique in Scully's oeuvre for the extravagance of its conception, caused something of a sensation when it was exhibited in a group show at P.S. 1 in Long Island City in early 1982.[4] Most people seemed to respond positively to it, and the artist remembers that the unorthodox character of the work, which is twenty feet wide, was appreciated especially by ''punk'' people. ''They loved it,'' he says, ''mainly, I think, because they could see that it had moved outside academic abstraction.'' The painting indeed amounted to a manifesto, letting everyone know that Sean Scully had entered a new phase, and that his work could no longer be counted on to be predictable. The tiger was out of the cage.

Scully wasted no time in exploring the possibilities latent in *Backs and Fronts*. One of them concerned the tension generated when a vertically striped panel is inserted within a horizontally striped composition. *Come and Go* of 1981 (no. 57) includes such a panel, the tension being stimulated further by an abutting panel on the left whose horizontal stripes are much thinner than those on its right.[5] Substantially more complex is *Enough* (no. 58), a painting Scully says was about how much he could put into a single work. The composition indeed abounds in changes of direction, of colors, and of stripe dimensions: wider ones on the left, narrower ones on the right, and still narrower ones at the top, bottom, and center. It would appear that the artist was attempting to compress within an almost perfect square all the formal relationships alluded to in *Backs and Fronts*. The way the painting was composed was, in fact, much the same. Scully kept adding panel after panel, the last one being the long rectangular one at the top, which appears to have been painted as a separate unit. The title reflects the fact that, after adding it, the artist decided against further accretions: ''I felt that was enough, and I called it *Enough*.''

Analyzing a characteristic painting by Scully such as *Enough* raises important issues, the most fundamental involving the interaction of verticals and horizontals. It is a well-known fact that each of these directions has its own set of connotations that the human mind tends to accept automatically. Each of these directions triggers a mechanism in the psyche that ordinarily goes unnoticed unless we pause to reflect on the subject. This is because we are so surrounded by verticals and horizontals—we literally live in a perpendicular environment—that the conscious part of our mind chooses to ignore their implications. With verticality, because it is the direction in which plants and trees normally develop, flames take shape, and volcanoes erupt, the human mind tends to associate the process of growth. Any human yearning or feeling that has the potential for growth we also relate to verticality: aspirations, hope, passion, love, and ambition. With horizontality, principally because it is the direction in which oceans settle, deserts unfold, and far dis-

tances vanish from the eye, the mind will associate the qualities of stability, calm, peace, passivity, boundless continuity, and permanence.

A peculiar feature of horizontality and verticality is that, in equal proportion, they tend to cancel each other out. This is quite evident in the plus sign (+) and in the square, but it is also manifest at the associative level: growth, hope, and aspiration stand at the opposite pole from passivity, stability, and permanence. From this reasoning, it follows that a preponderance of one of the directions will heighten its connotations and dampen those of the other in the mind of the viewer. A striking application of this affective principle is the design of the facade of Gothic cathedrals, such as Notre Dame in Paris and Reims Cathedral. Here, relatively unimpeded verticals in the upper-part of the buildings impart a forceful movement upward, the intention being to lift the religious pilgrim's thoughts toward the sky, or heaven, where God was believed to reside.

The same reasoning allows us to infer that in any given painting, its shape—unless it be square or round—always contributes a directional impulse of its own. Take *Rose Rose* (no. 45), for example, a work in which all the internal elements are horizontal. Owing to its tall rectangular shape, an assertive upward pull, resisted by the horizontality pervading the work, can be perceived. The upward pull increases if vertical elements are included in the composition, as we can observe in *Tyger Tyger* (no. 48), a work measuring the same as *Rose Rose*. Because of the natural inclination of the eye to read from left to right, a perceptibly different kind of tension is generated if the vertical elements are at the right of the composition, as in *Tyger Tyger*, or at the left, as in *Catherine* of 1980 (no. 49). One other visual situation should be noted here, as exemplified in a tall rectangular painting such as *In the Old Style* (no. 52), where horizontals occupy the entire upper part of the composition and verticals the lower part. As we would expect, whatever upward movement might be contributed by these verticals is tamped down appreciably by the presence of the horizontals above. In a mirror-image composition such

as *Blue Blue Red* (no. 53), on the other hand, where no such constriction exists, the upward thrust is intensified.

Let us now pursue this discussion with the image of a rectangular stripe. Depending on whether it is deployed horizontally or vertically, there will be a dominance of horizontals or verticals and with it a dominance of the corresponding connotations. Complications arise when the stripe is itself segmented into smaller stripes that unfold in the opposite direction. In *Enough* (no. 58), for example, the vertical panel on the right may be read as a tall stripe subdivided into small horizontal stripes; likewise, the rectangular panel at the bottom toward the center may be read as a horizontal stripe subdivided into smaller vertical stripes. It is easy enough to imagine the mind quickly resolving these conflicts and contradictions and deciding on the dominance of one direction over the other. But then further obstacles come into play, for the vertical panel on the left is itself subdivided into small horizontal stripes, while the top panel is a resounding assertion of horizontality.

The final decision for the mind to make in cases such as *Enough* is not an easy one. Whether verticality or horizontality prevails, strength has been built up in the opposite camp, not to mention the countless nuances of association that have been generated through the interlocking of all the verticals and horizontals present. In addition, many connotations other than those mentioned above may come into play within the domain of each direction: depending on their configuration and location within the compositional scheme, vertical stripes, for example, may conjure up the bars of a cell. Obviously most of this mental calculation evades awareness; hence the difficulty of articulating the impact of such painting on an individual's sensibility.[6]

Adding to the complexity of the problem is the coloring of the painting. All colors have some kind of emotive property. Red, for instance, is generally associated with passion, violence, danger, and fire. The color of passivity it is not.[7] Thus, to impose it on a horizontal stripe will tend to diminish

the connotations of horizontality, while a vertical stripe painted with the same color will gain in emotive power. It is true that some colors may ally themselves with both directions with equal persuasion, but the possibilities for reinforcement or conflict still remain considerable. To this problem, of course, must be added the one generated by the juxtaposition of colors. A red surrounded by black, for instance, will trigger an emotional response different from a red surrounded by white.

Suffice it to say that although Scully's development had brought him in full contact with these issues, it was only now that he would address them head on. Henceforth, more than ever before, the connotations of horizontality and verticality, as well as the emotive language of color, would be the substance of his pictorial endeavors. Not that the artist would consciously and deliberately compose and color his paintings with this preoccupation in mind. On the contrary, most decisions would be made on an intuitive basis. But the intention guiding him would be to extract from these formal means as much eloquence as he could for the expression of human concerns, be they spiritual yearnings, emotions, or obsessions.

NOTES

1 Scully uses the terms canvas and panel interchangeably, and I have adopted this terminology throughout.

2 The title is taken from the famous poem in William Blake's "Songs of Innocence and of Experience."

3 Every year Scully names a painting after his wife Catherine.

4 Joseph Masheck, who selected Scully's painting, was one of the curators of the exhibition "Critical Perspectives."

5 As a whole, the imagery of this painting may bring to mind the flag of the United States and, with it, the interpretations of it by Jasper Johns. In some people, the thought may even arise that Scully here is skillfully appropriating an image of Johns. It should be noted that the motif of such stripes, or of such an overall image as the painting may suggest, was there long before Johns ever turned to it—specifically in the flag of the United States. What Johns did was to legitimize its use for and by artists. He dealt with it repeatedly and with such artistic flair that the motif gradually sank into the public's sensibility. Before Johns, and because of its association with the American flag, the motif would have been harder for any serious artist to use with such blatantness as Scully has used it. Johns made it possible. In that regard, Scully is indebted to him. But Scully went on using the motif, whenever it suited him, for purposes far different from those Johns had ever aspired to. Unlike Johns, Scully has been fully committed to abstraction and its unique power of expression in his use of the motif.

6. The theoretical interpretation of the emotive meaning of abstract lines goes back to Humbert de Superville, *Essai sur les signes inconditionnels dans l'art* (Leiden, 1827, with supplement, 1832). Superville's work was of substantial influence on the theories developed on this subject by Charles Henry and Georges Seurat. See Robert L. Herbert, "*Parade de cirque* de Seurat et l'esthétique scientifique de Charles Henry," *Revue de l'Art* 50 (1980), pp. 9–22. Oddly enough, Mondrian, for whom horizontals and verticals were crucial, did not dwell much on this subject. In his early writings, he associated the vertical line with the ascending trees of a forest and the male principle; the horizontal line he related to the sea and the woman. Both directions complement each other like man and woman, he implied. In 1926, he wrote that "in Neo-Plastic art the essential question is not of vertical or horizontal, but of the perpendicular position—and the relationship thus obtained. For it is this relationship that expresses the immutable in contrast to the mutable in nature." See *The New Art—The New Life: The Collected Writings of Piet Mondrian*, ed. and trans. Harry Holtzman and Martin S. James (Boston: G. K. Hall, 1986), pp. 18, 210.

7. This subject has been examined by numerous artists and writers. One of the most penetrating as well as easy-to-read discourses on color remains Wassily Kandinsky's in *Concerning the Spiritual in Art* (1912). Excerpts from Kandinsky's text pertinent to this discussion can be found in Herschel B. Chipp, *Theories of Modern Art* (Los Angeles: University of California Press, 1968), pp. 152–55.

44 Upright Horizontals 1, 1980. Oil on canvas, 84 × 28 inches.

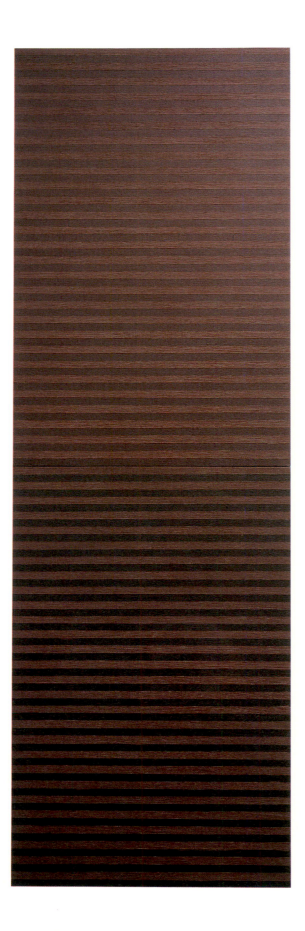

45 Rose Rose, 1980. Oil on canvas, 70 × 30 inches.

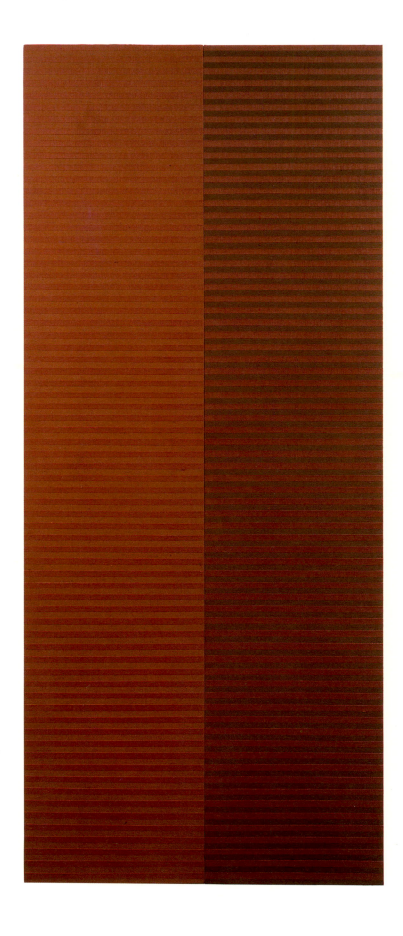

46 Quintana Roo, 1980. Oil on canvas, 84· × 42 inches, Mr. and Mrs. Harry W. Anderson, Atherton, California.

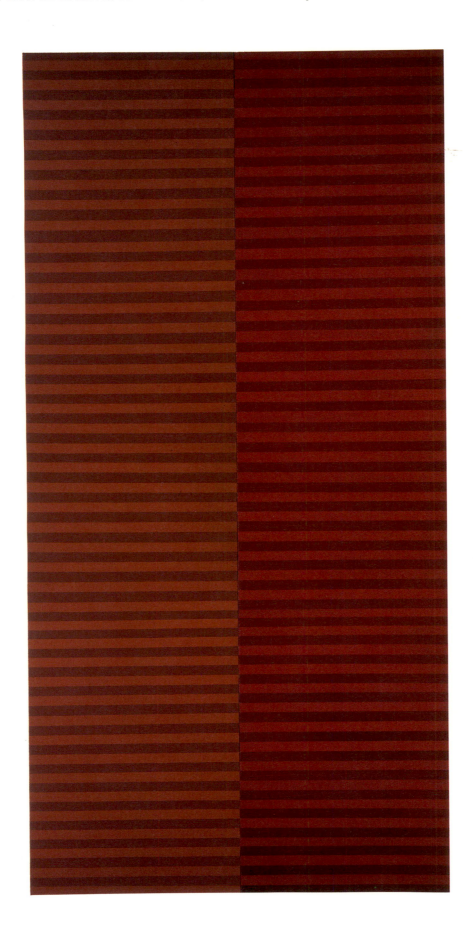

47 Ada, 1980. Oil on canvas, 96 × 48 inches, William Beadleston, New York.

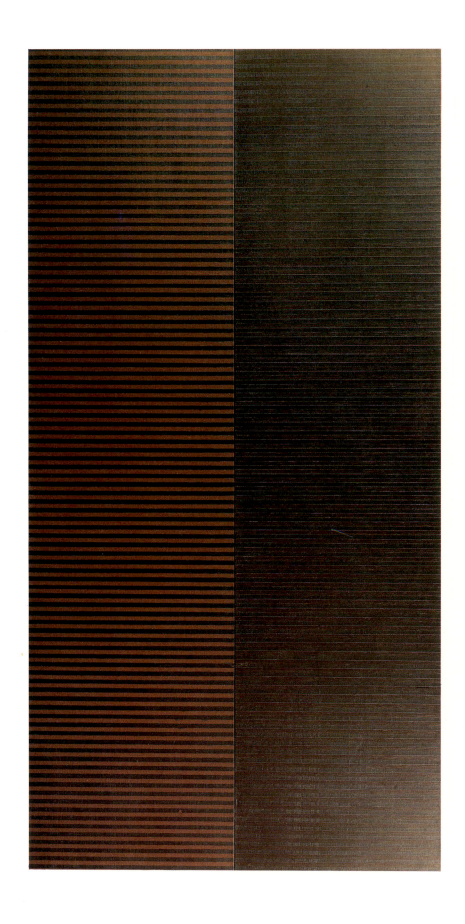

48 Tyger Tyger, 1980. Oil on canvas, 70 × 30 inches, private collection, Japan.

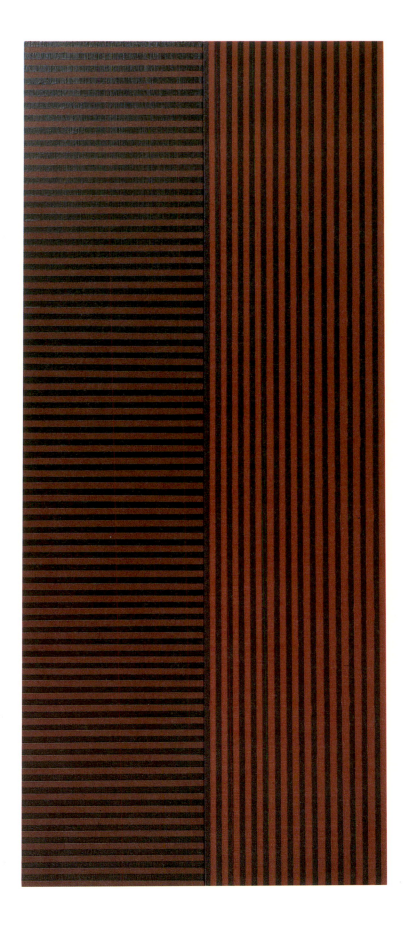

49 Catherine, 1980. Oil on canvas, 84 × 36 inches, collection of the artist.

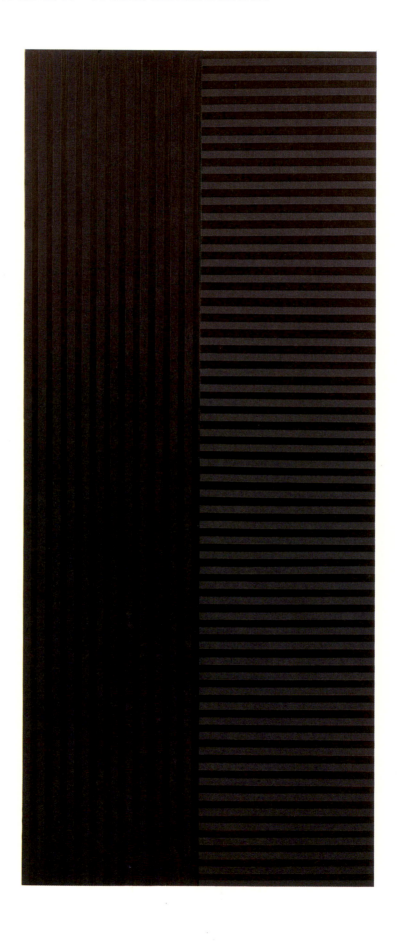

50 Firebird, 1980. Oil on canvas, 96 × 48 inches.

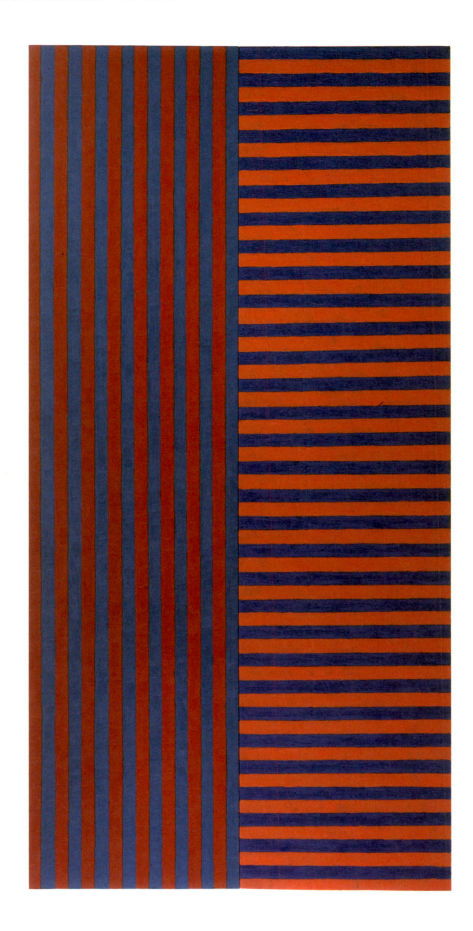

51 Boris and Gleb, 1980. Oil on canvas, 96 × 35 inches.

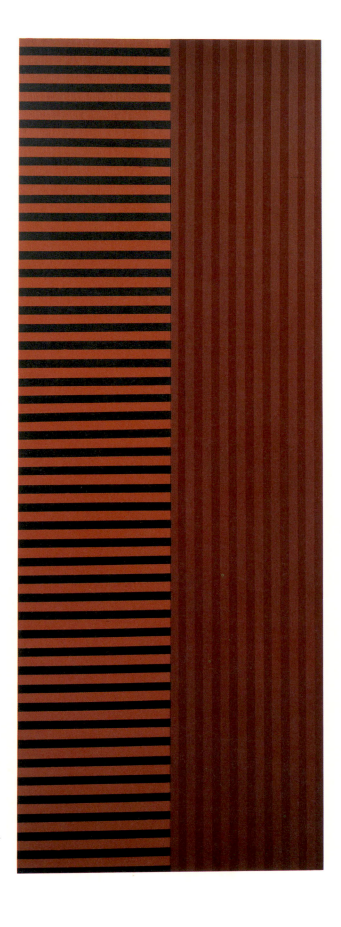

52 In the Old Style, 1980. Oil on canvas, 40 × 20 inches.

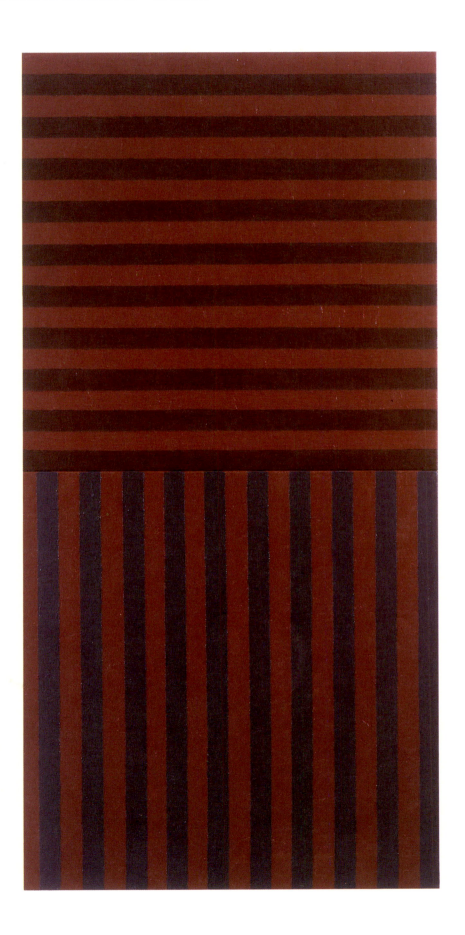

53 Blue Blue Red, 1980. Oil on canvas, 60 × 30 inches.

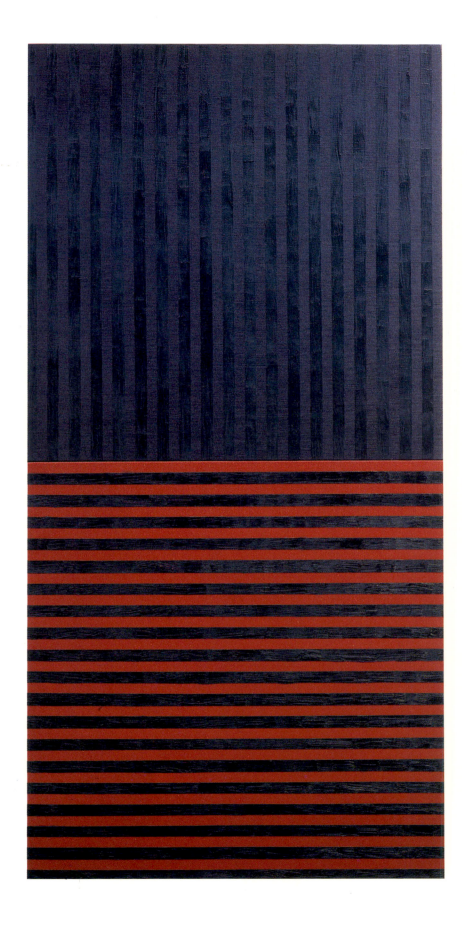

54 Fort 5, 1980. Oil on canvas, 41 × 41 inches, private collection, Japan.

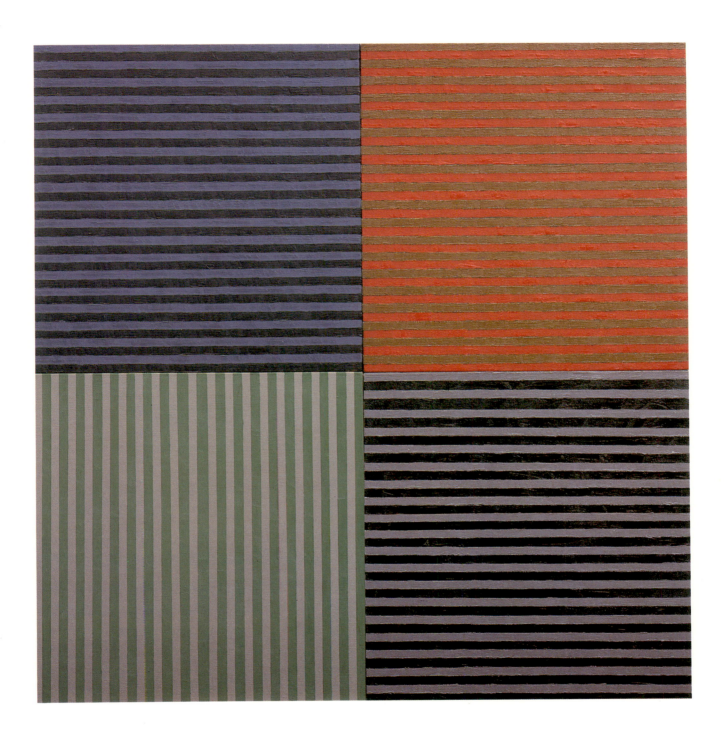

55 How It Is, 1981. Oil on canvas, 42 × 42 inches, Arts Council of Great Britain, London.

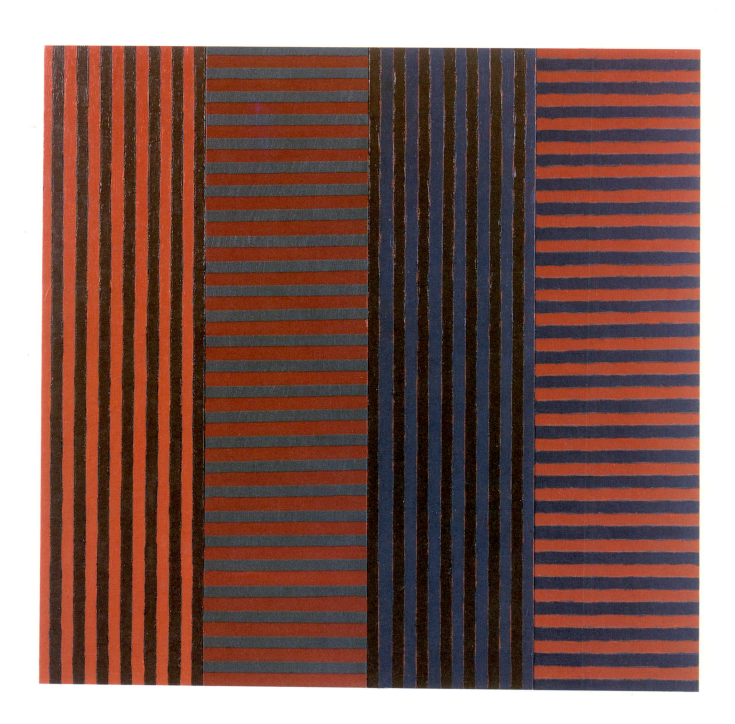

56 Backs and Fronts, 1981. Oil on canvas, 96 × 240 inches, collection of the artist.

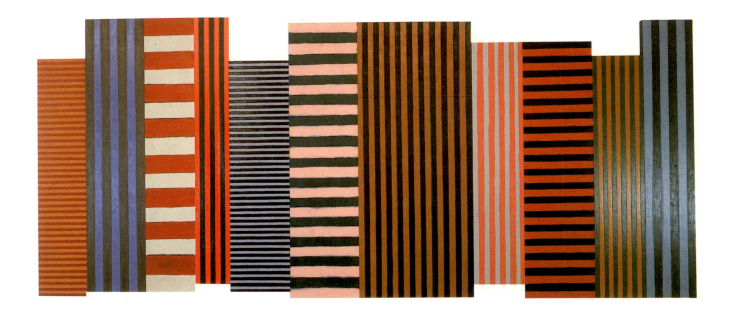

57 Come and Go, 1981. Oil on canvas, 84 × 93 inches.

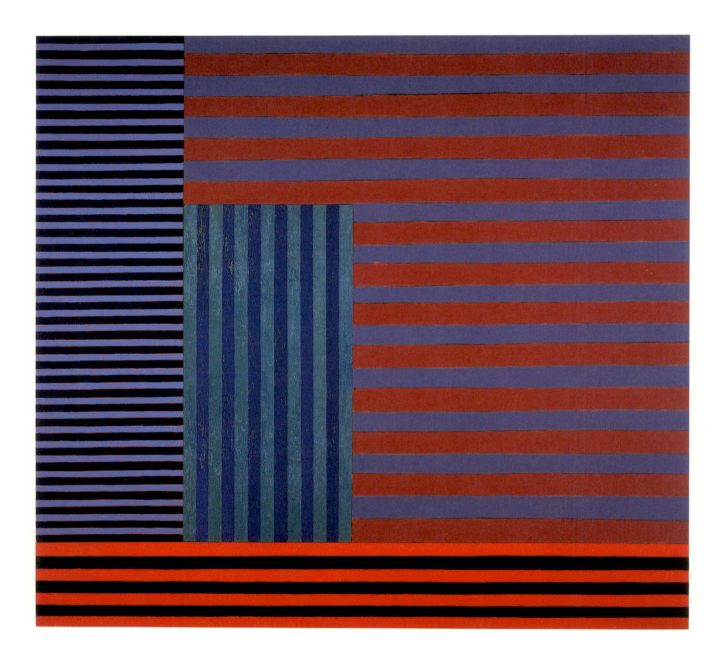

58 Enough, 1981. Oil on canvas, 67 × 65 inches, Mellon Bank, Pittsburgh.

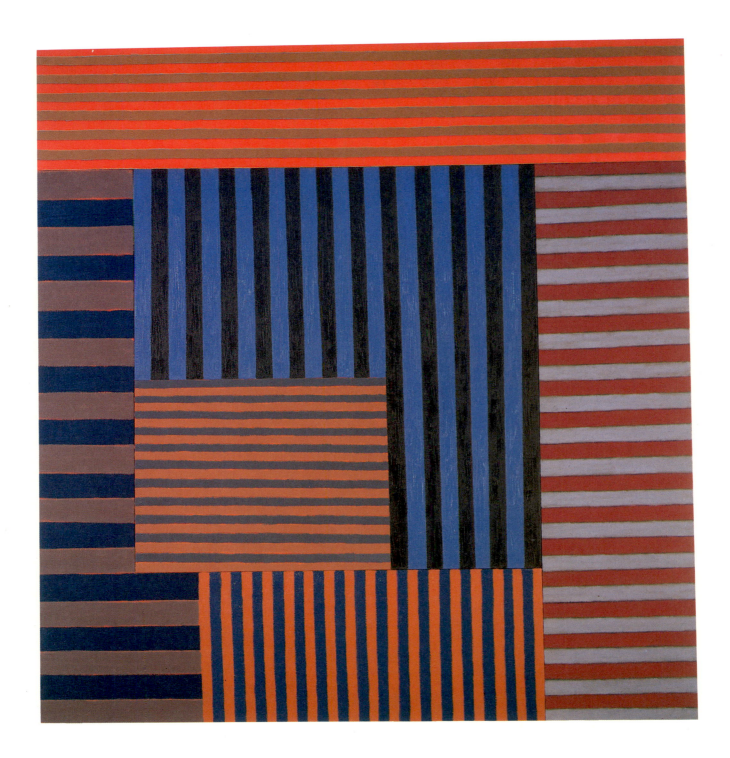

Thus far, we have seen Scully's development proceed through a rhythmic up-and-down sequence, like waves that must fall after they crest. After the busy mobility of the grid paintings, a quiet phase had set in, to be followed, at the beginning of the 1980s, by a new outpouring of extrovert energy that climaxed in *Backs and Fronts*. *Enough* was a sequel to this episode, as was *Adoration* of 1982 (no. 59), a work that in some respects goes still further in complexity of statement. Now the paintings would become less hectic again, as Scully would enter a territory of more searching expressiveness. Compositions would become more focused in their reach. Stripes would grow wider and become more pulsating. Colors would gain in intensity. Black would often be used to evoke feelings ranging from the solemn to the sinister.

Heart of Darkness (no. 60) takes us deep into this realm. A tripartite work forming a large horizontal rectangle, the painting at first impresses with its sense of order and balance, as if verticality and horizontality were perfectly matched. On closer examination, it is apparent that virtually all the stripes have been hand painted. Some of them deviate perceptibly from the straight line, a feature that will henceforth be seen widely in the artist's work. The immediate effect of such deviations is to impart a living, breathing feeling to the composition, an impression reinforced by the blurred, smeared edges of the stripes and the impure paint surfaces. Somehow the stripes here, black ones alternating with white ones on the left and with yellow ones on the right, conjure up the primal state of the African jungle. The ordered structure of the work combines and contrasts with this evocation to suggest a ritual, as if we were about to witness a ceremony intended to pacify some malevolent spirit. The ambiance of Joseph Conrad's novel, after which the painting is titled, suddenly comes to life. There is a savage beauty about this work that distances it from all others made by the artist up to this point.

In a related mode is *Angelica* (no. 61), which reinterprets Scully's *Diptych* of 1976 (no. 42). What a difference! While the earlier work was precise, ordered, and evenly painted, *Angelica* is approximate, off-center, and brutalized, as if the artist were renouncing his past. Conspicuous for its insolence is the dirty yellow of the stripes on the right. The process, which has remained a favorite of Scully's, involves laying on successive coats of paint in different colors that are allowed to show through.

Also to be compared with an earlier painting, *Morocco* of 1969 (no. 3), is *The Moroccan* (1982; no. 62), a work painted entirely freehand. The subject was particularly dear to the artist, and he no doubt intended to treat it with as much respect as he could. Parallel stripes constitute the imagery here too, but instead of a hole in the center the artist inserted a rectangular panel on which black stripes alternate with white ones. Scully also manipulated the surface texture of the black and white paint to give it a beat-up look, an effect he has continued to exploit with this color combination to the present day. On the right side of the composition, Scully joined a rectangular panel that projects beyond the adjacent top edge of the work, suggesting a disparity of some sort. As an evocation of Morocco, Scully's earlier work certainly captured an interesting aspect of its culture, namely the omnipresence of exotic colored stripes. While acknowledging this feature, *The Moroccan* seems to address issues that reach far deeper into the ethos of the country, issues having to do with poverty, precariousness of existence, and a sense of isolation from the Western world, which it shares with the rest of the African continent.

The year 1983 proved to be eventful for Scully. He became an American citizen and was awarded a Guggenheim Fellowship, one of the most prestigious grants available to artists in this country. He was also given his first solo exhibition at the David McKee Gallery, which has represented him in New York ever since.[1] A studio visit this same year by John Caldwell, curator at the Museum of Art of the Carnegie Institute in Pittsburgh, was to lead to Scully's first solo American museum exhibition two years later.[2] Significant recognition of Scully's achievements had taken place in England in 1981, when a retrospective exhibition of his work spanning the previous ten years had been mounted at the Ikon Gallery in Birmingham.[3] Clearly the artist

was on an ascendant path. The transition he had set out to make in 1980 had been achieved successfully.

Some of the works made by Scully in 1983 follow up on ideas developed in the previous year. In *South Eagle* (no. 63) alternating black and white stripes of the type used in *The Moroccan* (no. 62) can be seen. But instead of invading the composition deep down past the center, they are compressed at the top—there are only four of them compared with twenty-nine in the earlier work. Furthermore, these four stripes are surrounded on all three sides by thick vertical stripes of ocher and reddish brown that seem intent on pushing them up and out of the composition. The tendency of verticals to suggest movement upward is here vividly demonstrated.

Angel (no. 64) is a work in two parts whose left panel includes thin black lines on a white ground, while the right panel comprises luminous blue and ocher stripes thickly painted. Scully speaks of the contrast as symbolizing that between being naked and being clothed, or between spirit and body. The idea for the black lines actually derives from Matisse's wall drawings for the Chapel of the Rosary of the Dominican Nuns at Vence, France. Both conceptually and visually, *Angel* is an uncommonly moving work.

On the formal level, *Angel* may be compared with *Angelica* (no. 61), which is of the same height. *Angelica* includes thirty-six stripes on the right side as against thirteen in *Angel*. This raises an interesting issue: what is the visual effect of increasing the number of horizontal stripes within a given vertical rectangular area? Since the number of horizontal elements is increased, one would expect whatever upward movement is suggested to be toned down. But an unexpected complication arises. Because the stripes alternate in color (as is the case here), the eye may be inclined to read them as the bars of a ladder; the more bars, the more tempting it becomes to view them as stimulating the escalation upward. The experience of the phenomenon, which remains highly subjective, may be observed more easily in *Bonin* of 1982 (no. 65), a work containing three orders of stripes in vertical format. Scully was to exploit the dy-

namic of this theme again and again (see, for example, *One One One* [1984] and *Two One One* [1985]; nos. 66 and 67).

In 1982, Scully had spent part of the summer at the playwright Edward Albee's artists' colony in Montauk, Long Island, where he made a group of small paintings on wooden boards. Named after islands, these works proved crucial to the next phase of his development, which in the main was to involve setting aside flatness in favor of compositions with one or more panels jutting into the viewer's space. The concept emerged while Scully pondered over *Solomon* (no. 68), originally a painting measuring seven by eighteen inches, which he had just made. "I was thinking about making these really wide paintings," he recalls, "and I looked at this painting for a while, and it seemed like it was too wide, wider than I wanted it to be. So I sawed off a part of it, put it on top of the other part so that they overlapped, and screwed it in from the back. And I liked the combination. It was an act of discovery." The transformed painting, which literally had a step built into it, led the artist to experiment with a variety of projecting abutments and overhangs. The execution of *Ridge* (no. 69), as reported by Amy Lighthill, makes it clear that, despite Scully's deep involvement with structural problems, he remained as responsive to the light and colors of the environment as any Impressionist painter would have been. Scully said that he had painted the orange and brown panel while the Long Island sun was "burning my neck," and then, after looking at the ocean, added the blue panel.[4]

It took Scully a while to determine how to adapt the idea of jutting panels to big canvases. The problem was solved by building stretchers of various depths and juxtaposing them against each other. It should be noted here that in all of Scully's works of this nature, the jutting panels are deployed parallel to the wall, so that the eye is inclined to read the compositions in their totality much as it does two-dimensional paintings. As Carter Ratcliff noted, "one looks at them straight on in the absence of reasons to look at them any other way. There is nothing to peer into or around."[5] Yet one crucial differ-

ence is that the works, being three-dimensional, do present themselves with a new, more emphatic physicality. Also, the panels closer to the viewer tend to assert themselves more strongly than those recessed, thereby generating additional tension within the work. In close surroundings, these works can easily acquire a true architectural presence.

Tiger of 1983 (no. 70), a painting related in mood to *Heart of Darkness* (no. 60), includes a panel at the top that stops short of the right edge and projects more than two inches in front of the rest of the work. An inset at the bottom doesn't quite fit, adding to the shifting character of the composition. Scully views the vertical stripes in this inset as the teeth of a saber-toothed tiger hanging down. Most of the horizontal stripes are slightly curved, suggesting the moving presence of the animal. As is the norm in Scully's paintings, the brushstrokes parallel the direction of the stripes, emphasizing the impression of movement. In its totality, the composition is particularly eloquent in sunlight. Viewed at an angle, the rhythm of the brushwork in that light creates slight swellings that impart a furry look to the yellow stripes. This tiger is not only out of his cage; he is roaming free. The painting was included in the ''International Survey of Recent Painting and Sculpture'' held in 1984 at the Museum of Modern Art in New York, where it stood out for its striking combination of clarity and aggression.

The primitive has always fascinated Scully, and he took advantage of the new range of expression that jutting panels offer to investigate concepts pertaining more readily to sculpture. African masks were of great interest to him at the time, leading him to devise a configuration that would conjure up their peculiar affective power. In *Catherine* of 1983 (no. 71) a large rectangular panel at the top steps forward, the intention being, one presumes, to evoke the upper part of a mask. Wide vertical stripes on the bottom panel function like pillars, behind which some evil incantation might be taking place. There is a dark, brooding quality about this painting that belies its title. Similarly structured is *The Fall* (no. 72). Here, a horizontally striped inset seems to have

sunk down literally from behind the top panel, an impression reinforced by the slanting, uneven stripes, suggesting dislocation and commotion that we are not allowed to witness.

A compositional idea that was to interest Scully for some time involved one or more full-length vertical panels projecting toward the viewer. *Maesta* (no. 73), painted in 1983, includes such a panel near the center. The overall effect, which reminds one of a stage set, is here consonant with the iconographic arrangement in Duccio's *Maestà*, the inspiration for the work.[6] As Scully explains it, the side panels, with their starkly contrasting blackish and whitish stripes, are meant to evoke the spirit, while the central panel, with bright red vertical stripes, alludes to the body. The painting is a remarkable example of Scully's ability to use simple means such as horizontality, verticality, and a very restricted coloring to evoke feelings reaching beyond the material sphere. Red, signifying the carnal impulses and passions to which the body is subjected, rises up freely. Of the stripes flanking it, some unfold vertically to signify the transcendental aspirations of the spirit, others laterally to remind one that passions are ultimately to be kept in check if the spirit is to be freed. In its severity and seriousness of intention, the painting may be compared with Barnett Newman's *Stations of the Cross*.

Radically different in mood is *The Bather* (no. 74), a painting made by Scully in 1983 after a trip to Italy, where he had spent a great deal of time out of doors. Its composition includes two vertical panels that step out toward us, the more assertive one in warm colors and horizontally striped, projecting nearly a foot from the wall. Here we catch Scully in a rare upbeat moment. In both its structural arrangement and its color, the work captures the joyfulness and carefreeness of a day at the beach. The horizontally striped panel, its color and pattern reminiscent of skin and bathing suit, is naturally the bather himself, while the green and blue stripes, with their wavy outlines, re-create the sea and sky around him. The connections with Matisse's *Bathers by a Stream* of 1916 (in the Art Institute of Chicago)

are obvious, but other works by the French master come to mind as well: *The Joy of Life*, for example, *The Dance* (*I* and *II*), and *The Swimming Pool*. As is very often the case in the evolution of Scully's paintings, *The Bather* underwent important changes, which this time the artist photographed. The stages of process documented show that the green stripes, for example, evolved from brown through yellow before being given their final color.[7] Similar in composition to *The Bather* is *Molloy* (no. 75), a work of 1984 in which sonorous, red vertical stripes of the kind used in *Maesta* impart a power of presence of exceptional intensity.[8]

The early 1980s witnessed the rise of a trend known as Neo-Expressionism to a dominant position on the international art scene. Reacting against the restrictive, detached, and impersonal principles of Minimalism, which had maintained its momentum through the 1970s, Neo-Expressionist artists such as Anselm Kiefer and Julian Schnabel turned with a vengeance to figuration, bold gestures, and theatrical devices of the most blatant kind. These were difficult years for abstraction, especially of the disciplined kind that Scully had been pursuing. The artist admits that he may have been induced to break away from flatness in favor of three-dimensional compositions by the rising tide of the new movement. Neo-Expressionism, no doubt, also played an influential role in the loosening up of his brushwork. In any event, the propaganda surrounding the new trend led Scully in 1984 to create one of his most disturbing works to date, which bears the ironic title *No Neo* (no. 76). Within the stylistic parameters that the artist was courting at the time, the painting seems to be an attempt to flout all conventions having to do with harmony, balance, and proper bearing. The key element is the coloring, more acerb and dissonant than in any of the artist's previous works; its rebellious character is magnifed by the unruly brushwork. Several of the stripes are slanted in such a way as to generate a feeling of distortion within the painting. Instability prevails. The panel on the left does not seem fully integrated. There are shades of the puzzling incongruities found in the early compositions of the Italian Mannerist painters Pontormo and Rosso.

The difficulty in making generalizations regarding Scully's paintings of any given year, beginning in 1982 and increasingly more so since then, is that on the whole each painting tends to project a content very much its own. While the situation could be attributed to vacillations in the artist's mood, there is more to it than that. More and more, Scully has been intent on handling every painting as a unique entity, exploring in each new work the possibilities of expressive content to an ever-changing level. The idea of creating a group of works around a given theme (let alone permutations on a theme), for instance, is one that he has shunned—at least in his large-scale paintings. When similarities of intention can be detected, it is usually in his works on paper, where he might be experimenting with limited means, or in a number of small paintings, where a specific objective is pursued. Such was the case with the paintings done in Montauk in the summer of 1982 and again in 1984, when the artist sought to resolve certain problems concerning pictorial structure. In *Bobo* (no. 77), *Westray* (no. 78), and *Stroma* (no. 79), for example, the main lines of demarcation within each painting, which would at the time have been articulated by individual panels, were painted, as Scully was in the process of perfecting his ability to build junctions out of paint. "I wanted to have that as an option, to be able to paint the divisions," he says. In this same group of paintings, Scully also experimented with applying the paint very thickly and with a hotter, more exotic coloring.

On the other hand, Scully has occasionally taken up a compositional idea developed previously in a large painting, but always with the intention of adding a new dimension of some kind to it. While *Narcissus* of 1984 (no. 80), for example, basically repeats the structural arrangement of *Catherine* of 1983 (no. 71), the mood has a new twist to it. Here an inset with vertical stripes evokes the lone window of a cell. In alliance with the somber blue and green coloring of the surrounding areas, the inset imparts a foreboding mood to the design, which as a whole suggests the confinement of a dungeon. Two years later Scully would return to the same compositional idea in a painting titled *Dark Face* (no. 90). In the latter work the impres-

sion created would be that of a gate in the process of closing, or of a curtain being lowered on some tragic performance.

A work made by Scully in 1984 still holds very special significance for him. Titled *Paul* (no. 81), it was dedicated to his son, who had died the previous year in an auto accident at the age of eighteen, and whom he had not seen in many years. The news shook Scully, and he set out to make a commemorative painting, deciding that if it didn't come out right he wouldn't name it for Paul. ''I didn't want it to be frightening or morbid,'' he says. ''I wanted it to be more like for a boy, to be inviting to someone who was young.'' Scully views the central panel as figurelike, and in it he energized the brushwork greatly, in part, no doubt, to evoke the vitality of youth. In composition the work recalls *Maesta* (no. 73), and the vertical red stripes may well stand for the yearning of the body to live on. Very wide and assertive horizontal stripes on the left, however, seem to deny this yearning emphatically, as if unbounded continuity could involve only the spirit.[9]

Scully's interest in otherworldly values may be detected in another painting of 1984, *Stare* (no. 82). An essentially black-and-white composition in which horizontality and verticality result in near equilibrium, the work seems to reach into a realm where time and earthly concerns have been obliterated. Scully painted it all with the same brush, which is unusual for him. ''It's a painting that made me stare a lot,'' he recalls. ''It seemed so enigmatic to me. It would just return my stare, like cats do. That's why I titled it that way.''

To pass from *Stare* to *Any Questions* (no. 83), painted the following year, is to exit from a sacred precinct where silence is the rule into busy street life. The work consists of two main parts, the left one centering on a wide, vertical black stripe flanked by two whitish ones—an image that in itself is not provocative. Commotion develops in the right-hand part, where six small canvases, vertically or horizontally striped, are assembled chaotically. At both the top and bottom, the canvases stick out. All are colored in variations of brown. Nowhere do the stripes match, either in size or alignment. What is going on? Is this an updated

replay of *Backs and Fronts* (no. 56)? To a large extent, yes. For the painting presents us with a similar dilemma and abandons us there. As Scully sees it, ''It's as if these six canvases fell off the back of a truck and were put together wrong.'' Here too the artist did not wish to create a unity. Disunity, in fact, would be the appropriate term. ''I wanted to make the left side of the painting very correct and the right side totally wrong.'' Here we seem to be getting a vivid glimpse into Scully's past, when he roamed the streets on a motorbike in defiance, seeking the freedom that social conventions denied him. To this day the artist considers *Any Questions* one of his best paintings.

The dichotomy of *Any Questions* is carried to another level in *Darkness a Dream* (no. 84), where the left side is painted very heavily, the colors (ochers and blacks) asserting themselves with exceptional intensity. On the right side, which is painted quite loosely, the image—in two parts—seems to slip away, as one would want a bad dream to do. Adding to the interest of this work is the emphatic weight given to the reality component, that is, the left side. Whereas in *Any Questions* the chaotic side monopolizes the total area of the composition, here it is the reverse: the dream takes second place. Reality must win, the painting seems to say. The present must prevail. Life must go on.

A major instrument that allows Scully to impart a living feeling to his compositions is the brushwork: rhythmic, energetic, and assured—the artist uses house-painters' brushes—it tends to generate movement within itself. Often, Scully will leave the underpainting partially discernible throughout most of the painted area, thereby transforming that area into a throbbing surface. He may also emphasize this effect by surrounding the areas so painted with stripes that are more evenly and solidly painted, thus literally adding a contrapuntal rhythm to the coloring. A vivid illustration of these pictorial means of expression is *Flesh* (no. 85), executed in 1985. Here the title guides us into reading the work as an evocation of sexually aroused, trembling flesh. But the painting is not about unrestrained abandonment to carnal pleasures. Two strong horizontal stripes on the left, especially the luminous one, and a stripe

on the right at the bottom impose stabilizing elements, suggesting control.

In *Song* of 1985 (no. 86) Scully began experimenting with squarish, blocklike stripes set off against a field of rectangular stripes. The idea, which was to be of increasing interest to him, is fully developed in *Conversation* (no. 87), executed the following year. Theoretically, insofar as directional impulse is concerned, a square form neutralizes itself. What such a form does is to add a frame of reference by which the eye can evaluate the assertiveness of the verticals and horizontals present. It also imposes a neutral "breathing" zone within the composition and, in this sense, it adds a further element of tension. Yet another compositional accretion of that same year—the diagonal stripe (see *Whisper*, no. 88)—itself adds tension to any composition based on the principle of rectangularity. Somehow it has a dislocating effect, especially if used too prominently. Concerned as he has been with adhering to the principle of rectangularity, Scully has generally refrained from making emphatic use of the motif, on the whole resorting to it, instead, for instilling just enough disruption into the work to give it an expressive twist of some kind. A notable exception is *Diagonal/Horizontal* of 1987 (no. 89).

The death of his son Paul triggered a thought process in Scully that took a while to unfold. Finally, in 1986, the emotional pressure had built up to such an extent that the artist could no longer avoid an open confrontation with himself. Deeply troubled, his past weighing on him more heavily than ever before, he entered psychoanalysis, which at the time did him more harm than good. "I had to confront all this stuff, and it made it very hard for me to work," he recalls. Unable at some point to cope with the stress of the situation, Scully stopped painting completely. "I didn't know what I wanted to express," he says. Over three months were to elapse before he would resume painting in early 1987.

Most of the paintings executed by the artist in 1986 reflect these personal difficulties. A sense of gloom seems to hover over them. We have already noted the unsettling character of *Dark Face* (no. 90). *Remember* (no. 91), as the title implies, is tantamount to a recollection of the past; its melancholic coloring, together with the virtually unchallenged verticals, evokes unrelieved guilt. Different in mood though relatable in spirit is *Once* (no. 92), an unexpectedly weighty composition, with three very large horizontal stripes dominating the surface. One is reminded of the heavy, disproportionate figure style in Michelangelo's *Last Judgment* (1536–41), a work executed at a time of crisis in that artist's life. In *Once Over* (no. 93), on the other hand, smaller stripes of even width are used throughout. At first this composition, with its severe black-and-white coloring, seems unusually serene. Only when we turn to interpreting the short vertical stripes in the lower right corner do we become aware of its psychological import. The extent to which these stripes are dominated by the horizontal stripes surrounding them is indeed striking, suggesting that the painting is about spiritual submission.

The last work executed by Scully before he stopped painting in 1986 is *Catherine* (no. 94). As in *Remember* (no. 91), the composition is virtually all verticals; with the exception of a small, light windowlike area, darkness now invades the entire painting. Are we justified in interpreting that area as a window of hope? The painting recalls poignantly the state of entrapment suggested by the "Change" drawings of 1975 (nos. 35 and 36). There, too, darkness prevailed, and there, too, glimpses of light could be perceived. Much the same pattern would emerge at this time in Scully's painting career. Once again hope, internal strength, and faith in his destiny would assist him to resurface and reengage in dialogue with the world.

NOTES

1 McKee made his first visit to Scully's studio in 1981.

2 The exhibition, which opened at the Museum of Art of the Carnegie Institute in Pittsburgh, traveled to the Museum of Fine Arts in Boston.

3 The exhibition "Sean Scully: Paintings 1971–1981" traveled within the United Kingdom under the auspices of the Arts Council of Great Britain.

4 Amy Lighthill, "Portrait of the Artist as Lightning Rod," *Sean Scully*, exh. cat. (Pittsburgh: Museum of Art, Carnegie Institute, 1985), p.14.

5 Carter Ratcliff, "Sean Scully and Modernist Painting: The Constitutive Image," *Sean Scully: Paintings & Works on Paper 1982–88*, exh. cat. (London: Whitechapel Art Gallery, 1989), pp. 21–22.

6 Duccio was an Italian painter from Siena active around 1300. The front panel of his *Maestà* (*Virgin in Majesty)* in the Museo dell'Opera del Duomo in Siena represents the Virgin and Child enthroned, flanked on both sides by saints and angels.

7 Concerning the evolution of this painting, see Brooks Adams, "The Stripe Strikes Back," *Art in America* (October 1985), pp. 118–23.

8 *Molloy* is named after a novel by Samuel Beckett.

9 Scully dedicated to his son Paul his 1985 exhibition at the Museum of Art of the Carnegie Institute in Pittsburgh.

59 Adoration, 1982. Oil on canvas, 108 × 156 inches.

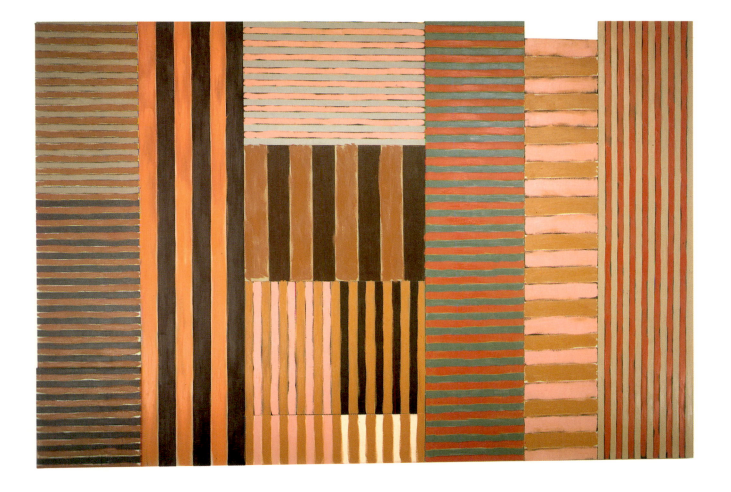

60 Heart of Darkness, 1982. Oil on canvas, 96 × 144 inches, Art Institute of Chicago.

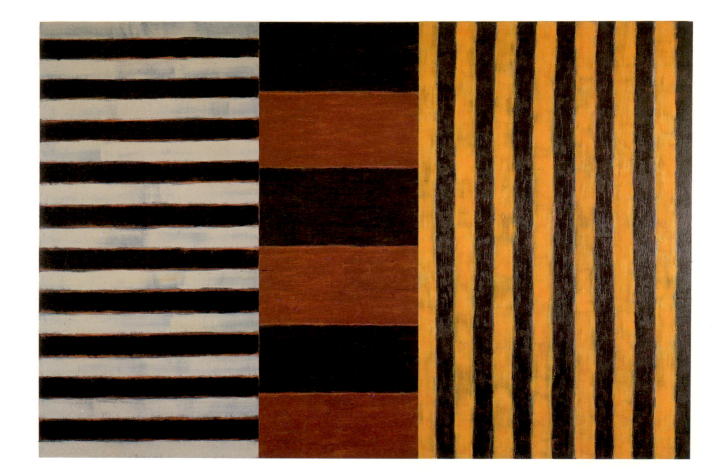

61 Angelica, 1982. Oil on canvas, 96 × 84 inches.

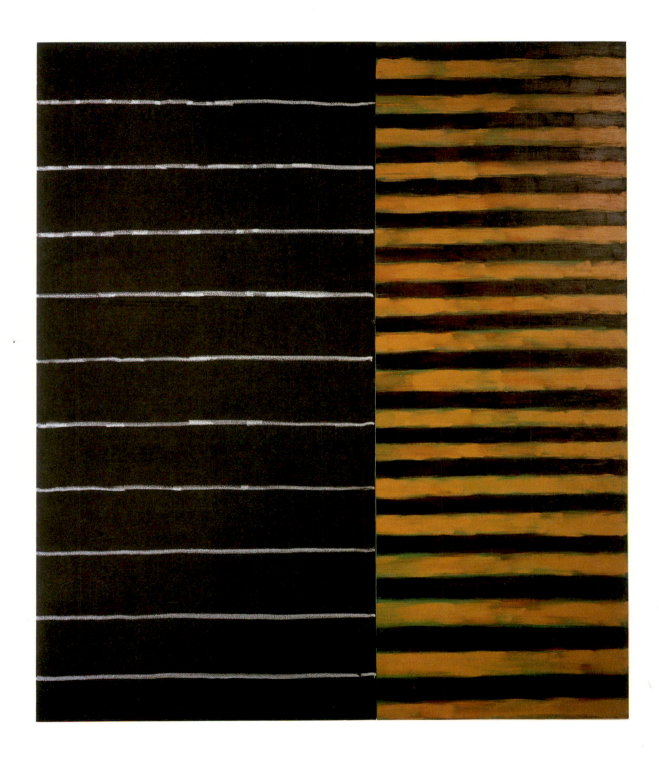

62 The Moroccan, 1982. Oil on canvas, 112 × 63 inches, William Beadleston, New York.

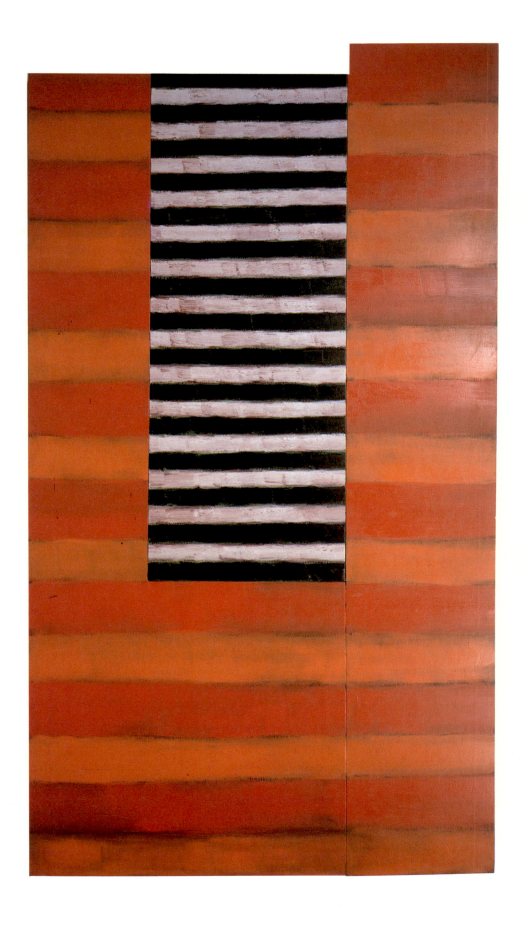

63 South Eagle, 1983. Oil on canvas, 72 × 72 inches, Philip Morris, Inc., New York.

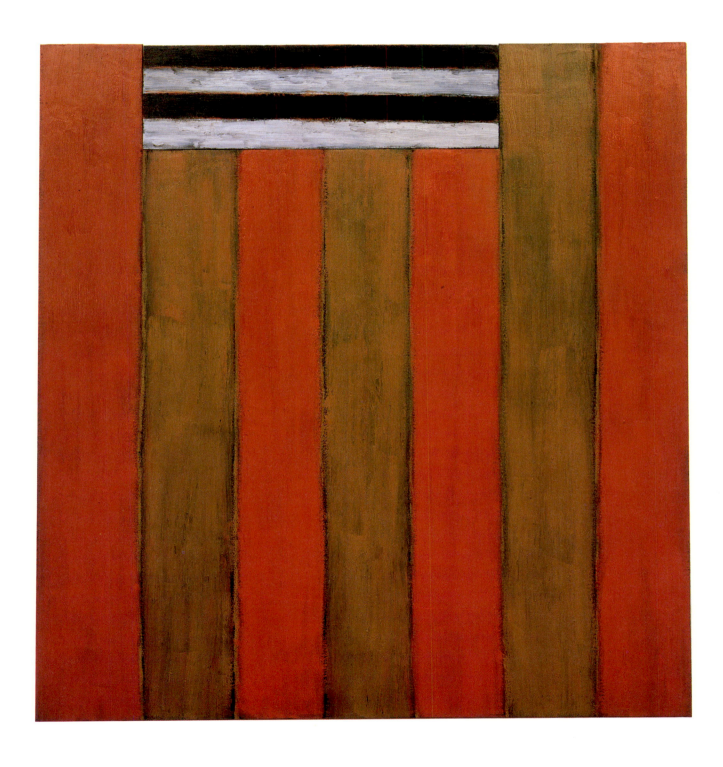

64 Angel, 1983. Oil on canvas, 96 × 108 inches, private collection, New York.

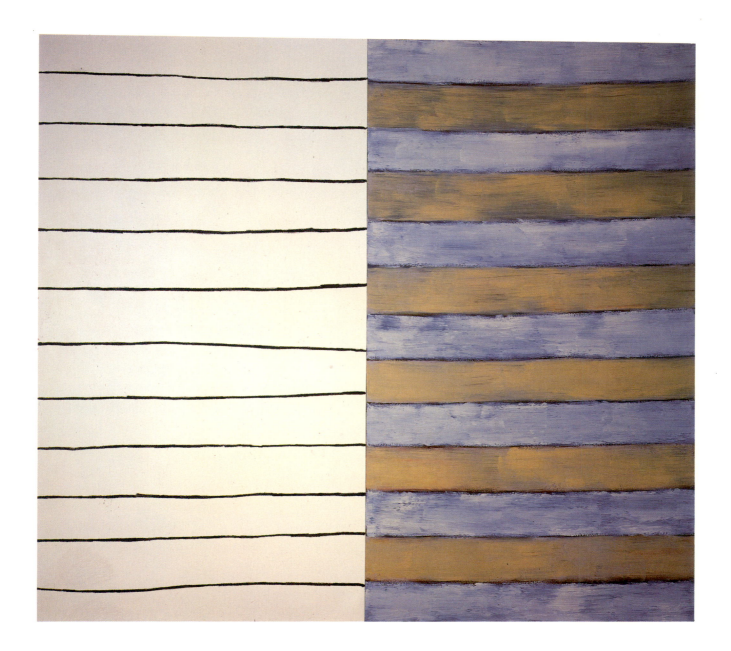

65 Bonin, 1982. Oil on Masonite with wood support, 17⅞ × 24⅝ inches, Ted Bonin, New York.

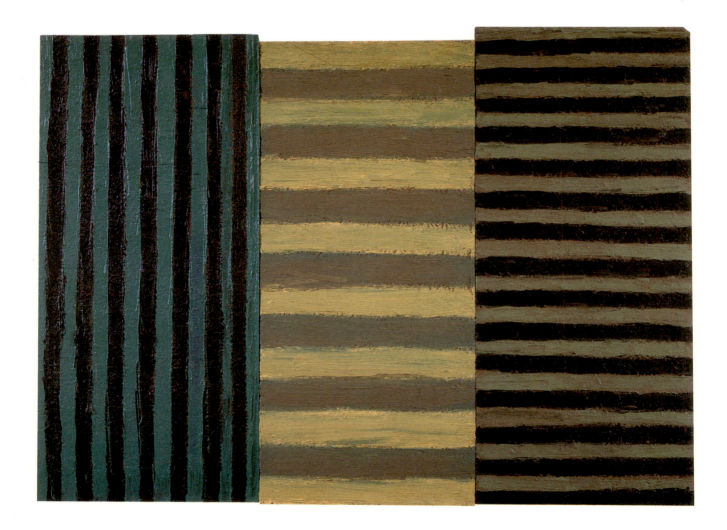

66 One One One, 1984. Oil on canvas, 72 × 90 inches, Milton Fine, Pittsburgh.

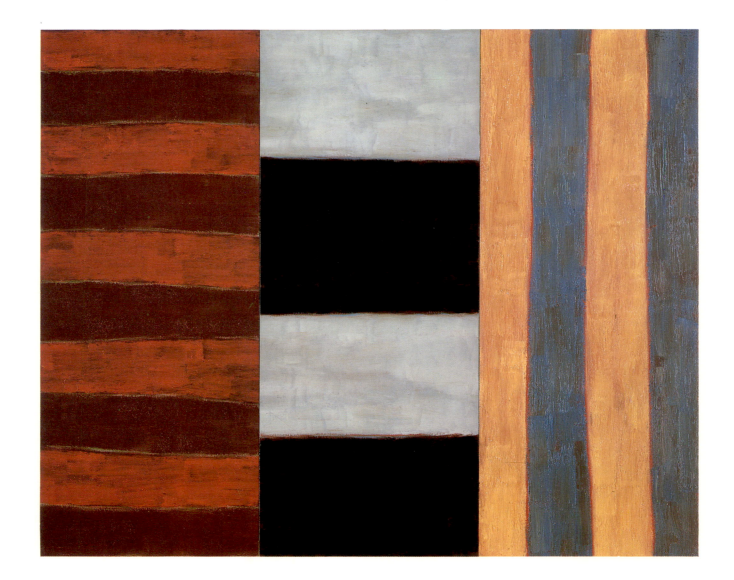

67 Two One One, 1985. Oil on canvas, 90 × 108 inches, private collection, Belgium.

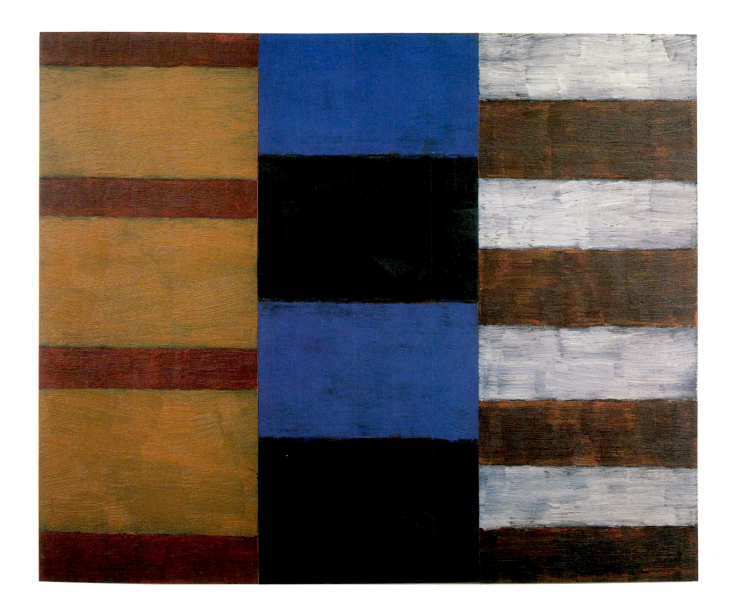

68 Solomon, 1982. Oil on wood, 7 × 13 inches, collection of the artist.

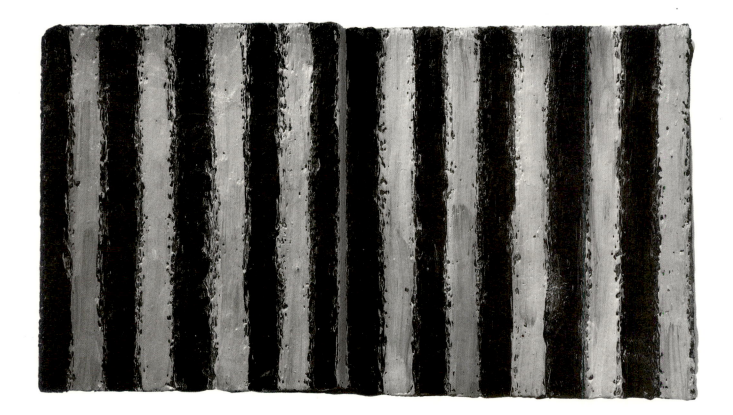

69 Ridge, 1982. Oil on board, 15 × 16 inches, collection of the artist.

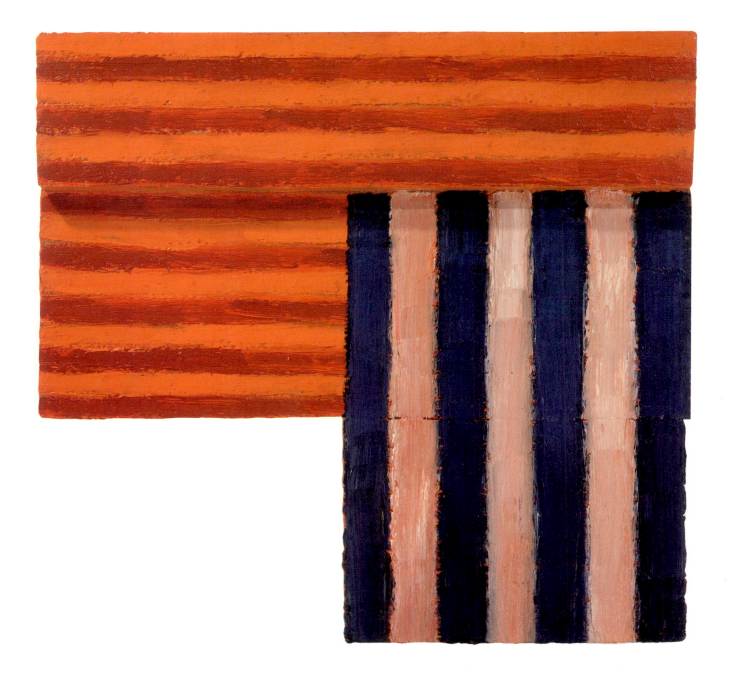

70 Tiger, 1983. Oil on canvas, 82 × 75 inches, private collection, New York.

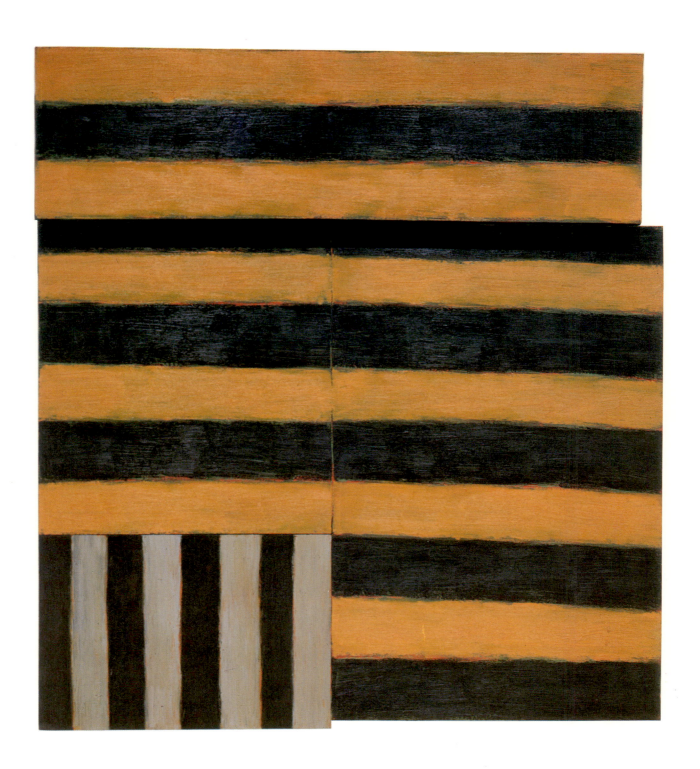

71 Catherine, 1983. Oil on canvas, 116 × 96 inches, collection of the artist.

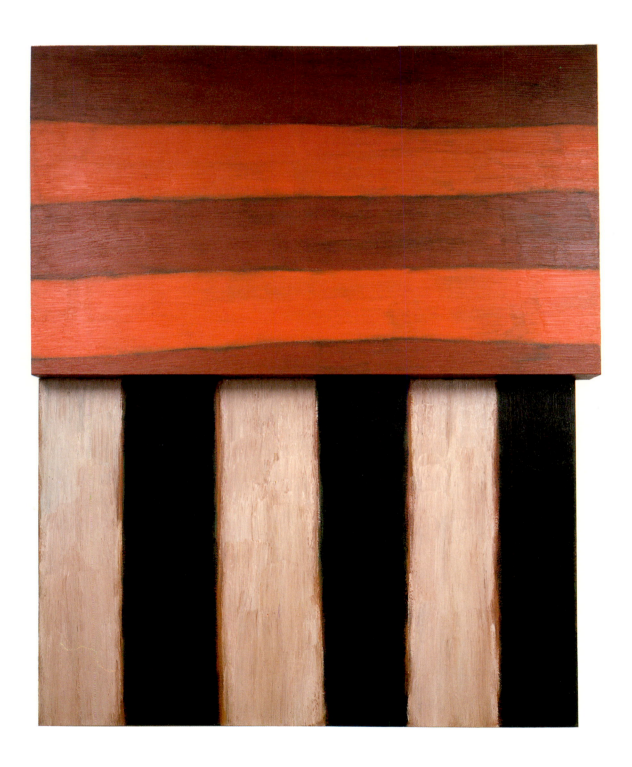

72 The Fall, 1983. Oil on canvas, 108 × 96 inches.

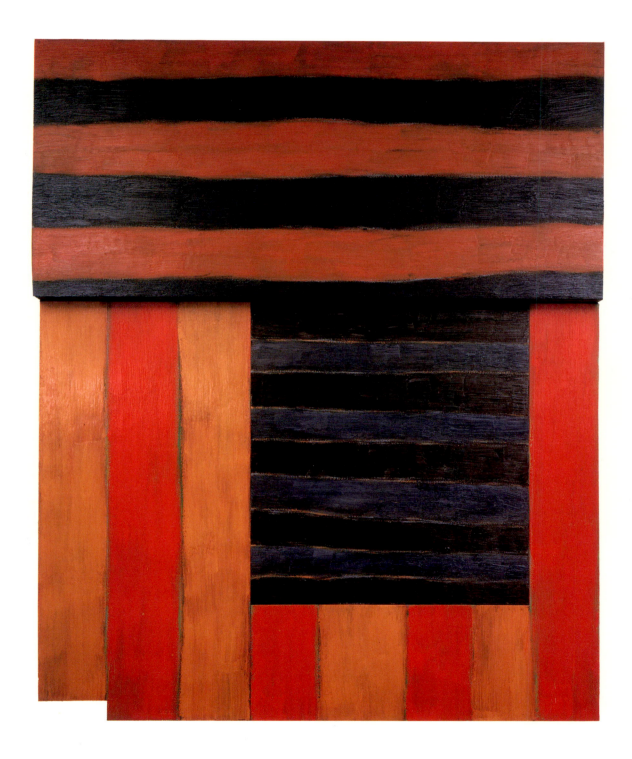

73 Maesta, 1983. Oil on canvas, 96 × 120 inches, Edward R. Broida Trust, Los Angeles.

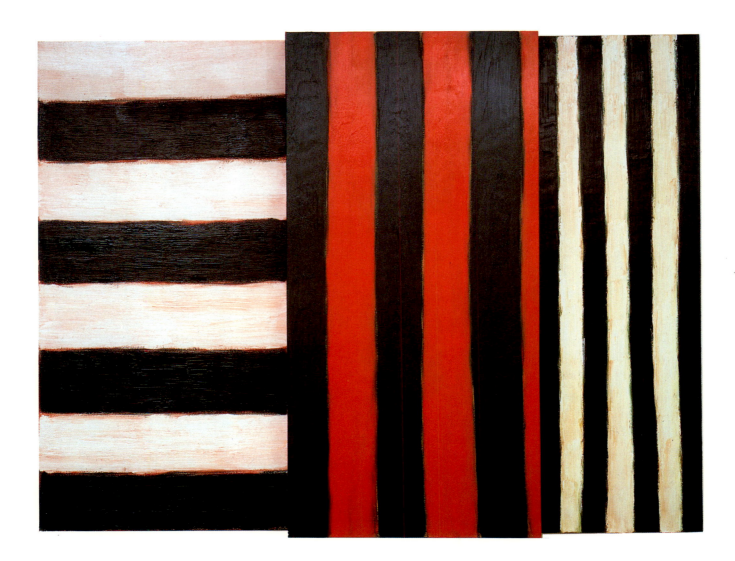

74 The Bather, 1983. Oil on canvas, 96 × 120 inches.

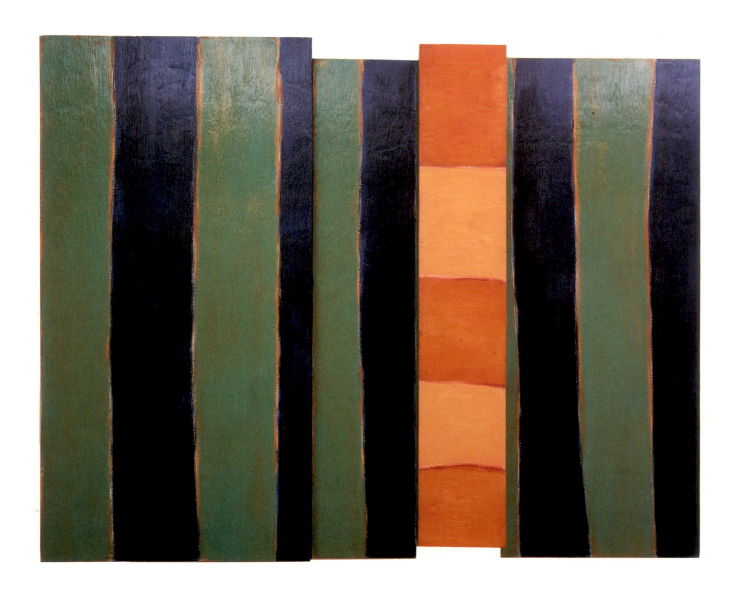

75 Molloy, 1984. Oil on canvas, 96 × 122¼ inches, Metropolitan Museum of Art, New York, Arthur Hoppock Hearn Fund.

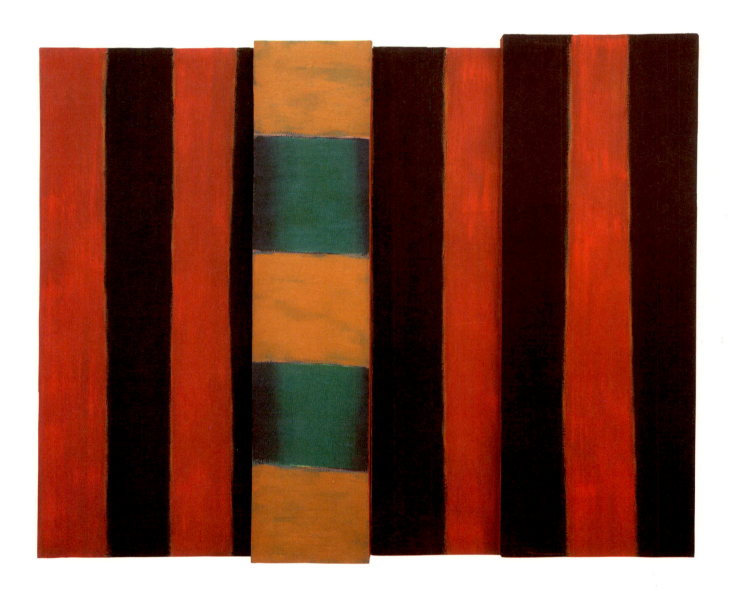

76 No Neo, 1984. Oil on canvas, 96 × 121 inches.

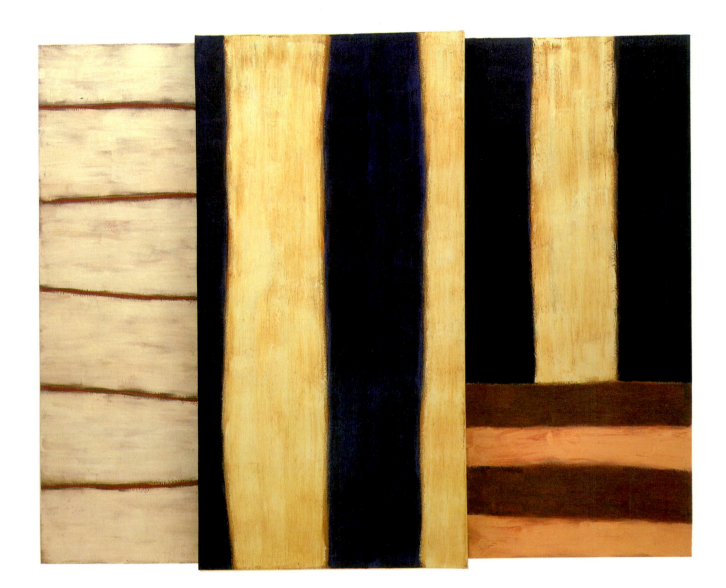

77 Bobo, 1984. Oil on canvas, 24 × 24 inches, Alvin and Barbara Krakow, Boston.

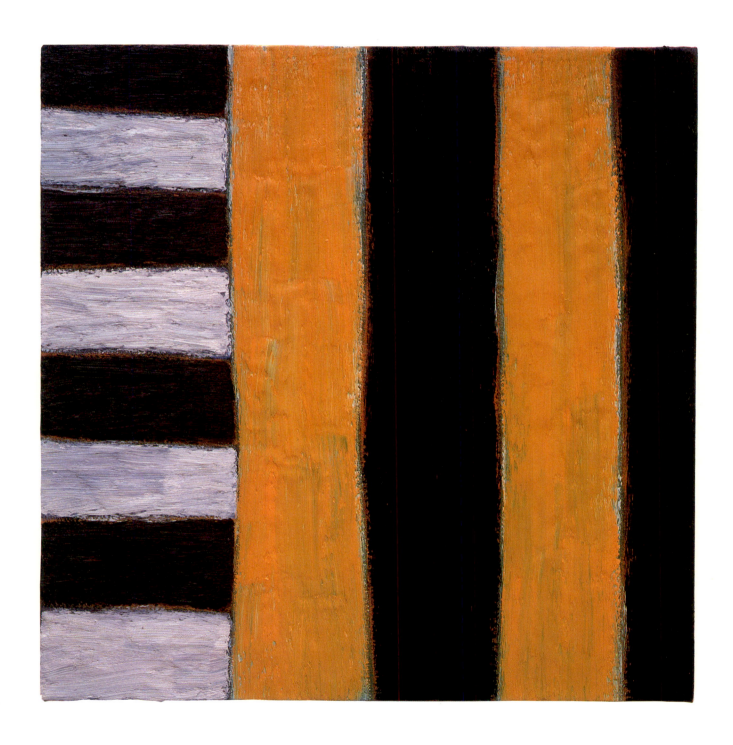

78 Westray, 1984. Oil on canvas, 24 × 24 inches.

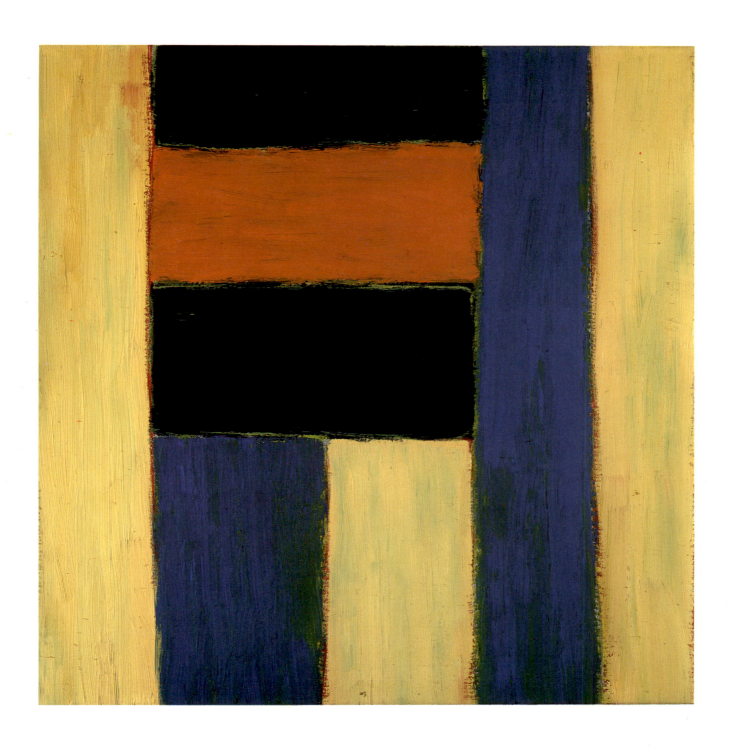

79 Stroma, 1984. Oil on canvas, 20 × 20 inches.

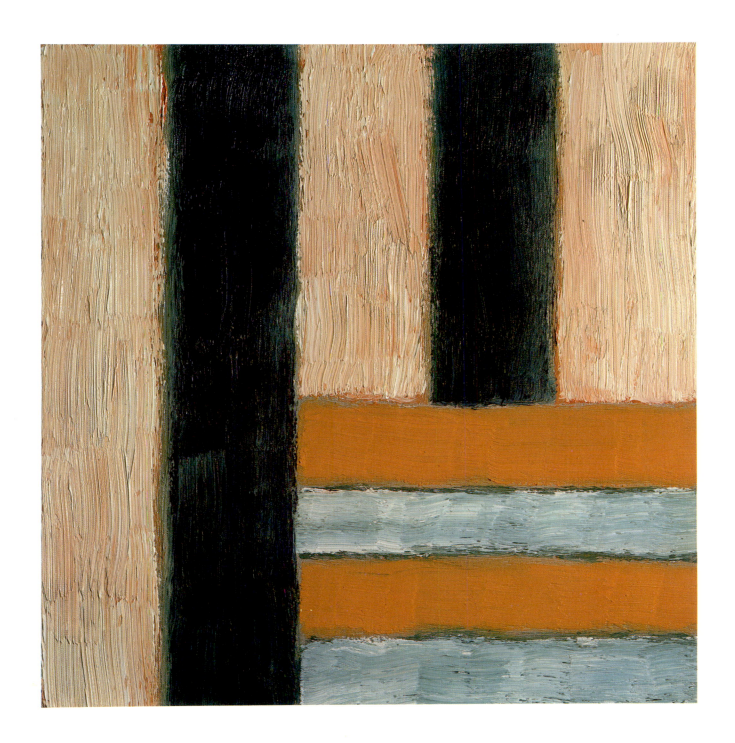

80 Narcissus, 1984. Oil on canvas, 108 × 96 inches, Edward R. Broida Trust, Los Angeles.

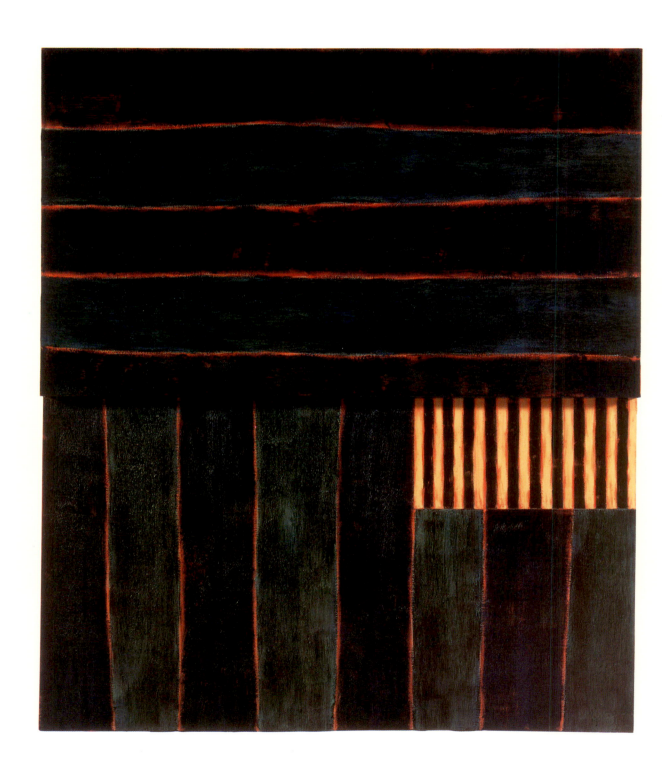

81 Paul, 1984. Oil on canvas, 102 × 126 inches, Tate Gallery, London.

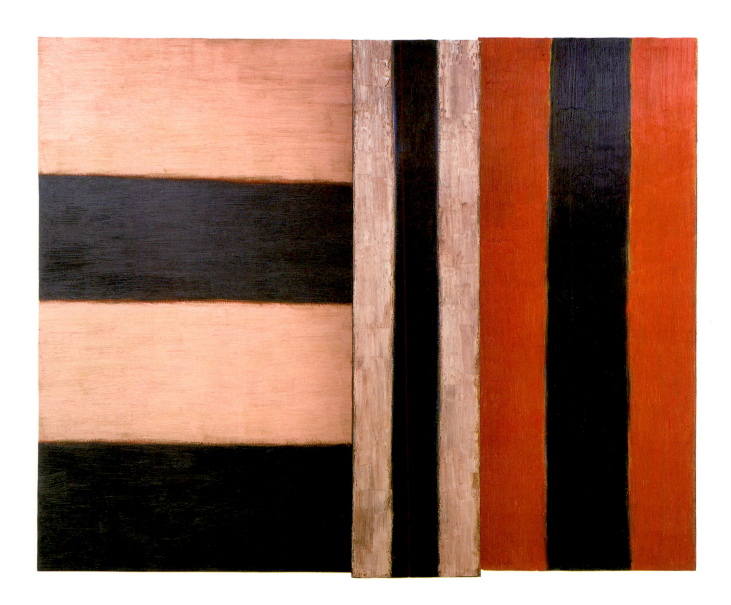

82 Stare, 1984. Oil on canvas, 38 × 60 inches, Jill Ritblatt, London.

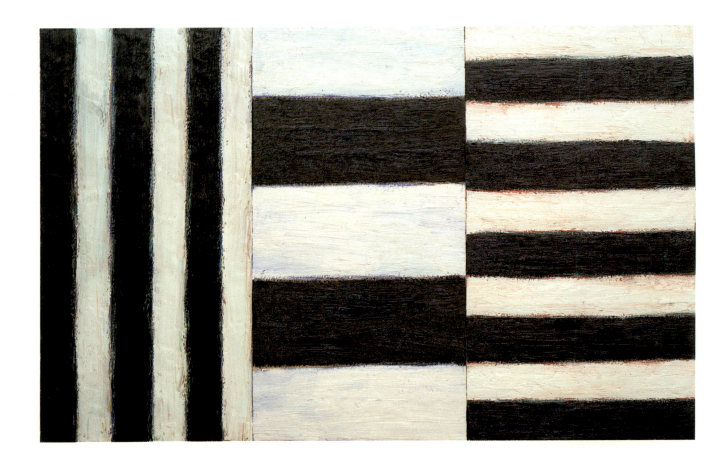

83 Any Questions, 1985. Oil on canvas, 102 × 126 inches.

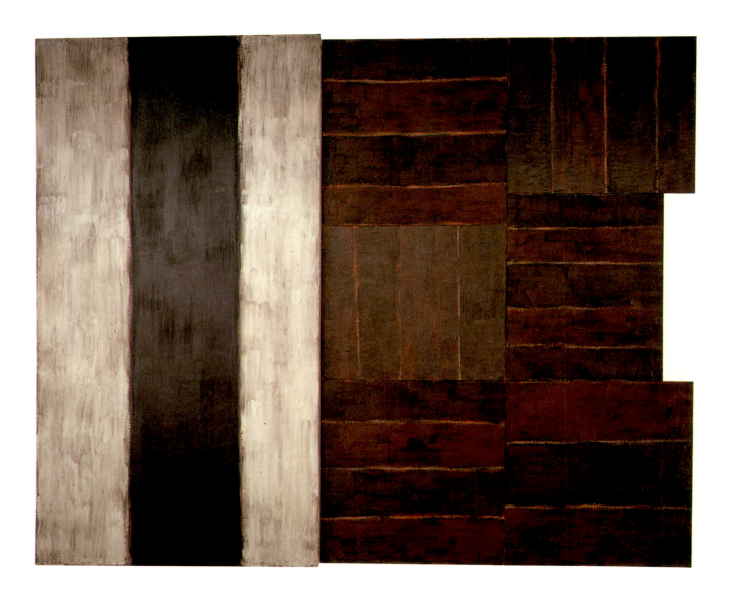

84 Darkness a Dream, 1985. Oil on canvas, 96 × 144 inches, Denver Art Museum.

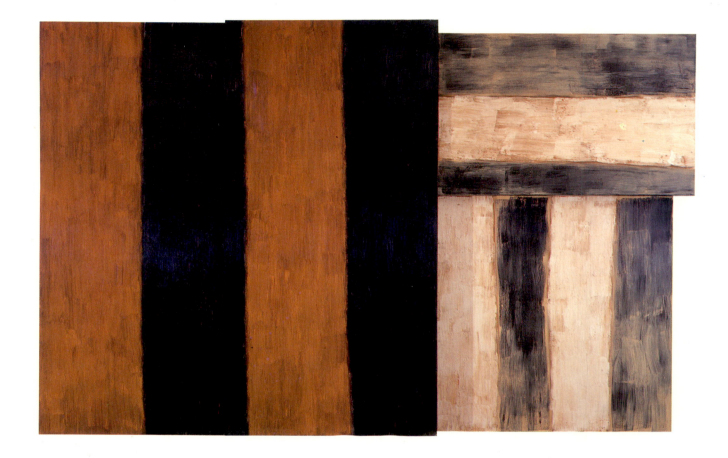

85 Flesh, 1985. Oil on canvas, 96 × 124 inches, Tom and Charlotte Newby, Neenah, Wisconsin.

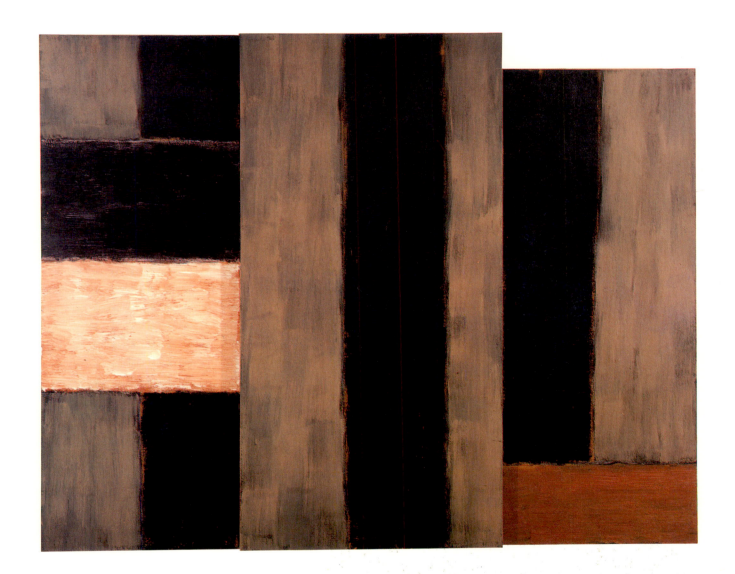

86 Song, 1985. Oil on canvas, 90 × 110 inches, private collection, Pittsburgh.

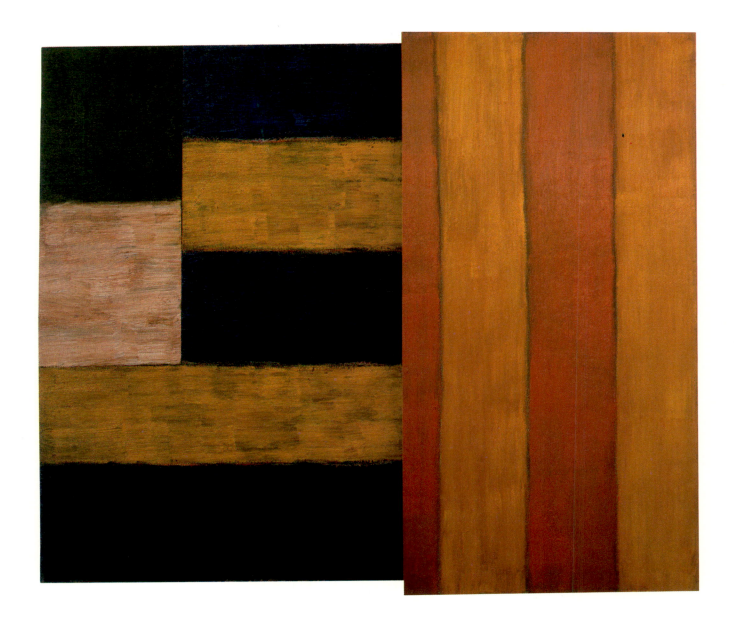

87 Conversation, 1986. Oil on canvas, 96 × 144 inches.

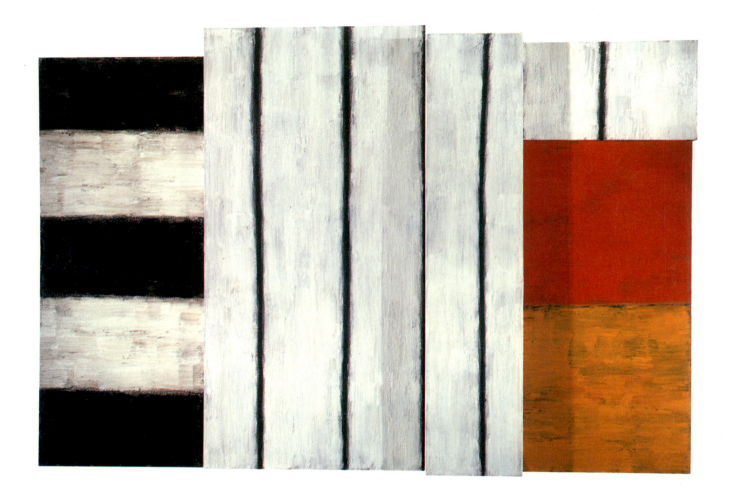

88 Whisper, 1985. Oil on canvas, 96 × 111 inches, collection of the artist.

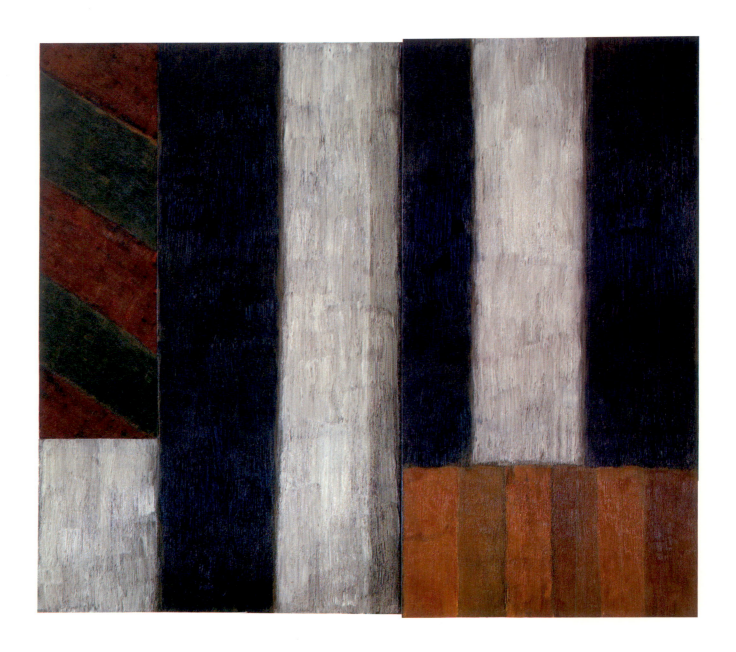

89 Diagonal/Horizontal, 1987. Oil on linen, 47 × 42 inches, private collection, Japan.

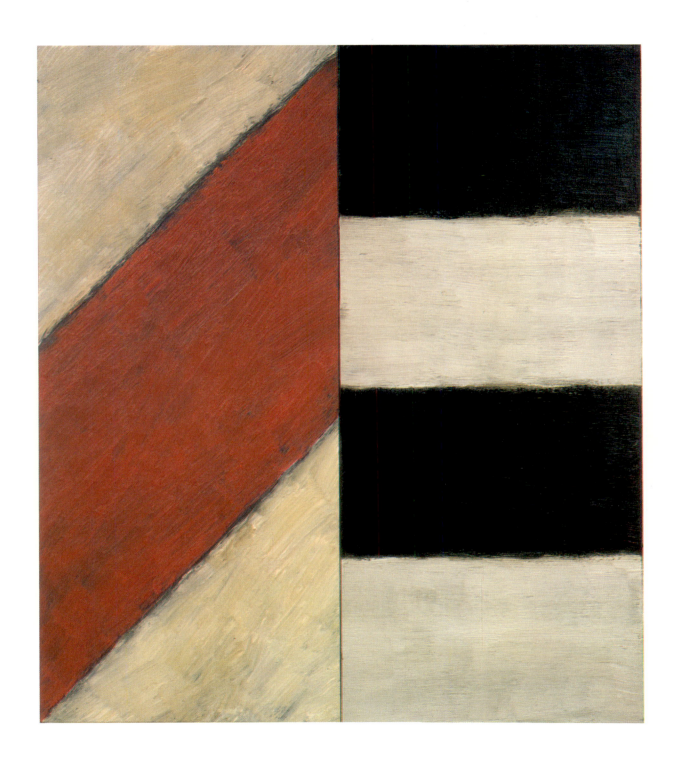

90 Dark Face, 1986. Oil on linen, 112 × 93 inches, Martin Sklar, New York.

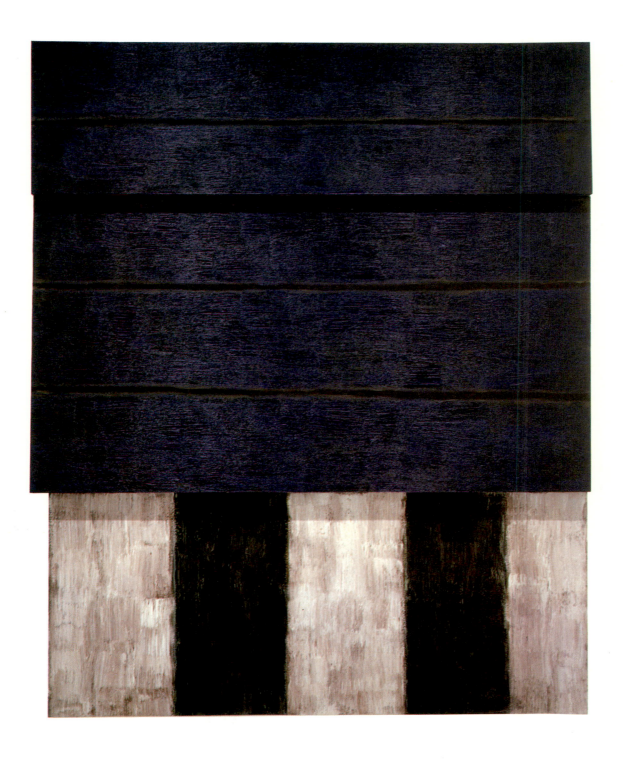

91 Remember, 1986. Oil on linen, 96 × 125 inches, private collection, New York.

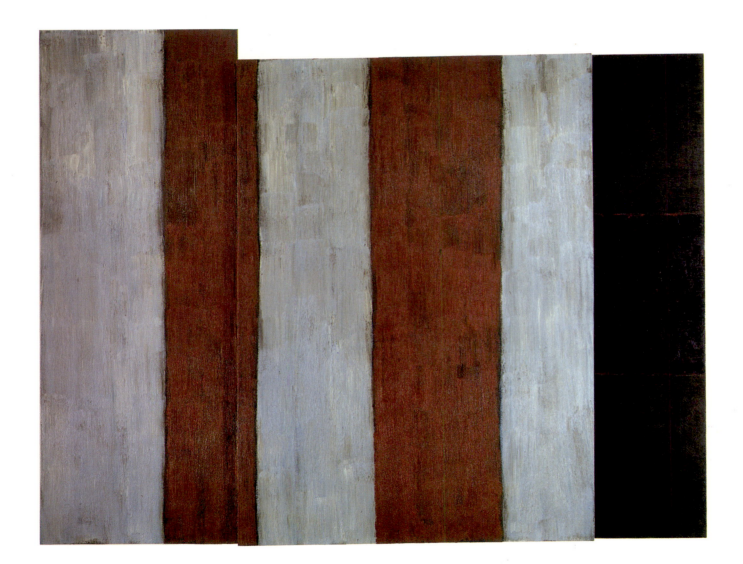

92 Once, 1986. Oil on linen, 96 × 111 inches, Janet Green, London.

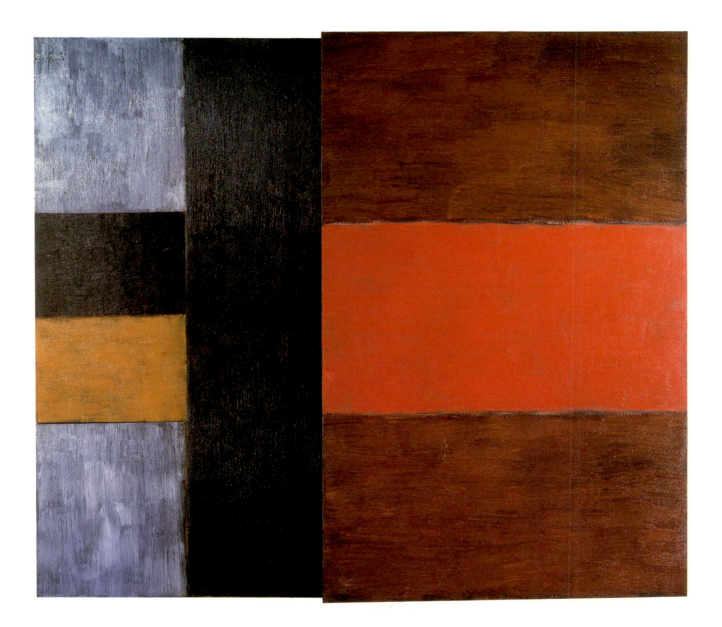

93 Once Over, 1986. Oil on canvas, 60 × 60 inches, private collection, San Francisco.

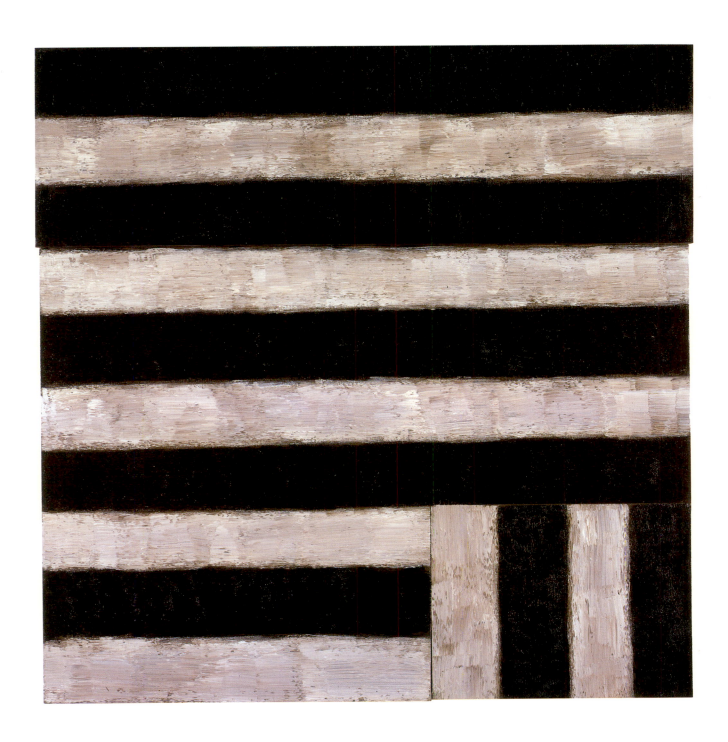

94 Catherine, 1986. Oil on canvas, 96 × 131 inches, collection of the artist.

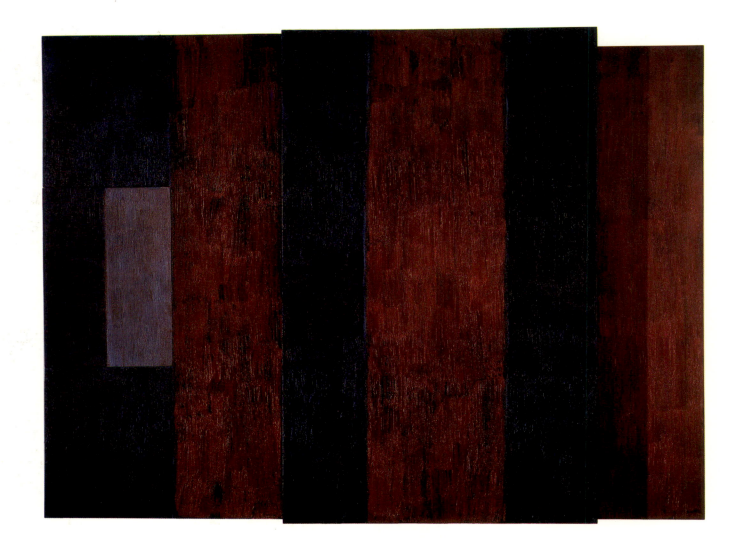

"I'd always wanted to be a painter in the complete sense, and I think it's very important to become expressive in as many media as possible," Scully once said. Particularly in times of stress, turning to the creation of works on paper for expression has been a refuge as well as a source of inspiration. Not that Scully merely adapts ideas taken from his paintings to such works. On the contrary, the idiosyncrasies of these works attest to a highly independent, ongoing creative search. Often the artist can be seen developing compositional thoughts that have no counterpart in his main work. What separates the works on paper more fundamentally from the paintings, however, is their involvement with a different range of expressive possibilities through the manipulation of color, surface feeling, and light. Whether he is creating a pastel drawing, a watercolor, or a print, Scully seeks to exploit the properties of the medium as fully as he can, so as to penetrate to levels of expression specific to the medium and not attainable in painting. These works not only enlarge his oeuvre uniquely; they reveal to us facets of his sensibility that the paintings would not lead us to suspect.

Over the years, Scully has used paper as a support for a variety of purposes, for example, to develop pictorial ideas different from those he was tackling on canvas at the time. Thus, in the early 1970s, he made a group of drawings consisting solely of strips of masking tape. The resultant configurations, highly conceptual in character, possessed a flatness that the artist began only later to cultivate seriously in his paintings. These drawings also anticipated Scully's eventual practice of retaining masking tape in his paintings. On another level, they provided the matrix in which the uniquely moving "Change" drawings were later developed (see chapter 1).

In the later 1970s Scully created a number of compositions on paper with gouache (see nos. 95 and 96) that complemented his austere paintings of the period. Gouache has the unique advantage of concealing brushwork; hence its wide use in graphic art. The artist exploited this feature to arrive at images in more rigorous harmony with the severe nature of the compositions than oil or acrylic would have permitted.

Scully's apprenticeship as a printer and a graphic designer (see chapter 1) proved to be a valuable asset. In the commercial print shop he had learned how to set type and how to run the presses, in addition to designing advertisements and layouts. In art school he furthered his familiarity with printing processes, experimenting with silkscreen, lithography, and etching. Although he admits that lithography can be beautiful, he has not so far used the process professionally. "When I experimented with it, I found it very temperamental and it irritated me," he explains. Control is obviously important to him.

But more important still is that Scully needs to feel a special relationship with the medium. "It's like a sexual relationship," he says. "You have to push it, but you can't push it where it doesn't want to go. If you can't bend to it, you are going to get something dead. You have to be flexible. You can't say, 'Okay, it's going to be like this or it's going to be like that.' It will influence what you can do, and you will influence what it can do. If that happens, you can get something really wonderful."

Nowhere is this intimacy of contact more in evidence than in Scully's pastels. Some, like *9.26.87* (no. 97), have a furry quality so pronounced as to invite caressing. In others, such as *9.11.88* (no. 98), Scully exploited the unique luminous properties of the medium to create hazy and sketchy vertical stripes that function like walls of light. Here, as in most works he executed in this medium, the thickness of the pastel is used to create textures of varying character.[1]

Until 1980, Scully had made use of watercolor very sporadically. A trip to Mexico at that time inspired him to do a group of such works and, since then, the medium has remained a favorite. The artist became fascinated by the congeniality of the medium with the effects of nature, especially bright sunlight. The watercolors he did on that occasion still stand out in his memory. "They were very much about collaborating with sunlight," he says, adding that he actually used the sun to dry them

quickly. For Scully, a main attraction of the medium of watercolor is that it requires minimal physical effort and is a welcome antidote to the athleticism needed for the creation of a painting. The colors also emerge as more luminous and transparent than is the case with oil, thus providing the artist a field of experimentation with its own specific challenges (see, for example, *4.30.87* and *5.8.87;* nos. 99 and 100). "I use the light that can be drawn out of the white paper to give the watercolors a kind of energy that the paintings are not able to achieve," he says. "They are really like studies in light."

Scully's ventures into printmaking since his student days have so far included etchings, woodcuts, and monotypes.[2] Among those that retain his signature most assertively are the color etchings such as *Square Light 1* and *Square Light 2* of 1988 (nos. 101 and 102). In these two examples the scratch marks are so forceful as to evoke the brushwork in the artist's paintings. *Square Light 1* was actually preceded by the painting *White Light* (no. 126), whose composition it basically repeats, and comparison of the two works is instructive. While the painting suggests both intimacy and warmth, the rawness of the colors in the etching is a compelling description of a frozen world. It is almost possible to feel the resistance of the metal plate into which the design was etched. If it can be said of Scully's pastels that they invite caressing, the opposite is true of these etchings. Their appeal lies in their esoteric character, as if we were being given a glimpse into the structural makeup of a distant planet. Others, in contrast, such as *Room* (no. 103), are much softer, with faint streaks that glow mysteriously, evoking the craggy forms in Clyfford Still's paintings.

A main concern of Scully's in the creation of woodcuts has been that they should not resemble traditional ones, especially those of the German Expressionists. To this end, he has taken a number of steps such as printing the layers of color wet onto wet, instead of waiting for each color to dry. The results re-create the surface texture of wood in a highly unusual way. In *Standing I* (no. 104) and *Conversation* (no. 105) of 1986, for example, the compositions, which relate to Scully's paintings of the period, seem to be made of old weathered boards left to bleach in the sun. The evocation of the palpable effects of nature in these works is striking.

In January 1987, during the period when he had stopped painting, Scully went to Santa Barbara, California, where he created a group of monotypes at the Garner Tullis Workshop. The experience proved invigorating and helped him return eventually to his main activity. Collaboration with the printer was close. Tullis suggested the material to work on, which was wood. He also suggested cutting the wood into units that could be interchanged proportionately. Once this was done, Scully went to work, using oil paint. A main interest of these monotypes lies in the way light is made to emanate from the individual color planes. Some, like *Santa Barbara 28* (no. 106), suggest panels of frosted glass, an impression all the more vivid here because of the inclusion of two short horizontal stripes of solid color. The effect was achieved by printing a coat of white paint over the previously printed dark ground and allowing this ground to filter evasively through the white paint. In other works of this group, such as *Santa Barbara 22* (no. 107), Scully relieved the dark tonality of the composition by a bright stripe (here a sunny yellow) that resonates like a bell. Even when the composition and color scheme closely correspond to those of a painting, for example *Santa Barbara 31* (no. 108), compared with *Nostromo* (no. 113), the impression is of greater purity and freshness, as if a screen had been lifted, allowing the air to flow through. The colors seem to breathe with a new freedom, as if the heaviness inherent in the density of oil paint had been eliminated in the printing process.

NOTES

1 Scully describes the process of building up the material as follows: "Pastel is like putting makeup on. There is this dust on the paper, which I rub in. I push it right into the paper with a piece of cloth or paper. Once it's embedded into the surface, I fix it. And then I work it up, adding a layer, fixing it, adding another layer, fixing it again, and so on until the pastel starts to stand up a little from the paper. At a certain point, if you keep pushing, you start taking it off. So you have to give in."

2 Scully's enthusiasm for printmaking was strengthened when he viewed the Jasper Johns "Print Retrospective" at the Centro de Arte Reina Sofía in Madrid in 1987 (the exhibition had originated at the Museum of Modern Art in New York the previous year). "When I saw that show, I became aware that it was possible to make prints that were complex and very beautiful, and totally connected to the sensibility of the artist," he says. Johns's leading role in expanding the significance and possibilities of printing processes is by now well known. As Riva Castleman wrote in her introduction to the catalogue of the exhibition just mentioned, "...there is little question that Johns has contributed more, qualitatively, than any living artist to the printed form of art." See *Jasper Johns: A Print Retrospective* (New York: Museum of Modern Art, 1986), p. 11; see also the review of this exhibition by Maurice Poirier in *Artnews* (September 1986), p. 119.

95 Untitled, 1976. Gouache on paper, 12 × 12 inches.

96 Untitled, 1976. Gouache on paper, 12 × 12 inches.

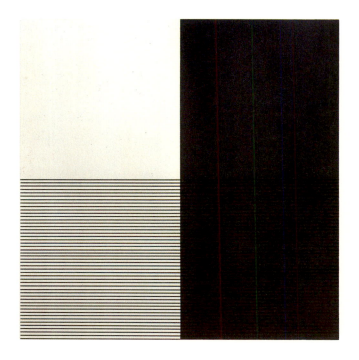

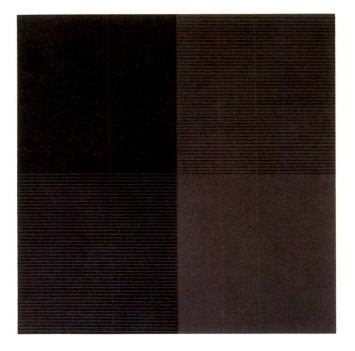

97 9.26.87, 1987. Charcoal and pastel on paper, 22¼ × 29½ inches.

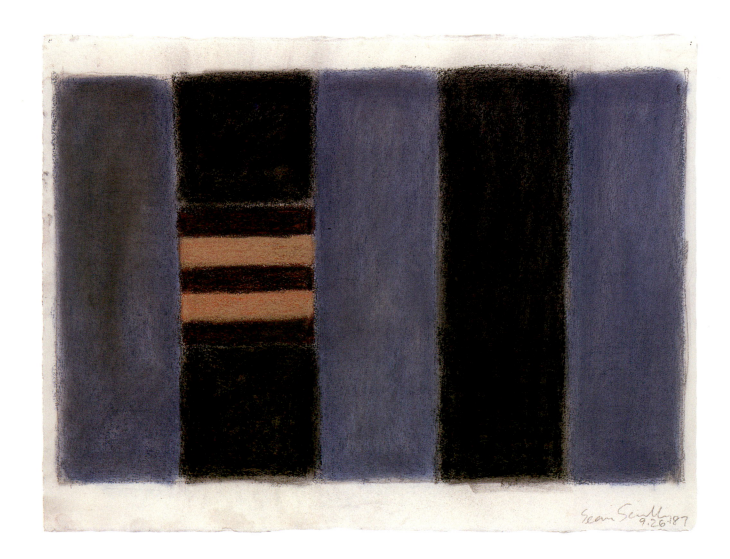

98 9.11.88, 1988. Pastel on paper, 30 × 40 inches.

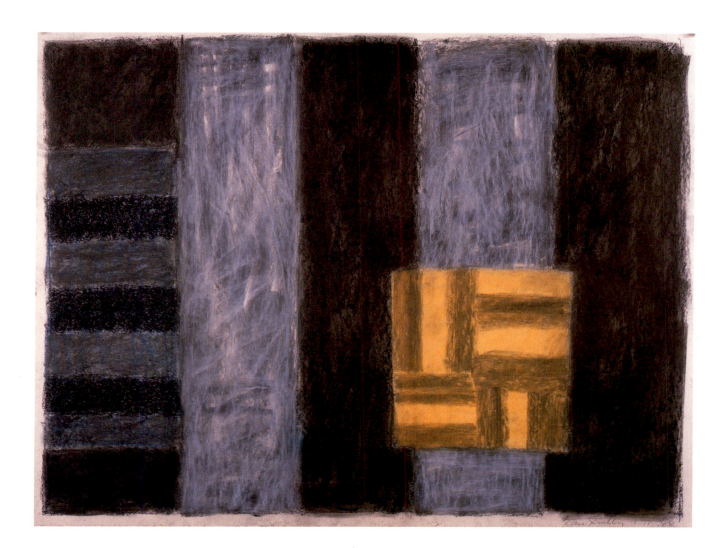

99 4.30.87, 1987. Watercolor on paper, 16 × 12 inches.

100 5.8.87, 1987. Watercolor on paper, 16 × 12 inches, collection of the artist.

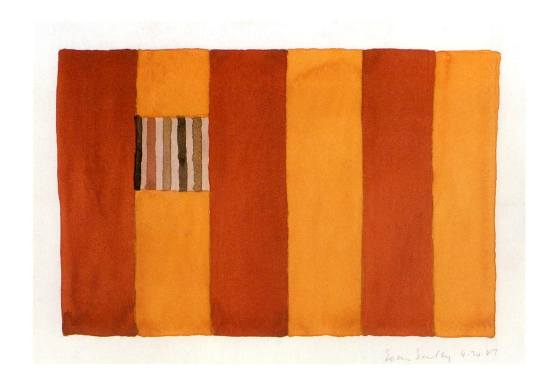

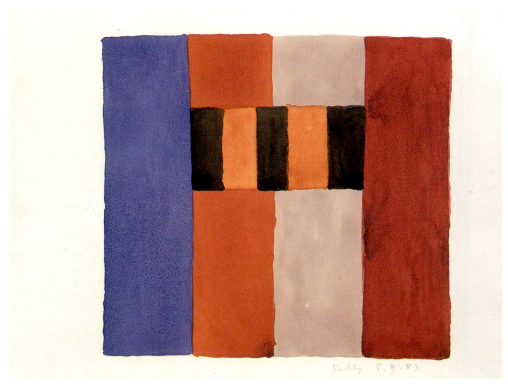

101 Square Light 1, 1988. Aquatint on paper, edition of 25, 34 × 30½ inches, published by Crown Point Press.

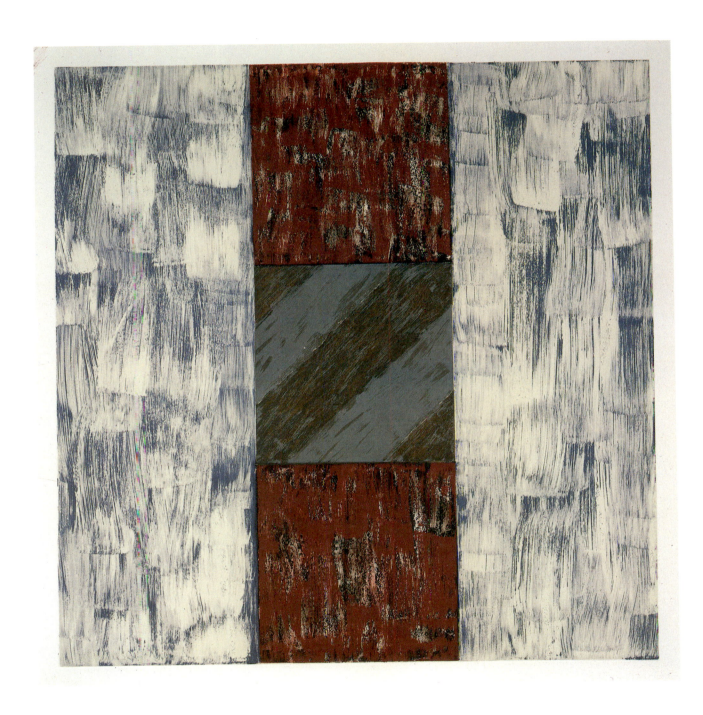

102 Square Light 2, 1988. Aquatint on paper, edition of 25, 34 × 30½ inches, published by Crown Point Press.

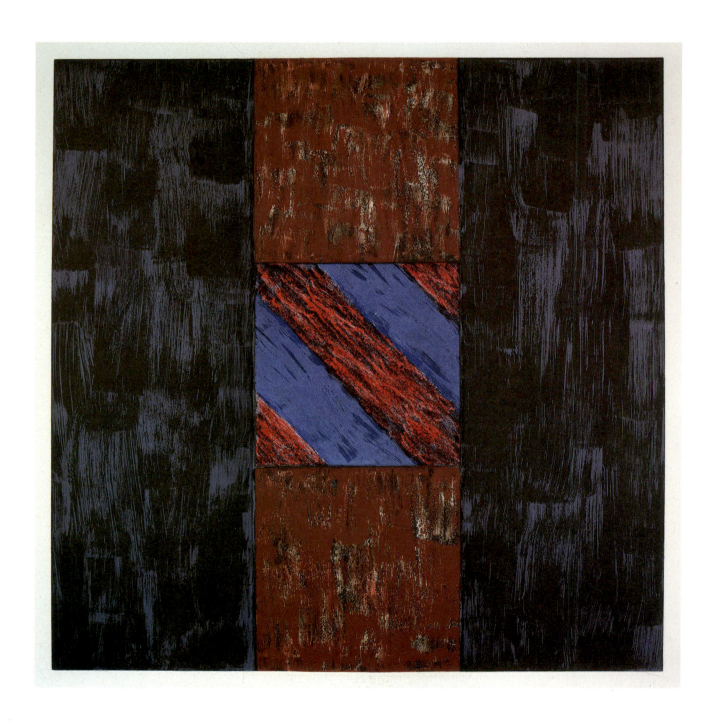

103 Room, 1988. Color etching, edition of 40, 42 × 51 inches, published by Crown Point Press.

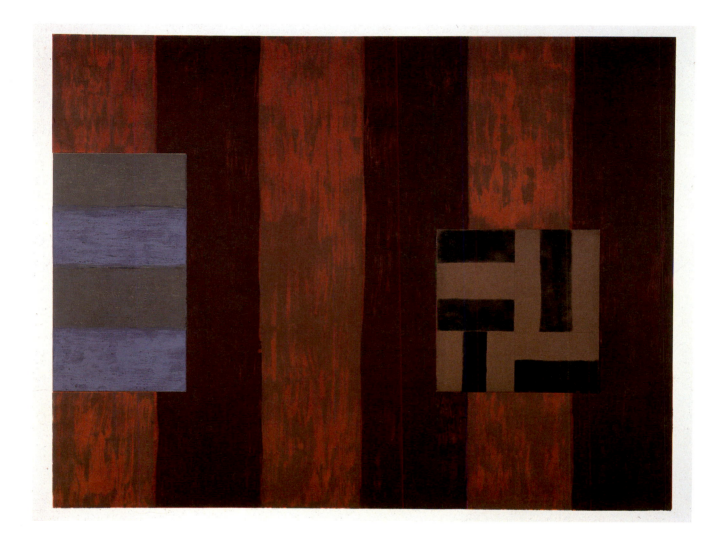

104 Standing I, 1986. Color woodcut, edition of 35, 51½ × 36¼ inches, published by Diane Villani Editions.

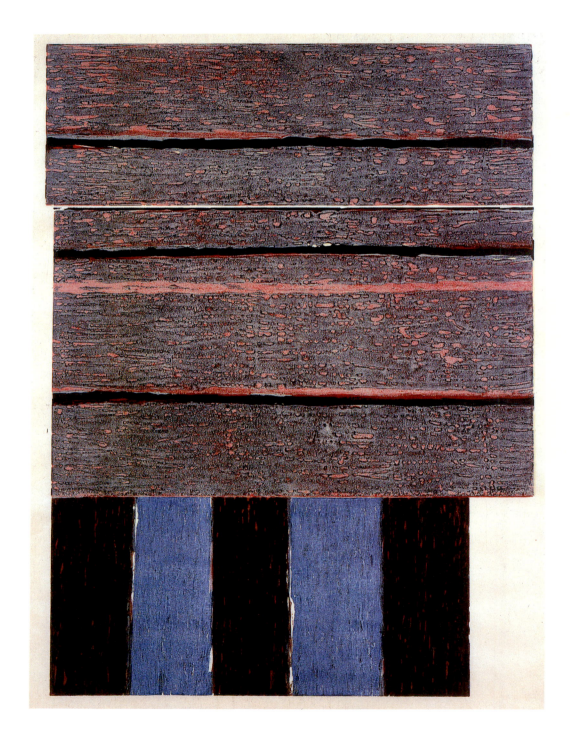

105 Conversation, 1986. Color woodcut, edition of 40, 37¼ × 53½ inches, published by Diane Villani Editions.

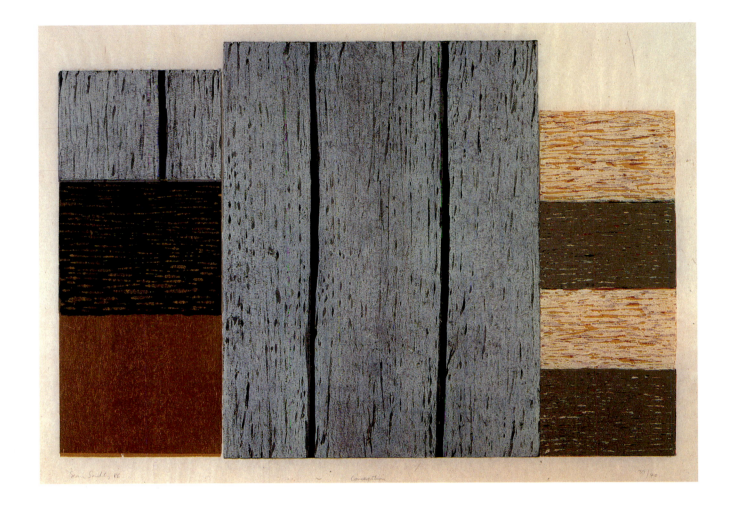

106 Santa Barbara 28, 1987. Monotype, 42 × 55 inches, published by Garner Tullis Workshop, collection of the artist.

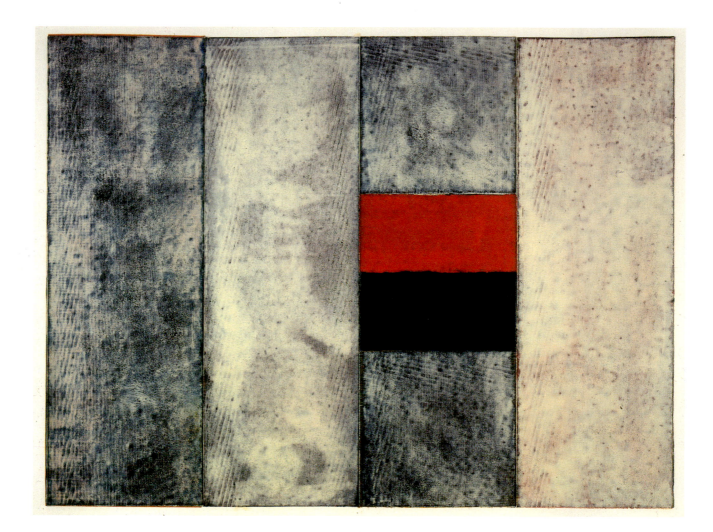

107 Santa Barbara 22, 1987. Monotype, 42½ × 55 inches, published by Garner Tullis Workshop.

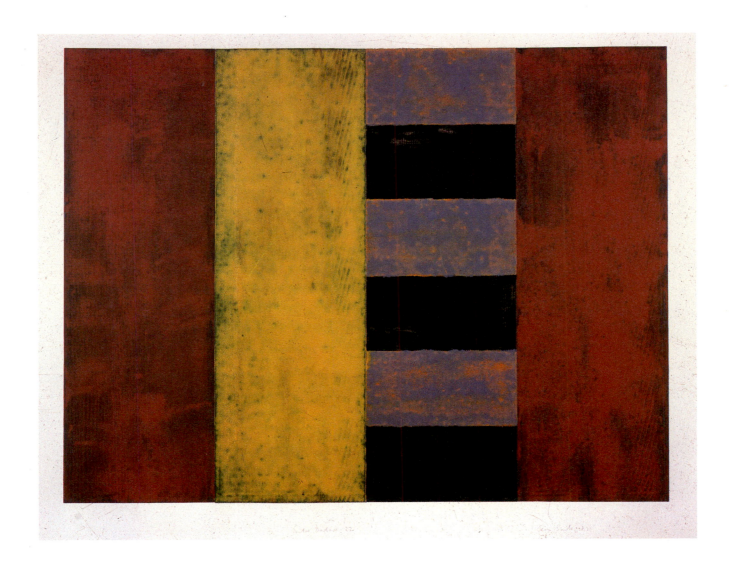

108 Santa Barbara 31, 1987. Monotype, 42½ × 55 inches, published by Garner Tullis Workshop.

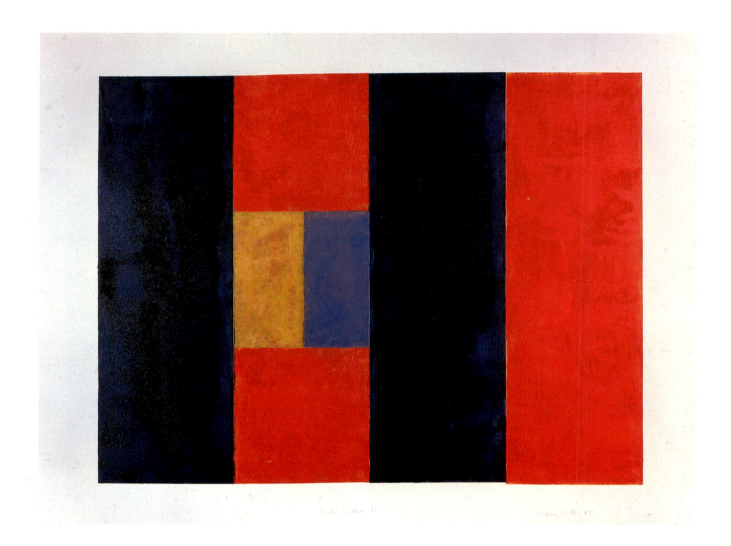

Scully's ability to persuade himself that life is, after all, worth living is evidenced in his title for the work that marked his return to painting in early 1987: *A Happy Land* (no. 109). Not that the work recalls the carefree exuberance of *The Bather* (no. 74). The artist says, in fact, that the painting is about "a land that doesn't exist." But in the context of his preceding paintings it certainly conveys tranquility, order, and even comfort. Somehow one feels the lingering glow of Scully's brief sojourn in California. Essentially the composition consists of a square within a square, a format whose passivity, here, seems quite in harmony with the interlocked verticals and horizontals within. Scully was obviously concerned also, in painting the edges of the large stripes, that they be adequately precise and straight, without fluctuations. We notice how drastically the brushwork has been tamed and how its quietness contributes to the overall serenity of the painting.

An additional element of significance in *A Happy Land* is that it is physically flat. Gone are the components projecting into the viewer's space. With a single exception,[1] all the paintings Scully was to make in this new phase were to be in a planar mode, as the artist sought to adapt the lessons learned in three-dimensional compositions to a two-dimensional surface. The triggering event behind his decision may well have been his recent experience with monotypes, since their creation had reawakened him to both the challenges and the virtues of working two-dimensionally. But concerns having to do with expressiveness seem to have played a more pivotal role: "I needed my work to grow, to be less overtly physical and more intensely emotional and psychological," he says.

A major component of Scully's new paintings, as exemplified in *A Happy Land*, was to be the inset panel located within the composition rather than at the edge of it. Whether square or rectangular, and whether by itself or in combination with one or more other such units, the inset was to provide the artist with a compositional means of great flexibility as well as pictorial eloquence. Its independent existence meant that it could be painted separately, enabling the artist to finish its edges without having to ponder over how to link them with the edges of the field around it, a perennial problem in pictorial design. For the imagery, stripes of dimensions and coloring different from those in the rest of the work would be used, thereby isolating the inset and enabling it to generate its own expressive tension. It would appear that Scully, deeply shaken by the turmoil of 1986, turned with a new fervor to the motif that had been tantamount to his muse all along—the stripe—assigning to it, in this intimate and independent format, a new prominence and a new role, as if seeking to extract from it a renewed life current.

The results proved to match the artist's expectations. As we have come to expect from him by now, however, there would be no consistency in the moods evoked, not even during that first year after his return to painting. As much as *A Happy Land* speaks of contentment, *Empty Heart* (1987; no. 110) takes us into a world of sadness and sorrow. One of the most powerful works created by Scully, it brings to awareness a host of emotional associations. First, there is the feeling of isolation and loneliness, generated in part by the centering of the rectangular inset and accentuated by the inset's being a physically separate unit. (The same image painted onto the matrix would not be as effective.) And here a curious phenomenon comes into play. Such is the motion of the brushwork in the large horizontal stripes on both sides of the inset that it generates a movement toward the inset as well as away from it, thereby contributing further to isolating it. The coloring, too, adds to that effect, being subtly different in the inset from the color of the rest of the work. Throughout the white stripes all around the inset, reddish undertones seep through, as if to allude to eyes swollen from crying. In virtually every respect this throbbing painting lives up to its name. Much of its spirit can be perceived in *Light to Dark* (no. 111); the composition and coloring here conjure up isolation and powerlessness.

Of a very different mood is *Summer* of 1987 (no. 112), a sun-filled painting where we find the inset positioned off-center within a vertical stripe. This compositional idea is reinterpreted in *Nostromo*

(no. 113), a work named after Joseph Conrad's novel. Here intense colors lend a weighty and assertive presence to the design, its vertical thrust enhanced by both the placement of the inset in the upper part of the painting and the multiplicity of small vertical stripes. Neither of these works prepares us for the impact of *Black Robe* (1987; no. 114), however—one of the most haunting of Scully's creations. The painting, whose compositional structure bears affinities with that of *Nostromo*, was inspired by a recently published novel of the same title by Brian Moore. Its subject is a Catholic priest in the seventeenth century who comes to doubt the depth and meaning of his faith. Scully's rendering, which reaches far beyond the novel in its psychological implications, verges on the sinister. Three deep black vertical stripes set the tone. In the upper left, Scully inserted a large rectangular panel whose vertical stripes suggest the bars of a cell—an allusion to the Inquisition, perhaps, or to the highly traumatic experience Scully had with the Catholic Church when he was young (see chapter 1). These stripes are black, too, and they alternate with brown ones that may suggest a monk's habit. The power of the Church and its questionable means of retaining control over people across the centuries seem to be among the themes of the painting.

The recurring use of black and the exploitation of its expressive connotations with such vivid results in Scully's hands comes, in large part, from his familiarity with it. He became intimately acquainted with black while creating his paintings of the late 1970s, and since then he has been able to use it as a color, much as Matisse did. ("Most people use black as a non-color," he says.) At the same time, Scully is well aware of its psychological power: "Black represents the end of the line. When you look at black, you are looking at death. The paintings in which I use that color are mostly about the struggle between life and death."

Relatable to this preoccupation with the "dark side" is Scully's compulsive attraction to the imagery and feeling of rough urban environments—an attraction that derives from his having grown up in such environments. In New York, likewise,

the artist has been exposed to a wide range of eccentric images that have fed his imagination: for example, plywood sheets nailed on construction sites, boards patching up broken windows in deteriorating buildings, and steel plates casually covering holes in streets and sidewalks. Since 1978 the artist has made frequent trips to Mexico, where odd structures such as shacks built of discarded fragments always captured his attention. In the past few years, he has photographed such configurations (see figs. 6 and 7).

To a large extent, the peculiar rugged look of so many of Scully's compositions reflects his own personality, but it may also be interpreted as reflecting his attraction to the kind of imagery and environment just described. More specifically, the beat-up look of his paint surfaces that we have noted may be viewed in this light. Often the impression is of the paint being slapped on defiantly rather than being given methodical application. Likewise, the edges of his stripes can present the impression of having been smeared roughly into place. The placement of insets in arbitrary spots within his compositions should also be mentioned here.[2] Indeed, the constant sight of architectural patches out of alignment with their surrounding area in the New York landscape eventually led Scully to adapt this idea to his work. It meant allowing the painted inset to trespass into the territory of adjacent stripes rather than aligning it neatly with them.

In *Catherine* of 1987 (no. 115) two such insets dominate the lower part of the composition, each very different in design and color. Because of the painting's verticality, they seem to float; the impression is reinforced by the horizontal partitioning of the inset on the left, which suggests a waterline. There is a buoyancy about this painting that is remarkable, as if the laws of gravity were being defied. The coloring has also become more exotic and daring, suggesting that the novel arrangement of the work stimulated Scully to probe new possibilities in that regard.

In a related vein is *Us* (1988; no. 116), a painting in which four insets stand like islands. All are similar in design but differ in shape and orientation,

one darker in tone than the others. Scully views the peculiar tension of the painting as being about "all of us, people. Things don't quite come together . . . and I wanted the painting to reflect that strangeness." The conflicted character of the work emerges more eloquently still when it is compared with *Backwards Forwards* (1987; no. 117). Here, also, four insets are involved but symmetry prevails, imparting to the composition a severe hermetic quality. On the whole, the painting speaks of silence and renunciation. Yet the rich, somber coloring—deep brown and very deep burgundy for the main panels, black and white for the insets —seems to allude to something intangible and intense: spiritual commitment, perhaps. As an abstract icon, the work would suit the context of a monastery perfectly.

The variety of subject matter in Scully's paintings of any given year is particularly well illustrated in his output of 1988. While the artist continued to create works of striking unity and balance, this is also a year in which we observe him becoming increasingly restless with the notions of refinement and self-contained composition, a condition that would intensify in 1989. The perception of the canvas as an arena for venting one's conflicting needs and emotions likewise becomes more assertive. In *Battered Earth* (no. 118), whose composition derives from *Empty Heart* (no. 110), diagonal stripes at right angles with each other generate a spiraling movement within an inset that suggests energy struggling to free itself—an impression reinforced by the scruffy look of the paint handling around it. As a totality, the painting brings to mind a number of figurative works embodying a similar concept, chief among them Michelangelo's sculpture of the *Rebellious Slave* (or *Bound Slave)* in the Louvre in Paris. In *Green Gray* (no. 119), on the other hand, the storm has subsided. The small stripes have resumed their horizontal

Fig. 6
Photograph by Sean Scully:
Mexico, 1987

Fig. 7
Photograph by Sean Scully:
Oaxaca, Mexico, 1988

and vertical positions, the coloring has been toned down into smoky and golden hues, and a dreamy, exotic aura tinged with nostalgia flows from the composition.

Scully's interest in establishing a dialogue between the two halves of a painting resurfaces in *Without* (no. 120). Here a dark-toned inset on the left seems to be pulled toward the right side, much as nails are drawn to a magnet. This visual impression results not only from the color concordance—the stripes are of the same color and intensity—but from the slanting of the stripes in the inset toward the right. The painting is a good example of the way in which diagonals can foster unity while generating tension.

A different kind of dialogue is established in *Between You and Me* (no. 121). Here an inset on the left includes stripes so laid out and colored as to generate a circular movement within, vaguely recalling the ancient swastika motif. A wooden

frame emphasizes its isolation. Metaphorically the image suggests contained, or trapped, energy. Separated from it by an enormous, pierlike black stripe, a second inset stands tall and stable, suggesting someone in a "noli me tangere" pose or, alternatively, in a perversely laid-back stance. Is this a portrait of a relationship?

In contrast, a painting that does not seem to be about anything but itself is *Big Land* (no. 122). The authority with which the composition unfolds laterally (it is over thirteen feet wide), while being solidly anchored along multiple vertical axes, is indeed astonishing. The title was assigned, in fact, because of the sense of ponderous expansion suggested. This is one of those rare works in any artist's oeuvre wherein every element works in unison: the color, the composition, the diagonally striped inset. Not only does the inset help to draw the components together, but its imagery and coloring provide the exact amount of visual activity

needed at that point in the composition to prevent the ambitious lateral expanse from sagging. In its awe-inspiring monumentality, the painting so far remains unique among Scully's creations.

In 1987 Scully had made a painting titled *Inside* (no. 123), where an inset forces itself deeply inside the vertical panel on the left. *Counting* (1988; no. 124) is a reinterpretation of this theme. A main difference is that here the inset is colored more intensely than its surroundings, while the opposite held true for *Inside:* the field was more assertive and the inset's colors more subdued. Instead of originating within the composition, the inset in *Counting* begins at the edge, which imparts more aggressiveness to the thrust. To pass from this painting to *A Bedroom in Venice* (1988; no. 125) is to move into another world. Here all is poetry, lyricism, and romance, as the artist adapts the idea of levitating insets to images taken from the Venetian landscape. Nature seems to have suspended its laws in order for us to share more spontaneously in the intimacy of the experience. Dark tones have been banned; light travels across the surface unimpeded. The feeling is of the magic of the blue sea, that time is of no concern, that everything we need is here. A famous passage in Charles Baudelaire's poem "L'Invitation au voyage" is evoked vividly:

> Là, tout n'est qu'ordre et beauté,
> Luxe, calme et volupté.[3]

Two other works of 1988 relate in spirit to *A Bedroom in Venice*. *White Light* (no. 126) takes up the conception of *Light to Dark* of the previous year (no. 111) and transforms it into a vehicle of poetic expression of a very different kind. Warm colors have replaced the cold tones of the earlier work, and diagonal stripes in the inset somehow generate a subtle tremor. The imagery of the work as a whole suggests a flame kept alive in a sacred temple. More overt in its evocative power is *Pale Fire* (no. 127), a composition in which three bright red stripes set against a white ground may well stand for burning desires. A dark-toned inset could then be interpreted as alluding to difficulties in fulfilling them, but the upward thrust of its

shape, together with that of its stripes, seems to argue against rejection.[4]

In *White Window* (no. 128), also of 1988, commotion reappears, in a new disguise. Instead of traveling in one sweep from top to bottom or from side to side, as was the norm until then in the main field of Scully's paintings, stripes have literally broken loose. They begin at the top on a vertical axis, then suddenly their course is interrupted by horizontal stripes, and they may or may not be given another chance of reasserting themselves vertically. Their width also varies substantially. No clear program may be discerned. The inset, which has many of the characteristics of a window, adds to the turmoil by being painted much more sketchily and energetically than the rest of the work. Its whitish stripes glow eerily. Scully's evocation of an all-white flag painting by Jasper Johns here is too blatant to be ignored, as if a tribute to the artist was intended. It should be noted also that the clean-cut rectangular shape of the inset provides the only true stabilizing element within the work. All around it, stripes deviate subtly from verticality and horizontality, as if the composition were attempting to deconstruct itself. Scully admits that the painting, which is of striking originality and power, is unreasonable and not quite resolved. "It's uncensured emotion," he says.[5]

In *Why and What (Yellow)* (no. 129) the process of deconstruction discernible in *White Window* has intensified through more abrupt and frequent changes of direction. Several of the stripes are also out of alignment with their neighbors. Of the two insets, one, comprising deep-toned stripes of red and blue, clashes sharply with the impure, or "dirty," yellow and white stripes around it. The other inset is unexpected, although in retrospect maybe it was only a matter of time before Scully would take such a step: positioned on the left side is an actual steel plate whose stained surface is an arrogant violation of the painted picture plane. The painting, whose coloring and texture make it look as though it might have been dragged around the block a few times, seems to comment on the unresolvable conflicts inherent in overpopulated, deteriorating urban areas. In the way the composition

pushes beyond its boundaries on all sides it also brings to mind Jackson Pollock's struggle to rid his work of centralizing compositional elements.

As the year 1989 unfolds, we see Scully move between contrasting modes of expression with greater boldness and intensity. (No doubt a contributing factor is that a high point in his career has been reached: in the spring, a retrospective of his work of the past seven years was held at one of the most respected exhibition spaces in Europe, the Whitechapel Art Gallery in London.) In *Why and What (Blue)* (no. 130) the conflicts of *Why and What (Yellow)* have increased perceptibly, the most discordant element being a rusted steel plate set in the midst of the canvas of yellow and green stripes. The impression created here is of dissonant versus harmonic music translated into pictorial terms. Then we observe Scully compose himself and engage the viewer in a dream world where order prevails again. *Crossing* (no. 131) recalls *A Bedroom in Venice* (no. 125), except that two large, deep-toned vertical stripes now articulate the composition. The brushwork in the insets is more energized, and the smaller of the insets appears to be slipping away.

With *High and Low* (no. 132) compositional turbulence reappears with new strength, like a tropical storm that has gathered momentum from passing over a "dead" zone. The most irreverent of all works created by Scully to date, *High and Low* takes the implications of *Why and What (Blue)* to a new level. Here, while the whole composition (including two insets) is painted, the stripes, in their varied broken forms, behave more strangely than they ever have, generating perplexity and confusion for the viewer. A cluster of four dark stripes, pressed next to each other and framed by darker ones, is so unexpected that one is tempted to view them as conspirators of a coup, planning to overthrow whatever order remains in the painting.

The next two works made by Scully in 1989 are, in succession, *After Life* (no. 133) and *Secret Sharer* (no. 134)—two paintings that aptly bring this survey to a conclusion, for together they sum up vividly the two main traits of the artist personified in the first chapter as Scully the poet and Scully the fighter. Consider *After Life*, a painting in which black and white dominate, a rigorous order is maintained, and serenity prevails. The artist, while painting, could have had his mind turned to a realm where the spirit transcends the flesh and where all conflicts are resolved, and we would not be surprised. In just about every respect, especially in its defiance, *Secret Sharer* is its antipode. Five unruly panels make up the composition, and each one competes for attention. Nothing seems to fit, as if the panels had been shoved into place against their will. There is no dominant point of view. Stripes vary in width, many of them tilted. Everything seems to be in the process of repositioning itself, as happens when someone muscles his way into a subway car already filled. Even the brushwork has become insolent, deviating in several passages from the direction of the stripes. Yet out of this chaotic activity a bizarre beauty emerges. The painting holds up. Coursing through it is an unusually vigorous current of creative energy that no doubt presages a new phase in the artist's development. We are eager to see it.

NOTES

1 *Black Robe* (1987) has a small step built into it.

2 The construction work Scully did in the mid-1970s often involved deciding where a given window would be inserted, thus "preparing" him for his use of insets.

3 Charles Baudelaire, *Les Fleurs du mal* (Paris: Garnier Frères, 1961), p. 58.

4 Scully took the title from Vladimir Nabokov's novel, but says that beyond this, the painting has nothing to do with it.

5 As Carter Ratcliff also noted, "... this white window seems to gather the painting's solidity to itself, leaving the dark stripes in a wraith-like state." See "Sean Scully and Modernist Painting: The Constitutive Image," *Sean Scully: Paintings and Works on Paper 1982–88*, exh. cat. (London: Whitechapel Art Gallery, 1989), p. 18.

109 A Happy Land. 1987. Oil on canvas, 96 × 96 inches, Janet Green, London.

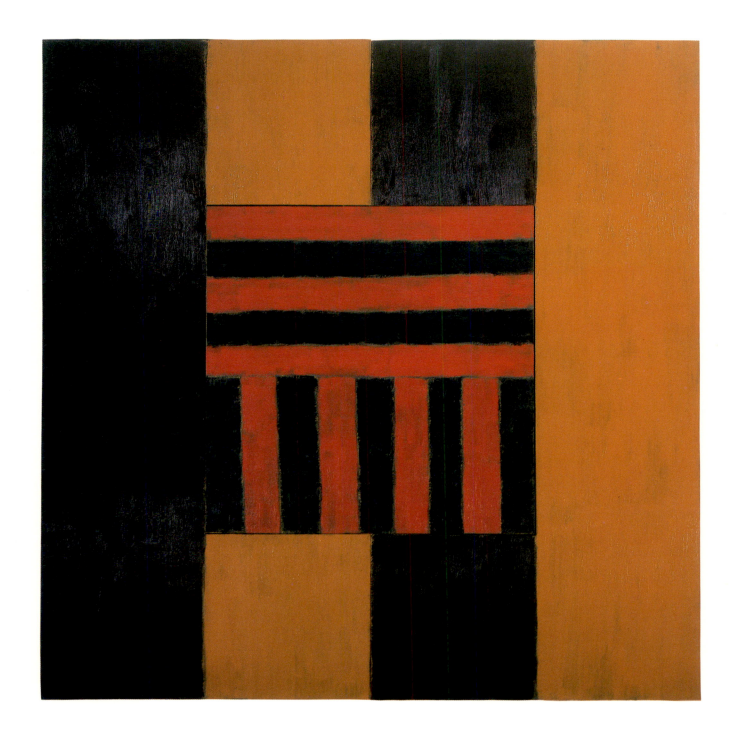

110 Empty Heart, 1987. Oil on linen, 72 × 72 inches.

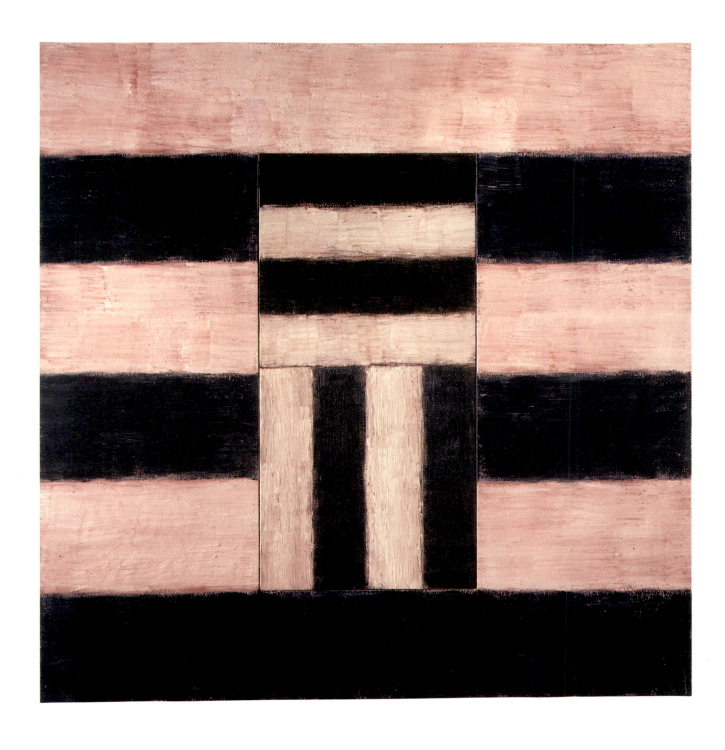

111 Light to Dark, 1987. Oil on linen, 60 × 60 inches, Jamileh Weber Gallery, Zurich.

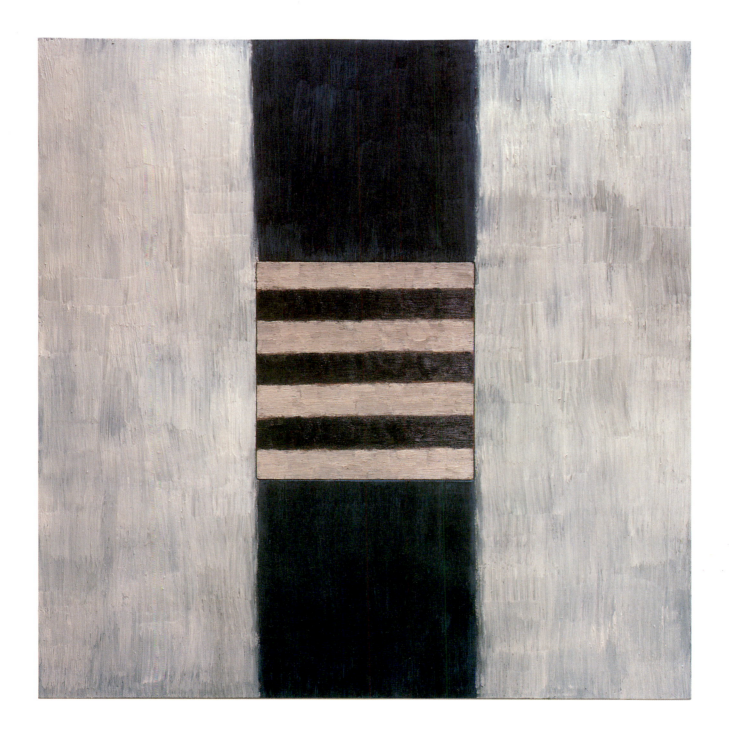

112 Summer, 1987. Oil on linen, 65 × 96 inches, private collection, London.

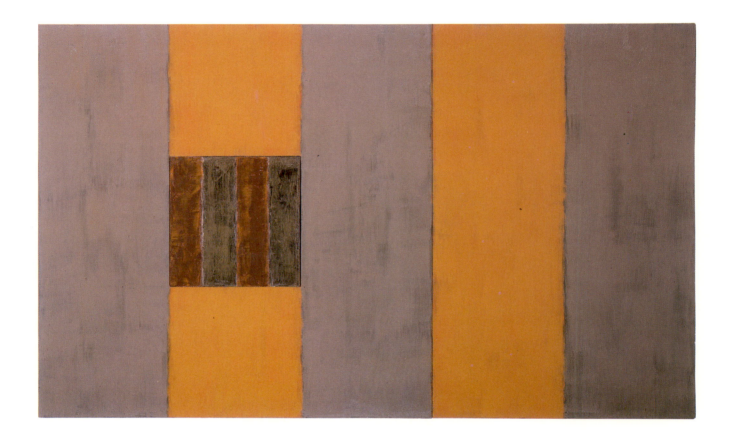

113 Nostromo, 1987. Oil on canvas, 90 × 148 inches, private collection, Switzerland.

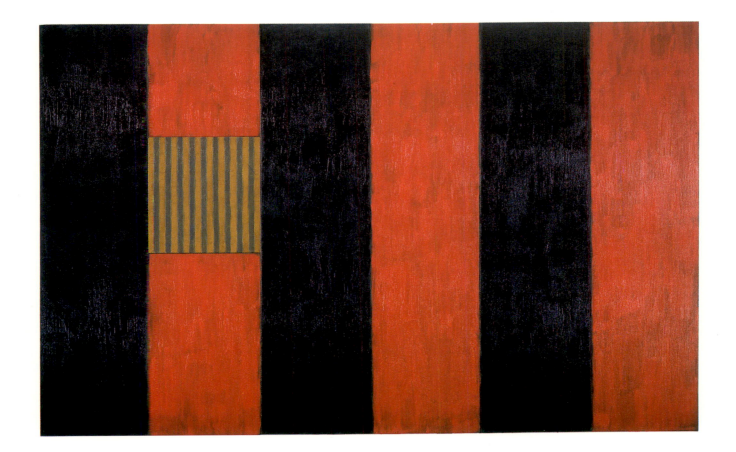

114 Black Robe, 1987. Oil on linen, 100 × 120 inches.

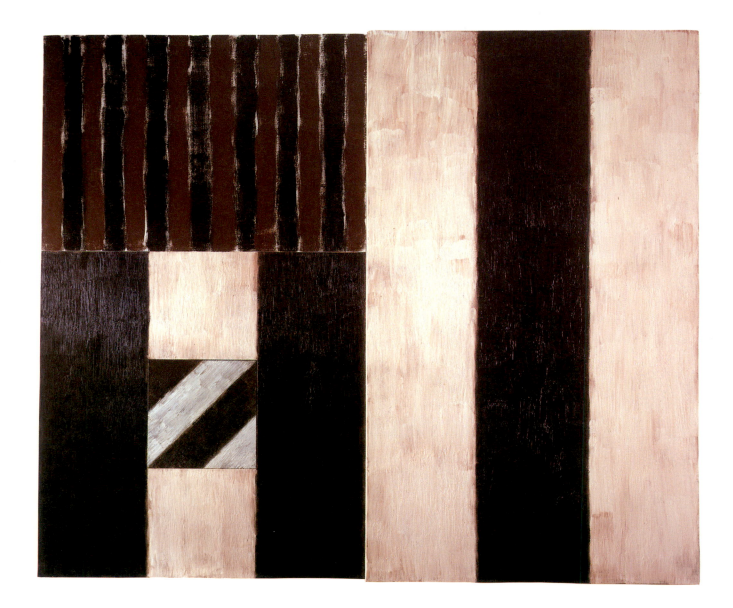

115 Catherine, 1987. Oil on canvas, 96 × 120 inches, collection of the artist.

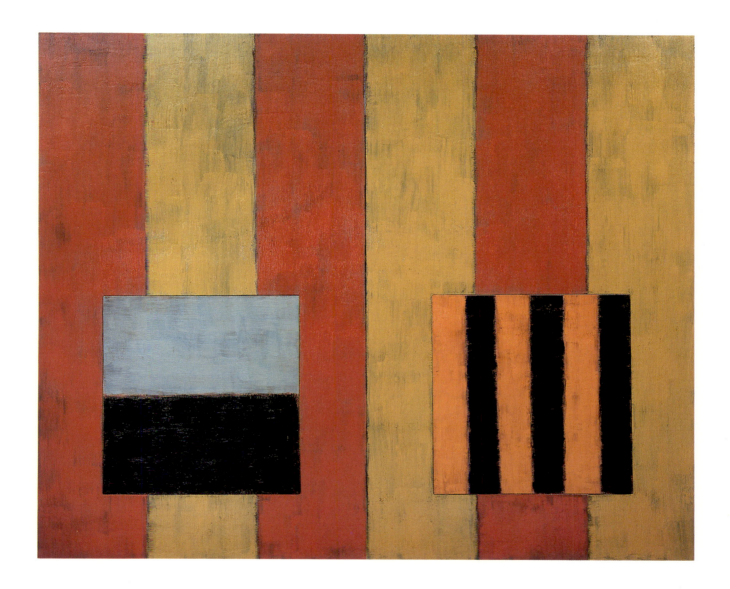

Mexico, 1987

Oaxaca, Mexico, 1988

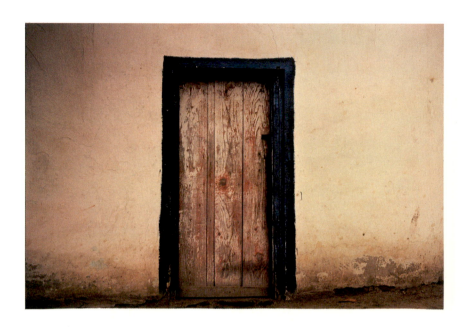

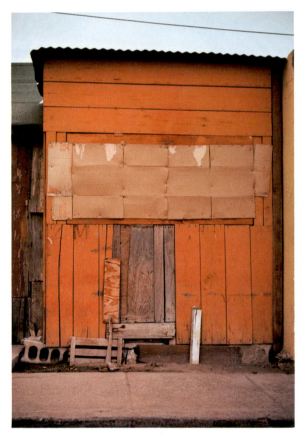

116 Us, 1988. Oil on linen, 96 × 120 inches, PaineWebber Group, Inc., New York.

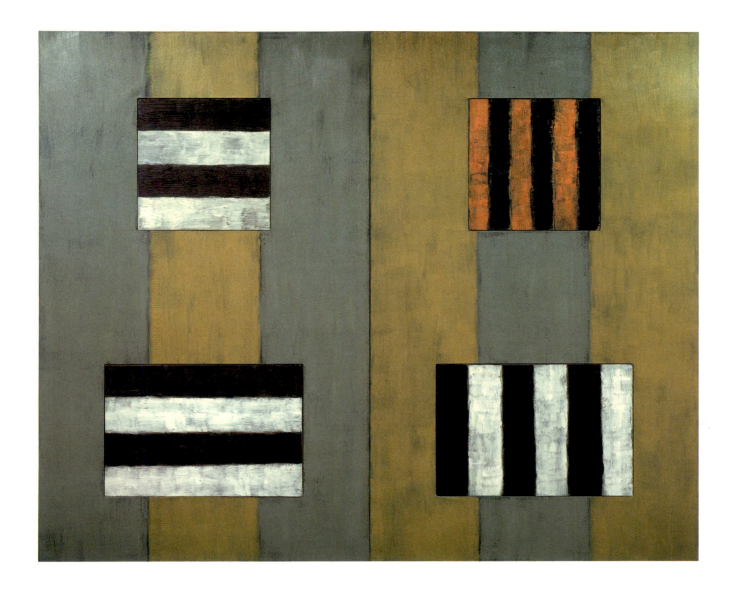

117 Backwards Forwards, 1987. Oil on canvas, 80 × 80 inches, private collection, New York.

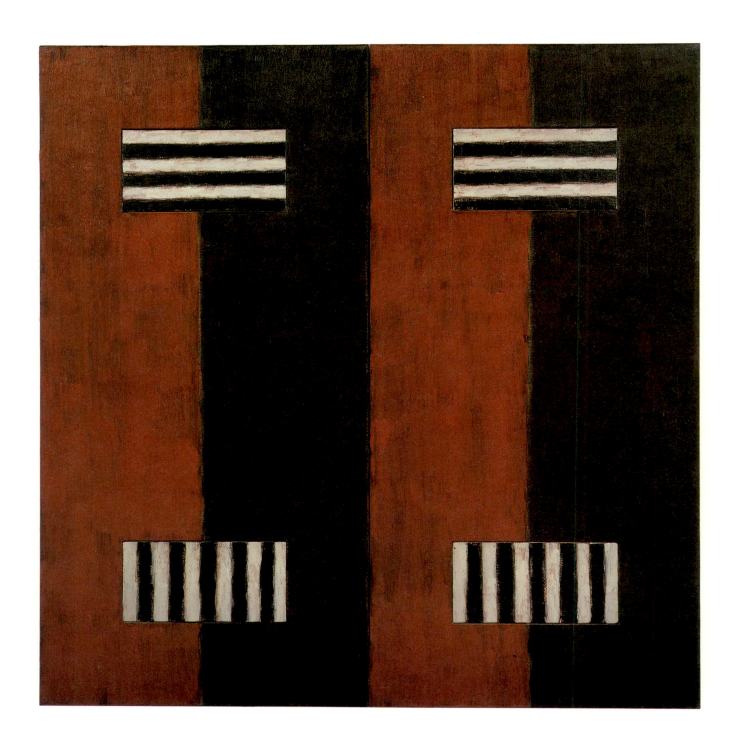

118 Battered Earth. 1988. Oil on linen, 72 × 72 inches.

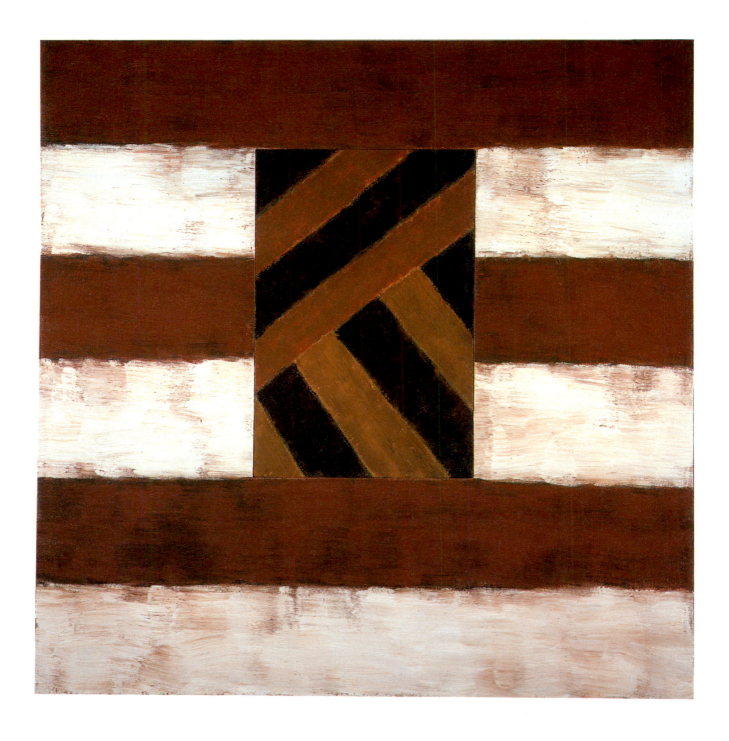

119 Green Gray, 1988. Oil on linen, 72 × 72 inches, private collection, Pittsburgh.

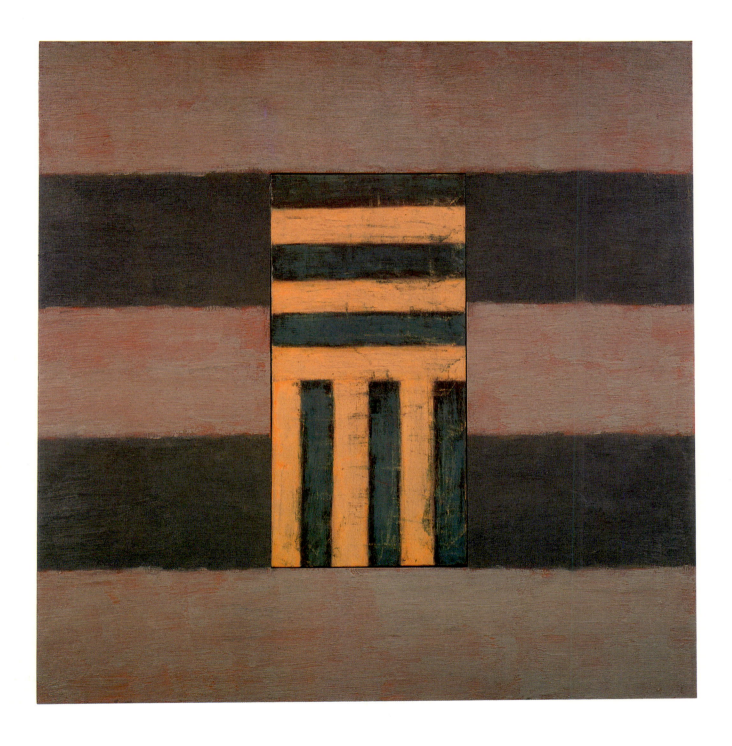

120 Without, 1988. Oil on linen, 96 × 144 inches.

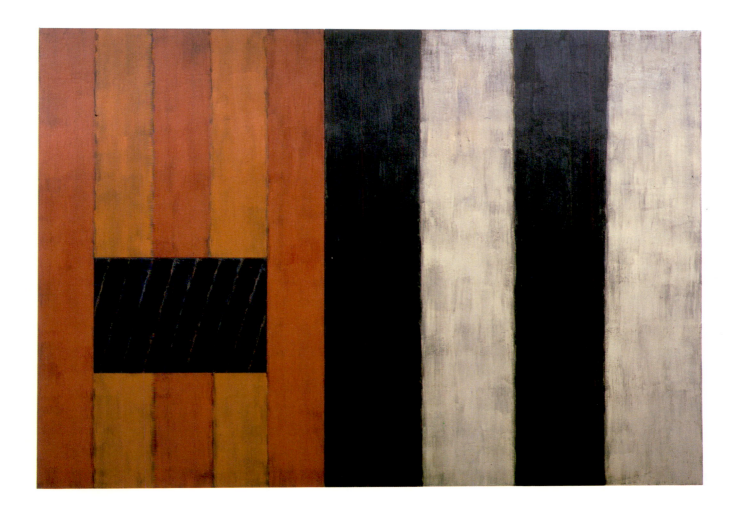

121 Between You and Me, 1988. Oil on linen, 96 × 120 inches, Albright-Knox Art Gallery, Buffalo.

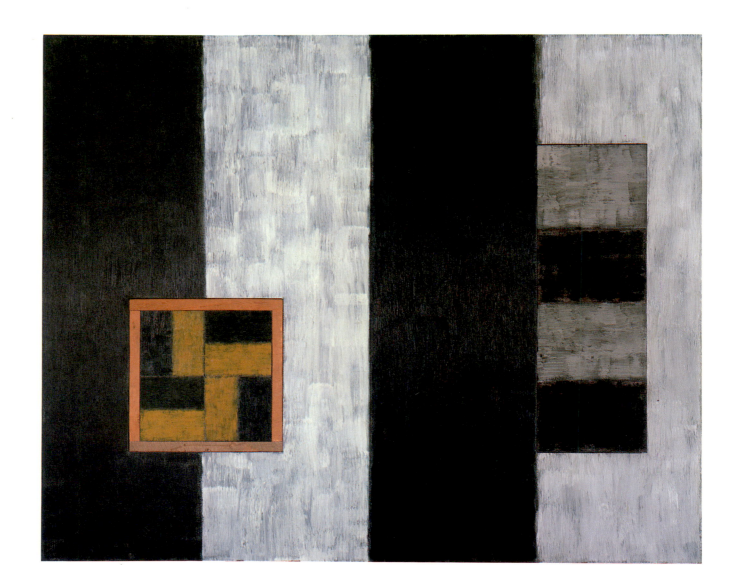

122 Big Land, 1988. Oil on linen, 96 × 160 inches, Australian National Gallery, Canberra.

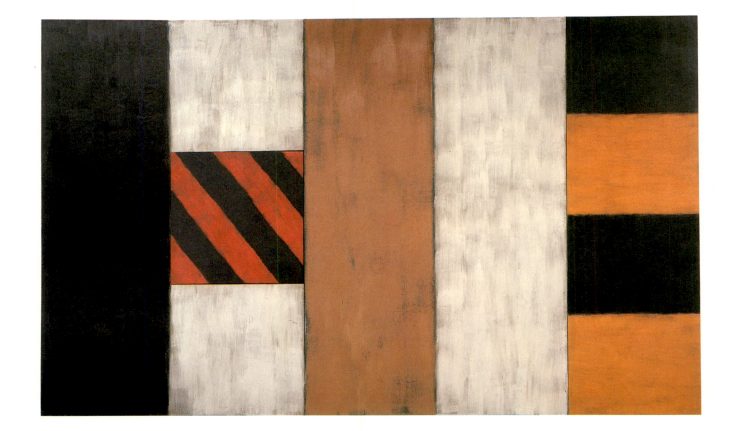

123 Inside, 1987. Oil on linen, 90 × 100 inches, private collection, Japan.

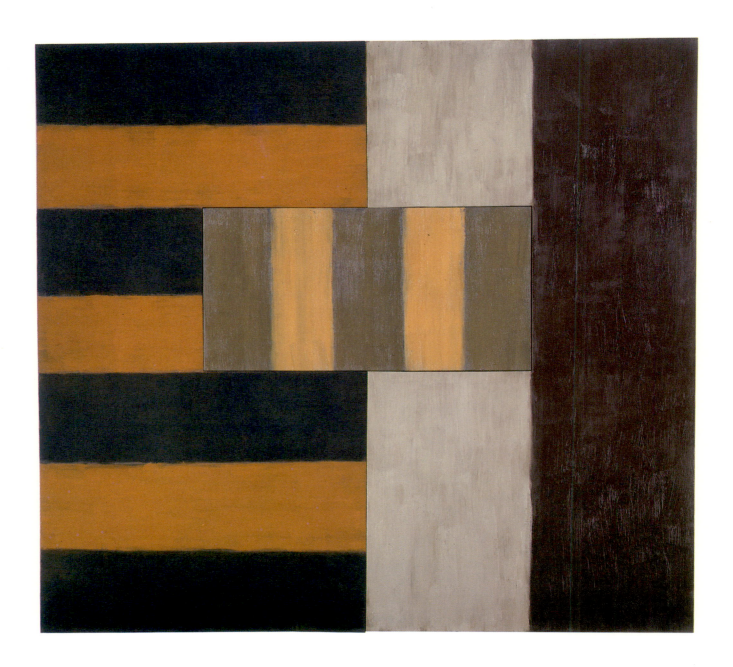

124 Counting, 1988. Oil on linen, 65 × 78 inches.

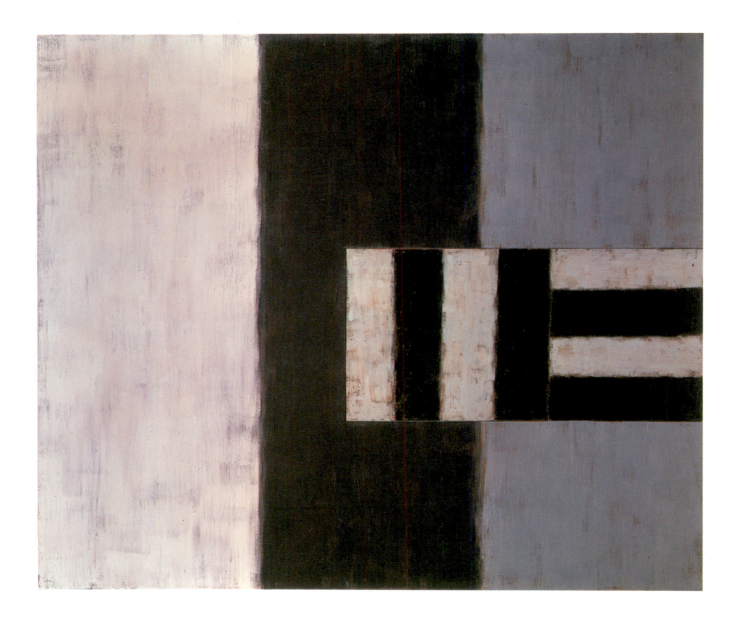

125 A Bedroom in Venice, 1988. Oil on linen, 96 × 120 inches, Museum of Modern Art, New York.

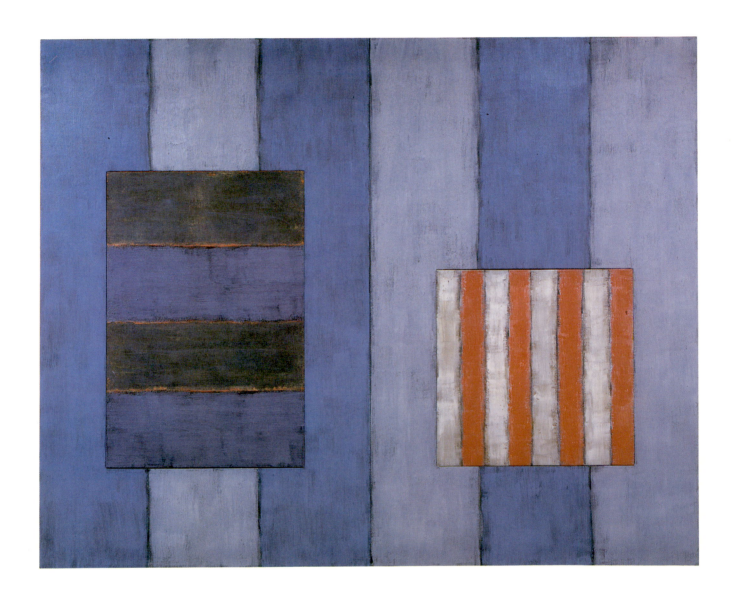

126 White Light, 1988. Oil on linen, 72 × 72 inches.

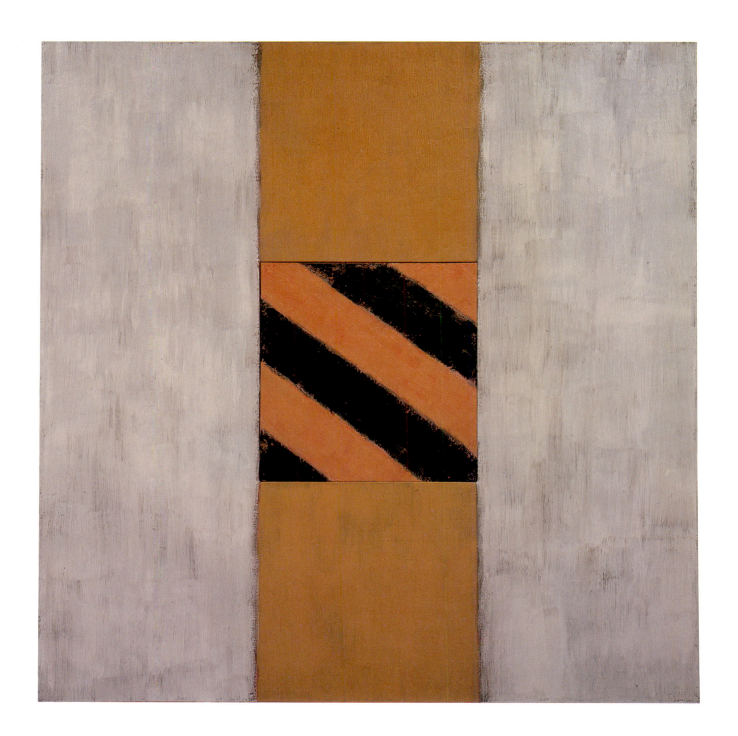

127 Pale Fire, 1988. Oil on linen, 96 × 147 inches, Modern Art Museum of Fort Worth.

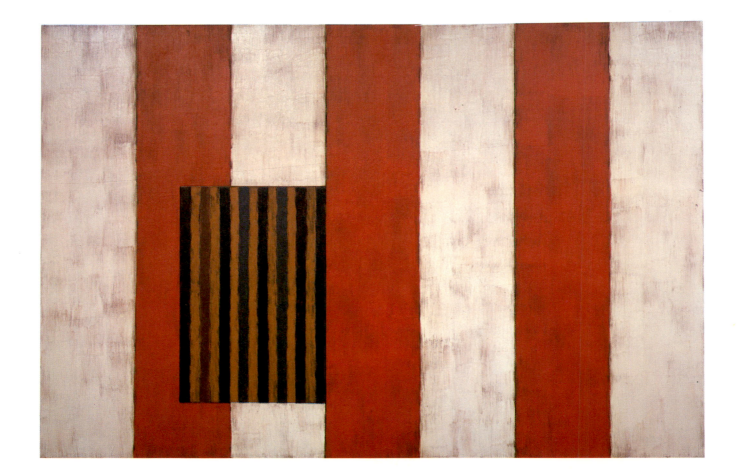

128 White Window, 1988. Oil on linen, 96 × 146 inches, Tate Gallery, London.

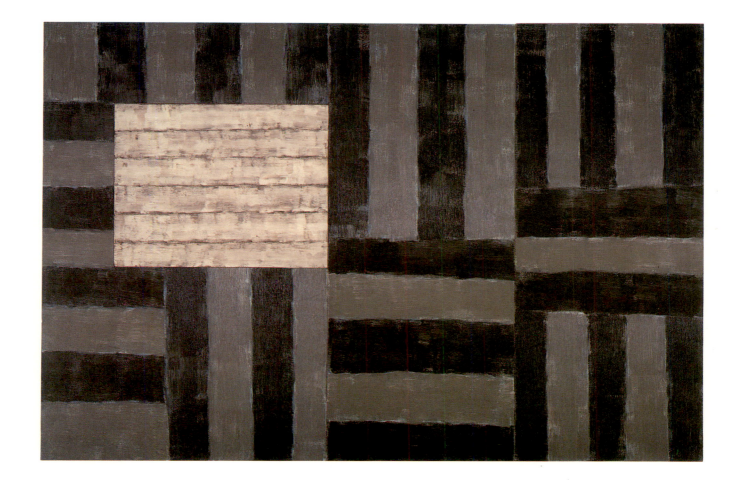

129 Why and What (Yellow), 1988. Oil on linen with steel, 96 × 120 inches, Hirshhorn Museum and Sculpture Garden, Smithsonian Institution, Washington, D.C.

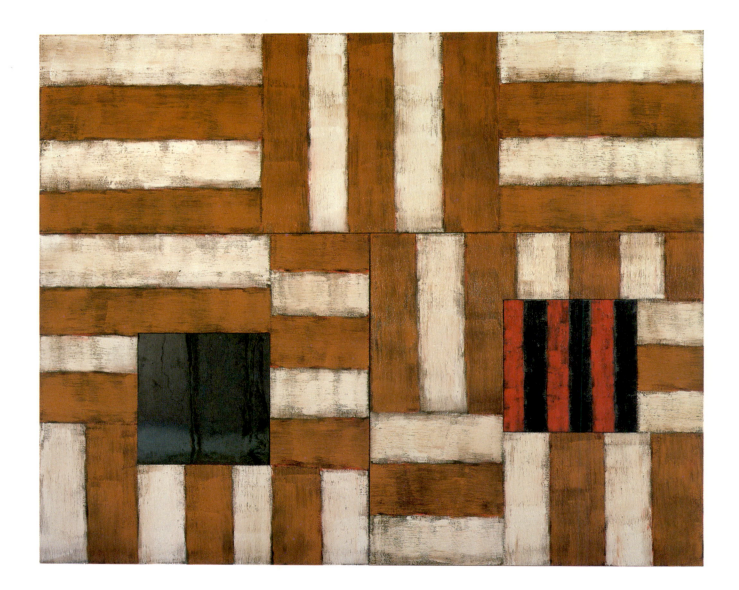

130 Why and What (Blue), 1989. Oil on linen with steel, 96 × 120 inches.

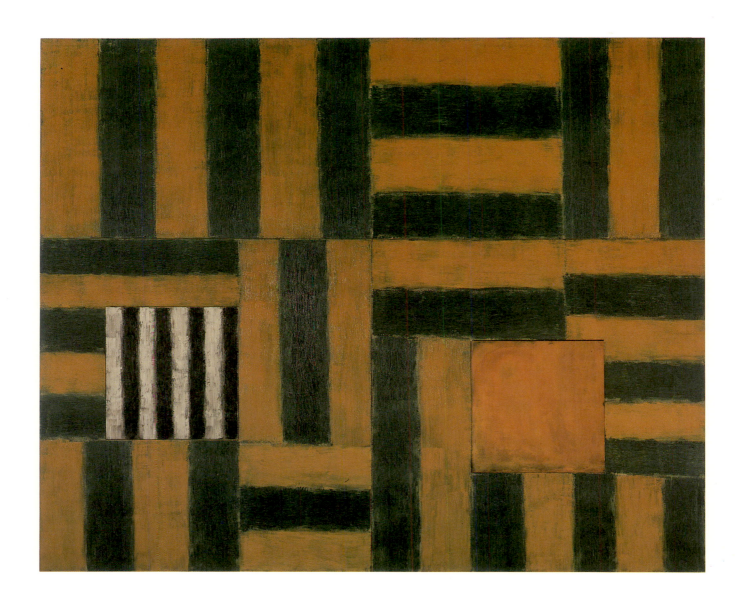

131 Crossing, 1989. Oil on canvas, 90 × 120 inches.

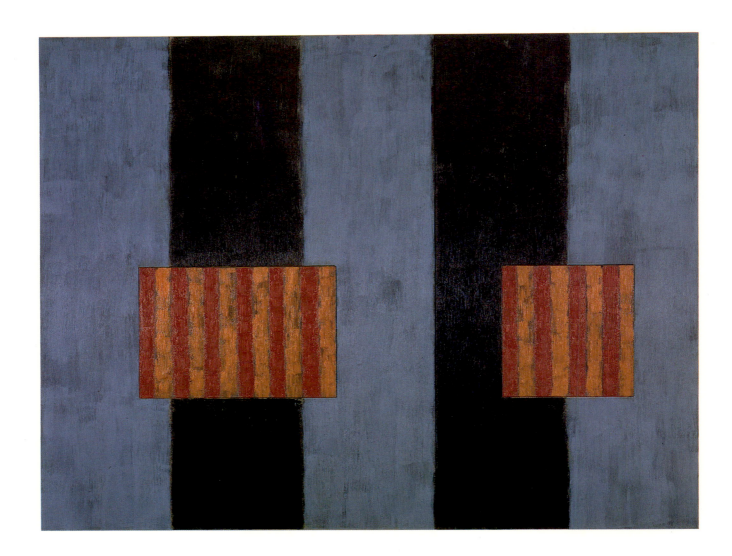

132 High and Low, 1989. Oil on canvas, 96 × 120 inches, Städtische Galerie im Lenbachhaus, Munich.

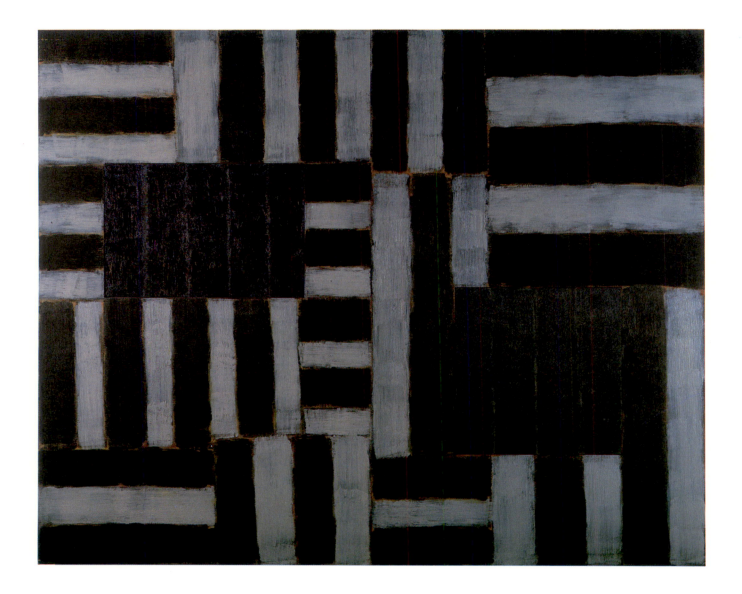

133 After Life, 1989. Oil on canvas, 72 × 72 inches.

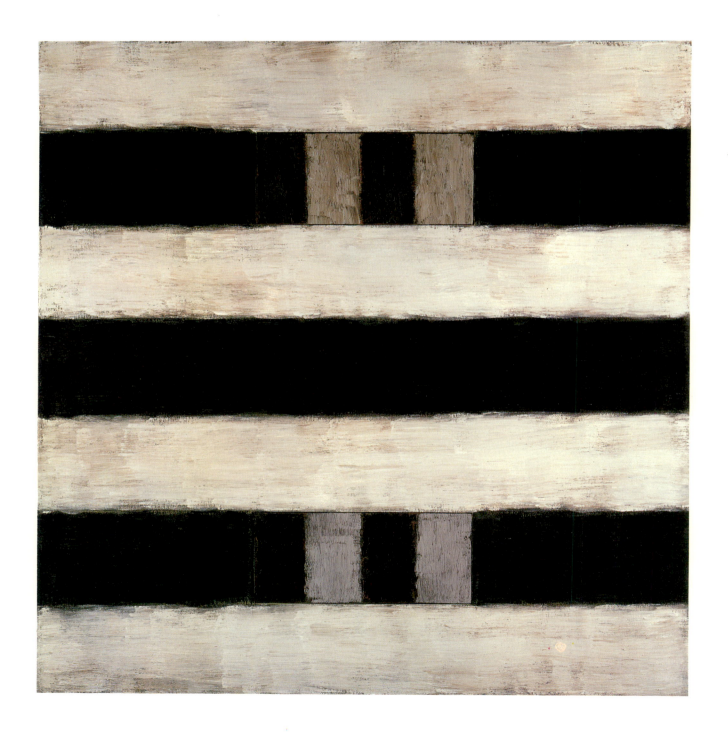

134 Secret Sharer, 1989. Oil on canvas, 100 × 126 inches.

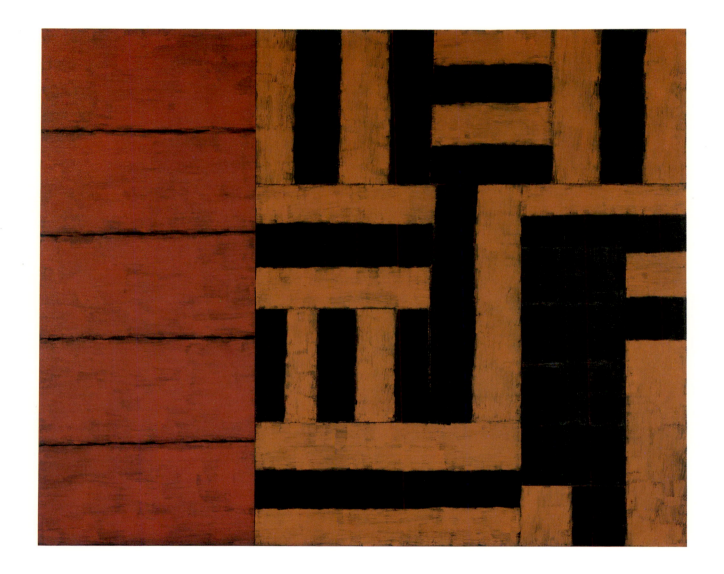

135 Africa, 1989. Oil on canvas, 90 × 144 inches, Centro de Arte Reina Sofía, Madrid.

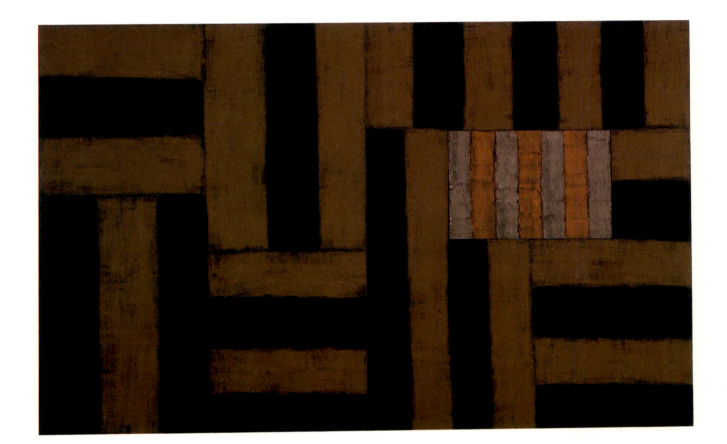

Sean Scully: A chronology

1945
Born in Dublin, Ireland, on June 30

1949
Family moved to London

1950–60
Attended local convent and public schools

1960–62
Worked as apprentice in a commercial printing shop in London, then joined a graphic design studio

1962–65
Attended evening classes at the Central School of Art, London

1965
Birth of son Paul Scully from first marriage to Jill Mycroft

1965–68
Studied at Croydon College of Art, London

1968–72
Studied at the University of Newcastle, graduated, and remained there as a teaching assistant
Spent part of summer of 1969 in Morocco
Awarded the Stuyvesant Foundation Prize in 1970
Prizewinner in the John Moore's Liverpool Exhibition 8 in 1972

1972–73
Worked at the Carpenter Center, Harvard University, Cambridge, under a Frank Knox Fellowship

1973
First solo exhibition in London at the Rowan Gallery

1973–75
Taught at Chelsea School of Art and Goldsmiths' College, University of London

1975
Met Catherine Lee in San Jose, California
Received a Harkness Fellowship, which allowed him to move to the United States
Settled in New York with Catherine Lee, whom he would later marry

1977
First solo exhibition in New York, at the Duffy-Gibbs Gallery
Began teaching part-time at Princeton University (New Jersey), a position he would relinquish in 1983

1981
Ten-year retrospective exhibition at the Ikon Gallery, Birmingham (traveled within the United Kingdom under the auspices of the Arts Council of Great Britain)

1982
Spent part of summer working at Edward Albee's artists' colony in Montauk, Long Island

1983
Received Guggenheim Fellowship
Became an American citizen
Son Paul killed in auto accident
Joined David McKee Gallery, which continues to represent him in New York

1984
Received Artist's Fellowship from the National Endowment for the Arts
Participated in *An International Survey of Recent Painting and Sculpture* at the Museum of Modern Art, New York

1985
First solo exhibition in an American museum, at Carnegie Institute, Pittsburgh (traveled to Museum of Fine Arts, Boston)

1989
Major exhibition spanning years 1982–88 at the Whitechapel Art Gallery, London (traveled to Städtische Galerie im Lenbachhaus [Munich] and Palacio de Velázquez del Retiro [Madrid])
Maintained studios in New York and London

SOLO EXHIBITIONS

1973
Rowan Gallery, London

1975
Rowan Gallery, London
Tortue Gallery, Santa Monica, California

1976
Tortue Gallery, Santa Monica, California

1977
Duffy-Gibbs Gallery, New York
Rowan Gallery, London

1979
Nadin Gallery, New York (special installation: ''Painting for One Place'')
Rowan Gallery, London
The Clocktower, New York

1980
Susan Caldwell Gallery, New York

1981
Rowan Gallery, London
Museum für (Sub)Kultur, Berlin
Ikon Gallery, Birmingham, England (exhibition under the auspices of Arts Council of Great Britain, traveled to: Sunderland Arts Centre; Douglas Hyde Gallery, Dublin; Arts Council of Northern Ireland, Belfast; Warwick Arts Trust, London)*
Susan Caldwell Gallery, New York
McIntosh/Drysdale Gallery, Washington, D.C.

1982
William Beadleston Gallery, New York

1983
David McKee Gallery, New York

1984
Juda Rowan Gallery, London
Galerie S65, Aalst, Belgium

1985
David McKee Gallery, New York
Museum of Art, Carnegie Institute, Pittsburgh (exhibition traveled to Museum of Fine Arts, Boston)*
Drawings, Barbara Krakow Gallery, Boston
Galerie Schmela, Düsseldorf

1986
David McKee Gallery, New York*

1987
Pamela Auchincloss Gallery, Santa Barbara, California (monotypes)*
David McKee Gallery, New York (monotypes)
Douglas Flanders Contemporary Art, Minneapolis (monotypes)
Mayor Rowan Gallery, London*
Galerie Schmela, Düsseldorf, West Germany*
University Art Museum, University of California, Berkeley*

*designates exhibition catalogue

1987—88
Art Institute of Chicago*

1988
Fuji Television Gallery, Tokyo*
Crown Point Press, New York and San Francisco (prints)

1989
David McKee Gallery, New York*
Whitechapel Art Gallery, London (exhibition traveled to Städtische Galerie im Lenbachhaus, Munich; Palacio de Velázquez del Retiro, Madrid)

1989—90
Pastel Drawings, Grob Gallery, London

1990
Karsten Greve Gallery, Cologne

GROUP EXHIBITIONS

1969
''Northern Young Contemporaries,'' Whitworth Art Gallery, Manchester, England

1970
''London Young Contemporaries'' (traveling exhibition, Arts Council of Great Britain)

1971
''Art Spectrum North,'' Laing Art Gallery, Newcastle-upon-Tyne; City Art Gallery, Leeds; Whitworth Art Gallery, Manchester

1972
''John Moore's Liverpool Exhibition 8,'' Walker Art Gallery, Liverpool
''Northern Young Painters,'' Stirling University, Scotland

1973
''La Peinture anglaise aujourd'hui,'' Musée d'Art Moderne, Paris
''Critics' Choice,'' Gulbenkian Gallery, Newcastle-upon-Tyne

1974
''Tenth International Biennial of Art,'' Menton, France
''British Painting,'' Hayward Gallery, London
Rowan Gallery, London
''John Moore's Liverpool Exhibition 9,'' Walker Art Gallery, Liverpool

1975
Contemporary Art Society, Art Fair, Mall Galleries, London

Rowan Gallery, London

The Arts Club, London

1976

"Invitational," John Weber Gallery, New York

"7 Artists from the Rowan Gallery," Sunderland Arts Centre, England

Rowan Gallery, London

"Invitational Exhibition," Susan Caldwell Gallery, New York

1977

"Four Artists," curated by Per Haubro Jensen, Nobe Gallery, New York

Rowan Gallery, London

"British Painting 1952–1977," Royal Academy of Arts, London

"Works on Paper—The Contemporary Art Society's Gifts to Public Galleries 1952–1977," Royal Academy of Arts, London

1978

"Certain Traditions" (traveling exhibition organized by Edmonton Art Gallery and the British Council, Canada)

Rowan Gallery, London

"Small Works," Newcastle Polytechnic Art Gallery, England

1979

"New Wave Painting," The Clocktower, New York

"Fourteen Painters," Lehman College, New York

"First Exhibition," Toni Birkhead Gallery, Cincinnati

Tolly Cobbold/Eastern Arts 2nd National Exhibition, Fitzwilliam Museum, Cambridge (exhibition traveled to Norwich, Ipswich, London, and Sheffield)

Susan Caldwell Gallery, New York

"Certain Traditions," Mostyn Art Gallery, Llandudno, Wales

"The British Art Show" (exhibition selected by William Packer; traveled to Sheffield, Newcastle, and Bristol)

1980

"Marking Black," Bronx Museum of the Arts

"New Directions," The Art Museum, Princeton University

"The International Connection," Sense of Ireland Festival, Roundhouse Gallery, London

Susan Caldwell Gallery, New York

"Growing Up with Art," Leicestershire Education Authority Collection, Whitechapel Art Gallery, London

"ROSC," University College Gallery and National Gallery of Ireland, Dublin; Crawford Gallery, Cork

"The Newcastle Connection," Newcastle Polytechnic Art Gallery, England

1981

"Arabia Felix," curated by William Zimmer, Art Galaxy Gallery, New York

"New Directions," curated by Sam Hunter, Sidney Janis Gallery, New York

Rowan Gallery, London

"Art for Collectors," Museum of Art, Rhode Island School of Design, Providence

1982

"Recent Aspects of All-Over," curated by Theodore Bonin, Harm Boukaert Gallery, New York

"Abstract Painting," curated by William Zimmer, Jersey City Museum, New Jersey

Sunne Savage Gallery, Boston

"Art for a New Year" (drawing exhibition organized by the Art Lending Service, Museum of Modern Art, New York)

"Workshop F," Chelsea School of Art, London

1983

"American Abstract Artists" (national touring exhibition)

"Nocturne," Siegel Contemporary Art, New York

"Contemporary Abstract Painting," Muhlenberg College, Allentown, Pennsylvania*

"Three Painters," Zenith Gallery, Pittsburgh

David McKee Gallery, New York

"Newcastle Salutes New York," Newcastle Polytechnic Art Gallery

"Student Choice Exhibition," Yale University Art Gallery, New Haven

1984

"An International Survey of Recent Painting and Sculpture," Museum of Modern Art, New York*

"Part 1: Twelve Abstract Painters," Siegel Contemporary Art, New York

"ROSC," The Guinness Hops Store, Dublin

"Currents 6," Milwaukee Art Museum

"Small Works: New Abstract Painting," Lafayette College and Muhlenberg College, Allentown, Pennsylvania

"Hassam & Speicher Purchase Fund Exhibition," American Academy of Arts and Letters, New York

"Art on Paper," Galerie S65, Aalst, Belgium

William Beadleston Gallery, New York

1985

"Painting 1985," Pam Adler Gallery, New York

"Abstract Painting as Surface and Object," Hillwood Art Gallery, C. W. Post Campus, Long Island University, Greenvale, New York*

"An Invitational," curated by Tiffany Bell, Condeso/ Lawler Gallery, New York

"Decade of Visual Arts at Princeton: Faculty 1975–85," The Art Museum, Princeton University

"Abstraction/Issues," three-gallery show: Tibor de Nagy, Oscarsson Hood, Sherry French, New York

"Art on Paper," Weatherspoon Art Gallery, University of North Carolina at Greensboro, North Carolina

"Masterpieces of the Avant-Garde," Annely Juda Fine Art/Juda Rowan Gallery, London*

"Small Works," Juda Rowan Gallery, London

1986

"After Matisse" (traveling exhibition organized by Independent Curators, Inc.)

"An American Renaissance in Art: Painting and Sculpture since 1940," Fort Lauderdale Museum of Fine Art, Florida*

"Public and Private: American Prints Today," The Brooklyn Museum, New York*

"Sean Scully and Catherine Lee," Paul Cava Gallery, Philadelphia

"Cal Collects I," University Art Museum, University of California, Berkeley

"The Heroic Sublime," Charles Cowles Gallery, New York

"Structure/Abstraction," Hill Gallery, Birmingham, Michigan

"Courtesy David McKee," Pamela Auchincloss Gallery, Santa Barbara, California

"Detroiters Collect: New Generation," Meadow Brook Art Gallery, Oakland University, Rochester, Michigan

"Recent Acquisitions," Contemporary Arts Center, Honolulu

"25 Years: Three Decades of Contemporary Art," Juda Rowan Gallery, London

1987

"Corcoran Biennial," Corcoran Gallery of Art, Washington, DC*

"Harvey Quaytman & Sean Scully," Helsinki Festival, Museum of Contemporary Art, Finland*

"Drawing from the 80's—Chatsworth Collaboration," Carnegie Mellon University Art Gallery, Pittsburgh

"Drawn-Out," Kansas City Art Institute, Missouri*

"Magic in the Mind's Eye: Part I & II," Meadow Brook Art Gallery, Oakland University, Rochester, Michigan*

"Large Works by Rowan Artists," Mayor Rowan Gallery, London

1987–88

"Logical Foundations," Pfizer Inc., New York, Winter, Curated by the Advisory Service, Museum of Modern Art, New York

"Works on Paper," Nina Freundenheim Gallery, Buffalo, New York

1988

"17 Years at the Barn," Rosa Esman Gallery, New York

"Works on Paper: Selections from the Garner Tullis Workshop," Pamela Auchincloss Gallery, New York

"New Additions," Crown Point Press, San Francisco and New York

"Sightings: Drawing with Color," Pratt Institute, New York (traveling exhibition)*

"Large Works on Paper," Mayor Rowan Gallery, London

"The Presence of Painting," Mapping Art Gallery, Sheffield (exhibition traveled to Laing Art Gallery, Newcastle; and Ikon Gallery, Birmingham)

1989

"The Elusive Surface," The Albuquerque Museum, New Mexico

"Drawings and Related Prints," Castelli Graphics, New York

"Essential Painting," Nelson-Atkins Museum of Art, Kansas City, Missouri

"The Linear Image: American Masterworks on Paper," curated by Sam Hunter, Marisa del Re Gallery, New York

Public collections

NORTH AMERICA

Albright-Knox Art Gallery, Buffalo
Art Institute of Chicago
Edward R. Broida Trust, Los Angeles
Brooklyn Museum, New York
Carpenter Center, Harvard University, Cambridge
Carnegie Museum of Art, Pittsburgh
Centro Cultural de Arte Contemporaneo, Mexico City
Chase Manhattan Bank, New York
Chemical Bank, New York
Cleveland Museum of Art
Corcoran Gallery of Art, Washington, D.C.
Dallas Museum of Art
Denver Art Museum
First Bank of Minneapolis
Fogg Art Museum, Harvard University, Cambridge
Modern Art Museum of Fort Worth
Hirshhorn Museum and Sculpture Garden, Smithsonian Institution, Washington, D.C.
McCrory Corporation, New York
Mellon Bank, Pittsburgh
Metropolitan Museum of Art, New York
Museum of Fine Arts, Boston
Museum of Modern Art, New York
PaineWebber Group, Inc., New York
Philip Morris, Inc., New York
Phillips Collection, Washington, D.C.
Santa Barbara Museum of Art
Walker Art Center, Minneapolis

GREAT BRITAIN

Arts Council of Great Britain, London
British Council, London
Ceolfrith Art Centre, Sunderland
Contemporary Arts Society, London
Council of National Academic Awards, London
Eastern Arts Association, Cambridge
Fitzwilliam Museum, Cambridge
Laing Art Gallery, Newcastle-upon-Tyne
Leicestershire Educational Authority, Leicester
Manchester City Art Gallery
Northern Arts Association, Newcastle-upon-Tyne
Tate Gallery, London
Ulster Museum, Belfast, Northern Ireland
Victoria and Albert Museum, London
Whitworth Art Gallery, Manchester

EUROPE

Centro de Arte Reina Sofía, Madrid
Louisiana Museum, Humlebaek, Denmark
Museum für (Sub)Kultur, Berlin
Städtische Galerie im Lenbachhaus, Munich

AUSTRALIA

Australian National Gallery, Canberra
National Gallery of Victoria, Felton Bequest, Melbourne
Power Institute of Contemporary Art, Sydney

Bibliography

BOOKS AND EXHIBITION CATALOGUES

Abstract Painting as Surface and Object. Greenvale, New York: Hillwood Art Gallery, C. W. Post Campus, Long Island University, 1985. Essay by William Zimmer.

An American Renaissance in Art: Painting and Sculpture since 1940. Fort Lauderdale, Florida: Fort Lauderdale Museum of Fine Art, 1986.

An International Survey of Recent Painting and Sculpture. New York: Museum of Modern Art, 1984.

Arnason, H. H. *History of Modern Art*. 3d. ed., revised and updated by Daniel Wheeler. New York: Harry N. Abrams, 1986.

Carrier, David. *Artwriting*. Amherst: University of Massachusetts Press, 1987.

Contemporary Abstract Painting. Allentown, Pennsylvania: Muhlenberg College, 1983.

Drawn-Out. Kansas City, Missouri: Kansas City Art Institute, 1987.

The Fortieth Biennial Exhibition of Contemporary American Painting. Washington, D.C.: Corcoran Gallery of Art, 1987.

Harvey Quaytman and Sean Scully. Helsinki, Finland: Helsinki Festival, 1987. Interview with Mari Rantanen.

Magic in the Mind's Eye: Part I & II. Rochester, Michigan: Meadow Brook Art Gallery, Oakland University, 1987.

Masterpieces of the Avant-Garde. London: Annely Juda Fine Art/Juda Rowan Gallery, 1985.

New York Studio Events: Sean Scully. New York: Independent Curators, vol. 3, no. 1, 1988.

La Peinture anglaise aujourd'hui. Paris: Musée d'Art Moderne de la Ville, 1973. Essay by Edward Lucie-Smith.

Public and Private: American Prints Today. New York: Brooklyn Museum, 1986.

Sean Scully. Pittsburgh: Museum of Art, Carnegie Institute, 1985. Contributions by John Caldwell, David Carrier, and Amy Lighthill.

Sean Scully. New York: David McKee Gallery, 1986. Conversation with Joseph Masheck.

Sean Scully. Düsseldorf: Galerie Schmela, 1987. Essay by Susanne Lambrecht.

Sean Scully. London: Mayor Rowan Gallery, 1987.

Sean Scully. Berkeley: Art Museum, University of California, 1987. Essay by Constance Lewallen.

Sean Scully. Chicago: Art Institute of Chicago, 1987–88. Essay by Neal Benezra.

Sean Scully. Tokyo: Fuji Television Gallery, 1988. Essays by Takashi Nibuya and John Loughery; interview by Kazu Kaido.

Sean Scully. New York: David Mckee Gallery, 1989.

Sean Scully. London: Whitechapel Art Gallery, 1989. Essay by Carter Ratcliff.

Sean Scully: Monotypes from the Garner Tullis Workshop. Santa Barbara: Pamela Auchincloss Gallery, 1987.

Sean Scully: Paintings 1971–1981. Birmingham, England: Ikon Gallery, 1981. Essay by Joseph Masheck.

Sightings: Drawing with Color. New York: Pratt Institute, 1988.

Small Works: New Abstract Painting. Allentown, Pennsylvania: The Gallery, Williams Center for the Arts, Lafayette College, 1984. Essays by Barbara Zabel and William Zimmer.

ARTICLES AND REVIEWS

Adams, Brooks. "The Stripe Strikes Back." *Art in America*, October 1985, pp. 118–23.

Allen, Jane Addams. "The Battle of the Biennials." *The World & I*, July 1987, p. 275.

Allen, Richard. "Sean Scully." *Aspects*, Autumn 1981.

Andrada, Beatriz. "Sean Scully: 'Intento que mis cuadros sean profundos, agresivos y hasta salvajes.'" *Diario 16*, September 14, 1989.

Anthony, Evan. "What Do You Know?" *Spectator*, April 22, 1975.

Artner, Alan G. "Stripe Up the Band." *Chicago Tribune*, January 17, 1988.

"Aus den Galerien." *Handelsblatt*, November 17, 1987.

Baker, Kenneth. "Abstract Jestures." *Artforum*, September 1989, pp. 135–38.

Barrett, Cyril. "Exhibitions—ROSC '84." *Art Monthly*, October 1984, pp. 11–14.

Batchelor, David. "Sean Scully." *Artscribe International*, September/October 1989, p. 72.

Beaumont, Mary Rose. "Sean Scully." *Arts Review*, October 23, 1987, p. 726.

———. "Early Work By Gallery Artists." *Arts Review*, October 2, 1989, p. 119.

Bell, Tiffany. "Responses to Neo-Expressionism." *Flash Art*, May 1983, pp. 40–46.

Bennett, Ian. "The Modest British Push Ahead." *Economist*, April 7, 1973, p. 124.

———. "They're English, They're Modern and They're Hotter than Old Masters." *Evening Standard*, September 18, 1974, p. 25.

———. "Minimal Respect." *Financial Times*, December 17, 1977.

———. "Loneliness of the Abstract." *Financial Times*, August 25, 1979.

———. "Sean Scully." *Flash Art*, January–February 1980, pp. 53–54.

———. "Modern Painting and Modern Criticism in England." *Flash Art*, March–April 1980, pp. 24–26.

———. "Sean Scully." *Flash Art*, Summer 1989, p. 157.

Blakeston, Oswell. *What's on in London*, April 25, 1975.

———. "Sean Scully." *Arts Review*, August 31, 1979, p. 453.

Bonaventura, Paul. "Sean Scully: 'Hay que ligar la abstraccion a la vida.'" *RS*, October 1989, pp. 26–34.

———. "Interview with Sean Scully." Exhibition guide to *Sean Scully: Paintings and Works on Paper 1982–88*. Whitechapel Art Gallery, 1989.

Bonin, Theodore. "Scully at William Beadleston." *Art Gallery Scene*, December 31, 1982, pp. 24–25.

Brenson, Michael. "Sean Scully." *New York Times*, February 8, 1985.

———. "True Believers Who Keep the Flame of Painting." *New York Times*, June 7, 1987.

Bumiller, Trine. "New York from 'A' to 'Z.'" *Juliet Art Magazine*, June–October 1985, pp. 7–8.

Burn, Guy. "Rowan Artists." *Arts Review*, May 26, 1978, p. 260.

Burr, James. "Round the Galleries—People and Patterns." *Apollo*, November 1984, p. 354.

———. "Sean Scully at the Whitechapel." *Apollo*, June 1989, pp. 432–33.

Carrier, David. "Theoretical Perspectives on the Arts, Sciences and Technology." *Leonardo*, vol. 18, no. 2, 1985, pp. 108–13.

———. "Corcoran Gallery 40th Biennial." *Burlington Magazine*, July 1987, pp. 483–84.

———. "Spatial Relations." *Art International*, Autumn 1989, pp. 81–82.

Carty, Ciaran. "Sean Scully." *Irish Independent*, November 29, 1981.

———. "Aesthetic Mugging (or How a Skinhead Made It in the New York Art World)." *Irish Independent*, November 25, 1984.

Cooke, Lynne. "Sean Scully." *Galeries Magazine*, August/September 1989, pp. 60–63.

Cork, Richard. "All Together Now." *Listener*, May 25, 1989.

Cotter, Holland. "Sean Scully." *Flash Art*, April–May 1985, p. 40.

"Council Refuses to Take *The Field*." *Irish Times*, December 10, 1985.

"Council Takes a Field Trip." *Irish Times*, December 6, 1985.

Crichton, Fenella. "Sean Scully at the Rowan." *Art International*, June 15, 1975, p. 58.

———. "London." *Art and Artists*, October 1979, pp. 41–48.

Danvila, Jose Ramon. "Sean Scully: 'La Emocion de la geometria.'" *El Punto*, September 22, 1989.

Davies, Allan. "Sean Scully." *Art Monthly*, December–January 1977–78, p. 27.

Decter, Joshua. "Sean Scully." *Arts Magazine*, December 1986, pp. 123–24.

Del Renzio, Toni. "London." *Art and Artists*, December 1974, pp. 33–35.

Denvir, Bernard, and Packer, William. "A Slice of Late Seventies Art." *Art Monthly*, March 1980, pp. 3–5.

Dixon, Stephen. "Fat Cat No Tics." *Manchester Guardian*, June 12, 1974.

Donohue, Victoria. "Is Abstract Painting Regaining Its Popularity?" *Philadelphia Inquirer*, September 24, 1984, p. 34.

Dorment, Richard. "Scully Earns His Stripes." *Daily Telegraph*, May 17, 1989.

Draper, Francis. "Sean Scully." *Arts Review*, November 25, 1977, p. 714.

Fallon, Brian. "ROSC '84—An Exercise in Time and Space." *Irish Times*, August 25, 1984.

Faure-Walker, James. "Sean Scully." *Studio International*, May–June 1975, pp. 238–39.

Feaver, William. "Farewell Blaze of Colour." *Manchester Guardian*, July 18, 1972.

———. "London Letter: Summer." *Art International*, November 1972, p. 39.

———. "Alive and Kicking." *Vogue* (British edition), November 1973.

———. "Sean Scully." *Art International*, November 1973, pp. 26, 27, 32, 75.

———. "Six Artists—A Critic's Choice." *Manchester Guardian*, December 1973.

———. "Sean Scully—Point of View." *Vogue* (British edition), April 1, 1975.

———. "Sean Scully—Smiting and Sacrificing." *Sunday Observer* (London), November 6, 1977.

———. "Sean Scully." *Artnews*, January 1978, p. 133.

———. "Menacing Pinpricks." *Sunday Observer* (London), March 29, 1981, p. 35.

———. "Peacocks at a Private View." *Sunday Observer* (London), August 9, 1981.

———. "Sean Scully." *Sunday Observer* (London), September 5, 1981.

———. "The New Valhalla." *Observer* (London), May 20, 1984, p. 20.

———. "Irish Continental." *Observer* (London), October 28, 1984.

———. "Sean Scully—Startling Image." *Sunday Observer* (London), November 4, 1984.

———. "Singing Stripes." *Vogue* (British edition), May 1989, p. 30.

———. "Starring in Stripes." *Observer* (London), May 7, 1989, p. 42.

———. "Sean Scully." *Artnews*, September 1989, p. 191.

Fisher, Susan. "Catherine Lee/Sean Scully." *New Art Examiner*, June 1986, p. 52.

Forgey, Benjamin. "Sean Scully." *Washington Post*, October 5, 1981.

Fuller, Peter. "Sean Scully." *Arts Review*, November 17, 1973, pp. 790–91.

Garlake, Margaret. "Double Scully." *Gallery Magazine*, November 1987.

———. "Sean Scully." *Art Monthly*, June 1989, no. 127, p. 23.

Glueck, Grace. "Aspects of All-Over." *New York Times*, September 10, 1982.

Godfrey, Tony. "Exhibition Reviews." *Burlington Magazine*, December 1987, pp. 822–24.

Gold, Sharon. "Sean Scully." *Artforum*, Summer 1977, p. 69.

Gooding, Mel. "Scully, Startup, Leverett." *Art Monthly*, December 1987–January 1988, pp. 21–23.

Gosling, Nigel. "Sean Scully." *Sunday Observer* (London), December 2, 1973.

———. "Sean Scully—Too Soon for Resuscitation." *Sunday Observer* (London), April 6, 1975.

———. "Gallery Guide." *Observer* (London), August 26, 1979.

Graham-Dixon, Andrew. "Anti-Cool Rules." *Vogue* (British edition), October 1987, pp. 420–22.

———. "Between the Lines." *Independent*, May 13, 1989.

Griefen, John. "Sean Scully." *Arts Magazine*, February 1980, pp. 35–36.

Grimley, Terry. "Sean Scully." *Birmingham Post*, September 5, 1981.

Hagen, Charles. "40th Biennial Exhibition of Contemporary American Paintings." *Artforum*, October 1987, pp. 135, 136.

"Happenings in the City." *Daily News*, February 18, 1988.

Harrison, Helen A. "Treating the Canvas as an Object in Its Own Right." *New York Times*, March 3, 1985, p. 6.

Harrod, Tanya. "Sean Scully." London Reviews, *Art Review*, April 10, 1981, p. 135.

Hart, D. J. "Sean Scully." *Birmingham Post*, September 21, 1981.

Higgins, Judith. "Sean Scully and the Metamorphosis of the Stripe." *Artnews*, November 1985, pp. 104–12.

Hill, Andrea. "Sean Scully." *Artscribe International*, September 1979, p. 60.

Hughes, Robert. "Earning His Stripes." *Time Magazine*, August 14, 1989, p. 47.

Huioi, Fernando. "El Reverso de la ilusion." *El Pais*, September 17, 1989.

Humeltenberg, Hanna. "Sean Scully Stellt in der Galerie Schmela aus ein Stück weit Verfremdt." *Rheinische Post*, October 28, 1987.

Hunter, Sam. "Sean Scully's Absolute Paintings." *Artforum*, November 1979 (cover illustration), pp. 30–34.

Januszczak, Waldeman. "Mr. Packer's Very Conservative Selection." *Manchester Guardian*, December 3, 1979.

Jarques, Fietta. "Sean Scully: 'Busco la emocion, no el sentimentalismo.'" *El Pais*, September 14, 1989.

Jeffett, William. "Sean Scully—Reinventing Abstraction." *Artefactum*, Summer 1989, pp. 2–6.

Jimenez, Pablo. "Sean Scully: 'La Geometria es una etica sin fe, pura utopia, algo asi como Suiza.'" *ABC*, September 9, 1989.

———. "Un Brillante final de siglo." *ABC*, September 21, 1989.

Jones, Ben, and Rippon, Peter. "An Interview with Sean Scully." *Artscribe International*, June 1978, pp. 27–29.

Juncosa, Enrique. "Las Estrategias de Apolo." *Lapiz*, vol. VI, no. 60, 1989, pp. 26–31.

Kelsey, John. "Gallery Exhibits London Works." *Journal* (Newcastle-upon-Tyne), January 31, 1976.

Kent, Sarah. "Sean Scully." *Time Out*, October 21–28, 1987, p. 42.

Kipphoff, Petra. "Kritiker-Umfrage." *Art Journal*, January 1985, pp. 8, 9.

Lambrecht, Susanne. "Blick auf das Wesentliche." *Rheinische Post*, December 2, 1985.

Larson, Kay. "Sean Scully." *New York Magazine*, October 3, 1983, p. 82.

———. "Love or Money." *New York Magazine*, June 23, 1986, pp. 65–66.

Lehrman, Robert. "Art Reviews." *Washington Review*, June–July 1987.

Levy, Mark. "The Permutations of the Stripe." *Shift*, vol. 1, no. 2, 1988, pp. 38–41.

Lewallen, Constance. "Interview with Sean Scully." *View*, vol. 5., no. 4, Fall 1988.

Load, Max. "Sean Scully." *New York Native*, October 22, 1986.

Lonkamp, Brigitte. "Kunstkalender." *Zeit*, December 13, 1985.

Loughery, John. "Sean Scully." *Arts Magazine*, December 1986, p. 122.

———. "Affirming Abstraction: The Corcoran Biennial." *Arts Magazine*, September 1987, pp. 76–78.

———. "17 Years at the Barn." *Arts Magazine*, April 1988, p. 110.

Lucie-Smith, Edward. "British Painting for Paris." *Illustrated London News*, February 1973.

———. "The Younger Generation." *Illustrated London News*, August 1974, pp. 69–71.

———. "Sean Scully—Gaining on the Roundabouts." *Evening Standard*, November 17, 1977.

Mac Avock, Desmond. "Sean Scully at Douglas Hyde Gallery." *Irish Times*, November 23, 1981.

———. "Irish Painter of the New York School." *Irish Times*, January 6, 1982, p. 8.

MacDonald, Robert. "On Sean Scully." *Time Out*, May 24–31, 1989, p. 45.

Madoff, Steven Henry. "Sean Scully at William Beadleston." *Art in America*, March 1983, p. 157.

———. "A New Generation of Abstract Painters." *Artnews*, November 1983, pp. 78–84.

———. "An Inevitable Gathering." *Artnews*, September 1987, p. 183.

McCarron, John. "Sean Scully." *Shift*, vol. 2, no. 3, 1988, pp. 14–19.

McEwen, John. "Boyle's Law." *Spectator*, November 19, 1977, p. 28.

———. "Jazz Bands." *Spectator*, April 11, 1980.

Meister, Helga. "Monumentale Balken." *Wochen Zeitung*, December 24, 1985.

"Minimal Respect." *Financial Times, Sotheby's*, December 17, 1977.

Moreno Ruiz de Eguino, Inaki. "El Palacio de Velázquez mafrileno acoge una muestra del minimalista Sean Scully." *Diario Vasco*, October 1, 1989.

Murphy, Sean. "Abstract Art." *Pioneer*, February 20, 1985.

Newman, Michael. "Sean Scully." *Art Monthly*, October 1981, p. 17.

"New York Reviews." *Flash Art*, June–July 1979, p. 52.

"No Field Day for the Council." *Irish Press*, December 10, 1985.

Oliver, Georgina. "Sean Scully." *Connoisseur*, December 1973, p. 302.

Packer, William. "Sean Scully." *Financial Times*, April 22, 1975.

———. "A Scott Comes to Artistic Judgement." *Financial Times*, December 4, 1984.

———. "An Idiosyncratic Look at One-Man Show." *Financial Times*, October 3, 1987.

———. "Simple Statements Speak Volumes." *Financial Times*, June 6, 1989.

Perez-Guerra, Jose. "Sean Scully: 'Geometria y emocion.'" *Cinco Dias*, September 17, 1989.

Poirier, Maurice. "Sean Scully." *Artnews*, January 1987, p. 160.

Puvogel, Renate. "Sean Scully—Neue Arbeiten." *Kunstwerk*, February 1986.

Ratcliff, Carter. "Artist's Dialogue: Sean Scully, A Language of Materials." *Architectural Digest*, February 1988, pp. 54, 62, 64B, 64D.

Raynor, Vivien. "Sean Scully." *New York Times*, June 19, 1987.

Reboiras, Ramon F. "Hay que humanizar el abstracto, romper su habitual distanciamento." *El Independiente*, September 14, 1989.

Roberts, John. "Patterns and Patterns: Sean Scully and Tony Sherman." *Art Monthly*, September 1979, pp. 11–12.

Rosenthal, Adrienne. "Paintings by Sean Scully." *Artweek*, March 29, 1975, p. 2.

Ruhe, Barnaby. "Sean Scully." *Art World*, January 16, 1981.

Russell, John. "Building on the Flat." *Sunday Times* (London), November 11, 1973, p. 35.

———. "Sean Scully." *New York Times*, December 10, 1976.

———. "Sean Scully." *New York Times*, March 4, 1977.

———. "Sean Scully." *New York Times*, December 14, 1979.

———. "Art Abstractions from Afro-America." *New York Times*, March 14, 1980.

———. "Sean Scully." *New York Times*, January 23, 1981.

———. "Sean Scully." *New York Times*, December 24, 1982

———. "Younger Americans: Visitors from the Past." *New York Times*, September 30, 1983.

———. "Paintings." *New York Times*, February 1, 1985.

————. ''Art: 'Heroic Sublime' or the Use of the Stripe.'' *New York Times*, June 13, 1986, p. C32.

————. ''Sean Scully.'' *New York Times*, October 10, 1986, p. 99.

Schappell, Elissa. ''Sean Scully: Star of Stripes.'' *GQ* (British edition), April–May 1989, pp. 114-21.

Schnock, Frieder, ''Sean Scully: Bilder und Zeichnungen.'' *Nike*, January 6, 1986.

Scotney, Stewart. ''Liverpool's Show.'' *Art and Artists*, August 1974, pp. 31–32.

''Sean Scully.'' *Print Collector's Newsletter*, January–February 1986, p. 218.

''Sean Scully.'' *ICI Newsletter*, Winter 1988, p. 4.

''Sean Scully.'' *La Economia*, September 15, 1989.

''Sean Scully, en Madrid.'' *El Independiente*, September 17, 1989.

''Sean Scully: 'Quiero quedarme en Espana durante algun tiempo.''' *El Punto*, September 21, 1989.

Searle, Adrian. ''Recent British Painting, Future Space.'' *Flash Art*, March–April 1980, pp. 28–29.

————. ''The British Art Show.'' *Artforum*, April 1980, pp. 87–88.

Shepard, Michael. ''Close Encounters.'' *What's on in London*, August 24, 1979.

Silverman, Andrea. ''Sean Scully.'' *Artnews*, October 1986, pp. 98–99.

Sofer, Ken. ''Monotypes from the Garner Tullis Workshop.'' *Artnews*, November 1987, p. 210.

Sozanski, Edward J. ''At Cava, Pastel Drawings and Ceramic Paintings.'' *Philadelphia Inquirer*, March 20, 1986.

Tatransky, Valentin. ''Sean Scully.'' *Arts Magazine*, February 1980, pp. 35–36.

————. ''Sean Scully.'' *Arts Magazine*, February 1981, p. 35.

Tisdall, Caroline. ''Meat on the Table, Not in the Nude.'' *Arts Guardian*, April 26, 1972.

Tockwell, Ann. ''At a Stroke.'' *Architect's Journal*, May 31, 1989, p. 94.

Trenas, Miguel Angel. ''Scully: 'La Humanizacion del abstracto.' *La Vanguarda*, September 15, 1989.

''Upcoming/Ongoing.'' *American*, November 1987.

Vaizey, Marina, ''Posters and Colour Surfaces.'' *Financial Times*, December 13, 1973.

————. ''Round the Galleries.'' *Financial Times*, December 14, 1973.

————. ''The Deathly Face of Flanders Field.'' *Sunday Times* (London), November 20, 1977.

————. ''Art.'' *Tatler and Bystander*, July–August 1979, p. 24.

————. ''Sean Scully.'' *Sunday Times* (London), April 5, 1981.

————. ''Painting on the Pleasure Principle.'' *Sunday Times* (London), April 12, 1981.

————. ''Painting Takes to the Stage.'' *Sunday Times* (London), December 2, 1984, p. 41.

————. ''The British Scene Shows Signs of Life.'' *Sunday Times* (London), October 11, 1987, p. 63.

————. ''Shedding Light on Simplicity.'' *Sunday Times* (London), May 14, 1989.

Varley, William. ''Art Spectrum, North in Newcastle.'' *Manchester Guardian*, Summer 1971.

————. ''Sean Scully.'' *Manchester Guardian*, July 18, 1972.

Walker, Dorothy. ''Sean Scully at the Douglas Hyde Gallery'' (letter to the editor). *Irish Times*, December 13, 1981.

————. ''Arts and Studies.'' *Irish Times*, January 4, 1985.

————. ''Shaming of a Brilliant Artist.'' *Irish Independent*, January 10, 1986.

————. ''Council Row on Modern Painting.'' *Irish Independent*, November 10, 1986.

Wallach, Amei. ''Abstract Power.'' *Newsday*, February 22, 1985.

Warman, Alistair. ''Six Artists—A Critic's Choice.'' *Manchester Guardian*, December 1973.

Westfall, Stephen. ''Recent Aspects of All-Over.'' *Arts Magazine*, December 1982, p.40.

————. ''Sean Scully.'' *Arts Magazine*, November 1983, p. 35.

————. ''Sean Scully.'' *Arts Magazine*, September 1985, p. 40.

————. ''Sean Scully.'' *Art in America*, September 1989, pp. 208, 210.

Winter, Peter. ''Blüten, Streifen, Neonlicht.'' *Frankfurter Allgemeine Zeitung*, November 26, 1987, p. 31.

Yoskowitz, Robert. ''Sean Scully/Martha Alf.'' *Arts Magazine*, April 1980, p. 24.

Zimmer, William. ''Sean Scully.'' *SoHo Weekly News*, December 13, 1979.

————. ''Sean Scully.'' *SoHo Weekly News*, October 28, 1981.

————. ''Condition Critical.'' *SoHo Weekly News*, February 9, 1982, p. 52.

————. ''Heart of Darkness: New Stripe Paintings by and an Interview with Sean Scully.'' *Arts Magazine*, December 1982, pp. 82–83.

————. ''Sean Scully.'' *Artnews*, May 1989, pp. 159–60.

Index

PHOTOGRAPH CREDITS